UPDATE on
Quality Enlarging with KODAK B/W Papers

This is Kodak's most comprehensive book on black-and-white enlarging. Since its original publication, Kodak has introduced four new enlarging papers. Their features are summarized on the next few pages, and data sheets for them are bound into the back of the book.

On page 103, we give a special procedure on processing prints for extra long-term keeping that uses KODAK Hypo Eliminator HE-1 to eliminate traces of fixer from the paper. We now recommend using Hypo Eliminator HE-1 only if residual thiosulfate is causing stains when toning. KODAK Hypo Clearing Agent should be used when water needs to be conserved or wash times shortened. If you make prints intended for extra long-term keeping (such as museum archives), we continue to recommend toning them for protection against oxidizing gases. Toning protection can be obtained with slight or no change in the print tones. (See pages 98, 101, and new data sheets.)

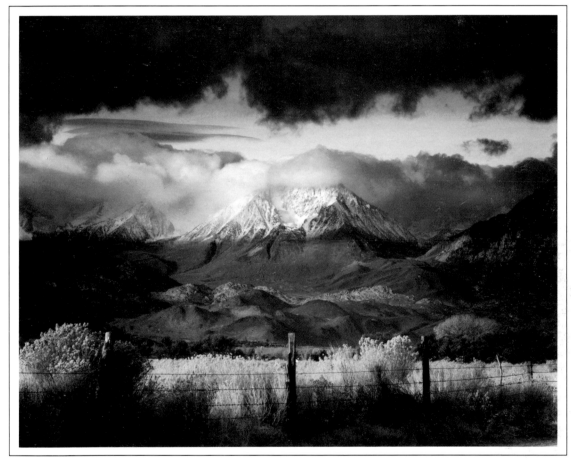

Bruce Barnbaum

KODAK POLYFIBER™ Paper

POLYFIBER Paper is an excellent fiber-base paper that is markedly improved over KODAK POLYCONTRAST Paper and POLYCONTRAST Rapid Paper, which it replaces. With its neutral image tone, deep blacks, and bright whites you can make exceptional prints. Its variable contrast and wide development latitude make it a responsive paper that can simplify enlarging problems. It is available in four surfaces: A (smooth lustre), F (glossy), G (fine-grained lustre), and N (semi-matt). See the data sheet for the weights available.

Cover photograph and print by Scott Griswold, Jr.
Print made on KODAK ELITE Fine-Art Paper.

©Eastman Kodak Company, 1985

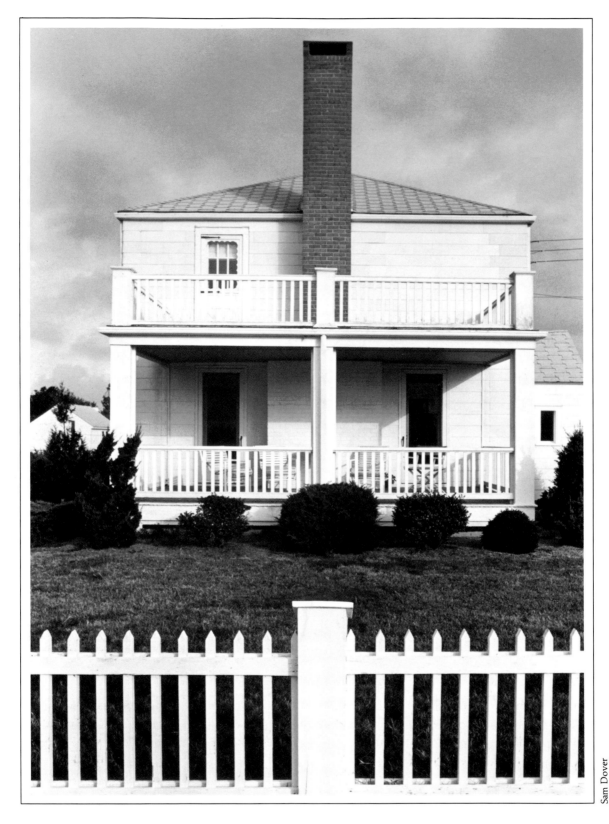

KODAK POLYPRINT RC Paper

Here's a resin-coated, variable-contrast paper that doesn't use incorporated developer. The absence of incorporated developer is an advantage to those who like to pull the print from the developer when it looks just about right. In other words, wide development latitude. You can develop the print longer to make it darker or pull it out sooner before it gets too dark. This paper also has a brightener for whiter whites and is available in three surfaces: F (glossy), N (semi-matt), and E (LUSTRE-LUXE®).

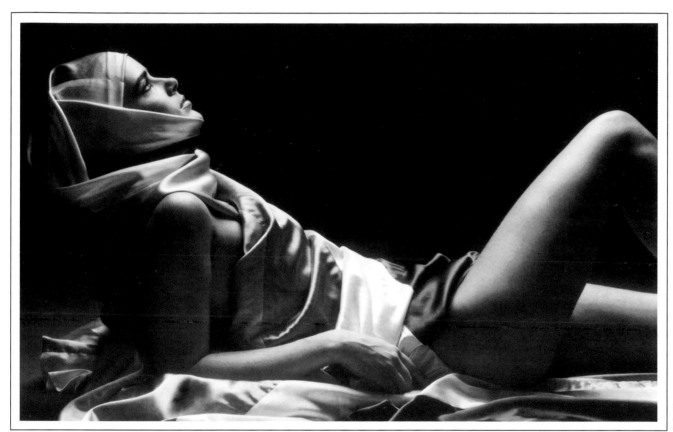

KODAK PANALURE II Repro RC Paper

This is a panchromatic paper for making black-and-white prints from color negatives. It is resin-coated, has incorporated developer, and a brightener. With about a grade lower contrast than its companion paper, KODAK PANALURE II RC, it's designed for making prints to be used for halftone reproduction, such as in yearbooks or magazines. In turn, the higher contrast of PANALURE II RC Paper works especially well for making black-and-white display prints from color negatives. If you're unfamiliar with panchromatic papers, you'll find they give more realistic tones when making black-and-white prints from color negatives than do normal black-and-white enlarging papers.

KODAK ELITE Fine-Art Paper

This is Kodak's top-of-the-line black-and-white enlarging paper for those who need to make superior prints on fiber-base paper. The silver-rich emulsion delivers deep, dark blacks. The paper is heavier than conventional double-weight paper and uses a brightener to reveal superb whites. It comes in three speed-matched contrast grades (1, 2, and 3). A special S surface designed for air drying delivers an ultra-smooth, high-lustre surface.

QUALITY ENLARGING WITH *KODAK* B/W PAPERS

Art, Technique, and Science

a KODAK Data Book

TABLE OF CONTENTS

First Edition, First Printing 1982
Library of Congress Number: 81-68717
©Eastman Kodak Company 1982

Catalog Number: 152 8314
ISBN-0-87985-279-8

Quality Enlarging with KODAK B/W Papers

Art, Technique, and Science

Eastman Kodak Company makes a variety of fine black-and-white photographic papers for use in making photographic prints. The purpose of this publication is to provide information about the characteristics of these papers and instructions on their use.

This Data Book is the combination of two previous KODAK Publications: No. G-1, *KODAK Black-and-White Photographic Papers* and No. G-5, *Professional Printing in Black-and-White*. The information in these two publications has been expanded and updated for this edition. Nearly all the illustrations are new.

Color photography has grown by leaps and bounds. It might be thought that this growth has been at the expense of black-and-white photography. However, in fact, black-and-white photography has also grown, if at a somewhat slower pace. The reasons for this have to do with cost, technical and artistic considerations, and an increasing interest in darkroom work.

Many photographs are made for reproduction in newspapers, magazines, brochures, etc. The cost of reproduction in black-and-white is considerably less than for color. Hence, a large percentage of the photographs made for reproduction are black-and-white. For artistic and print stability reasons, most fine-arts photographic prints are being made in black-and-white. Most of the photographs sold for high prices in art auctions are black-and-white. For these reasons, and others, black-and-white work continues to represent a substantial part of the photography being done today.

There have been a number of significant changes in photographic papers and their processing in recent years. Stabilization processing that produces a print in a few seconds has become popular in situations where deadlines are short and where print keeping is not a consideration. A new series of water-resistant papers with incorporated developers that makes activation processing possible is an even more recent innovation.

In this Data Book, we discuss the nature of the different types of papers, and how their structure makes possible the various types of processing. We show the advantages of the different methods, and compare them with the traditional tray method of processing.

With the great improvements in films over the last 90 years or so, most negatives are made with small-format cameras. As a result, most prints are enlarged. In this book we provide information on the various enlarging steps, and some of the special enlarging techniques that are used. We give comparisons of the results that can be expected from different types of enlargers.

The quality of a final print depends on many factors—the subject, the lighting, the film, the photographer's skill, the paper, the enlarger, the skill of the person making the enlargement, the processing, and the print finishing. We define the technical aspects of print quality in terms of its tone reproduction, its image stability, and its perfection or freedom from visible defects.

Don Maggio

In the text and especially in the Data Sheets, specific technical information is given about Kodak photographic papers. Eastman Kodak Company makes every effort to supply a variety of consistently high quality products. However, some variations in the characteristics of photographic papers occur, just as variations occur in most manufactured products. Sensitized materials must be considered perishable; their characteristics change slowly with time. Fairly rapid changes can occur if improper storage conditions are maintained. For these reasons, the data do not represent standards which must be met by the company. If closely repeatable results are required, it may be advisable to obtain the needed quantities of one paper emulsion, run carefully controlled tests to get exactly the results wanted, and store the paper in a freezer, and to allow an adequate warm-up time just before use. Then, by using extreme care to make sure of exposure and process repeatability, very consistent results can be obtained.

However, for regular work, the process flexibility will produce high quality results with normal care and with storage of paper at 70°F (21°C) or lower, for a reasonable period of time after the paper is purchased. The results should be monitored to achieve specific photographic goals.

A number of Kodak people helped prepare this Data Book for publication—photographers, technicians, reviewers, and Publications Department staff members. We all sincerely hope that it will prove useful to you.

W. Arthur Young
Technical Editor
Consumer/Professional & Finishing
 Markets Publications
Eastman Kodak Company

High print quality is the result of a number of factors—the subject, the lighting, the film, the exposure, the photographer's skill, the film processing, the enlarger, the paper, the paper processing and the darkroom worker's skill. The information in this publication covers nearly all the aspects of printmaking that lead to quality prints.

The Black-and-White Photographic Process

Photography is the process of recording the visual aspects of various subjects.

The various visual aspects—or appearance—of objects include tone, contrast, line, shape, form, texture, light and shade, size, apparent distance, and color. In black-and-white photography, the aspect of color is eliminated. Of these aspects tone is all important, because all of the other aspects are achieved by variations in tone. Tone can be defined as the apparent lightness or darkness of various subject areas.

The basic black-and-white photographic process consists of four steps:

1. Expose film
2. Process film
3. Expose paper
4. Process paper

This Data Book is concerned with the last two steps. KODAK Publication No. F-5, *KODAK Professional Black-and-White Films*, covers the first two steps.

When a black-and-white film has been exposed and processed, a negative results. The negative contains a record of subject tones, but in reverse. Light subject tones are dark in the negative, while dark subject tones are light. In the last two steps, the tones are reversed again, so that the paper print that results is a positive image of the subject.

It is a fairly simple process to obtain a photographic print. However, to produce high-quality prints for professional use involves a knowledge of the various characteristics of photographic papers, the various solutions and procedures in processing them, and the equipment and techniques used in exposing the paper.

And as important as any of these is a knowledge of what photographic quality is, what it looks like, and how to achieve it.

All these aspects of the last two steps of the basic photographic process are covered in this KODAK Data Book.

Structure of Papers

While different types of photographic papers vary in their characteristics, they all basically consist of a light-sensitive coating, called the emulsion, on a paper support or base. The emulsion consists of a suspension of light-sensitive silver halide crystals in gelatin.

Three silver halide salts are used in photographic emulsions: silver chloride, silver bromide, and silver iodide. The particular salt or mixture of salts, the method of its formation in manufacturing, and the addition of special agents determine such emulsion characteristics as speed, contrast, and image tone or color. In addition to these variations in emulsion characteristics, modern papers are made in different surface textures and sheens, and in different base tints and paper base weights to suit various applications.

Photographic paper base is made free from chemical contaminants such as bleaches and reactive oxidizing or reducing agents, and is made so that it retains a relatively high degree of strength when wet. When used to make fiber-base papers, the paper is coated with a layer of baryta coating, which is barium sulfate in gelatin, to give a smooth, reflective surface for the emulsion.

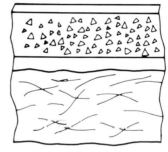

Gelatin overcoat
Silver halide crystals in gelatin emulsion
Baryta layer (pigmented)
Photographic paper base

Conventional Paper

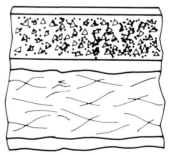

Gelatin overcoat
Silver halide crystals and developing-agent granules in hardened gelatin emulsion
Resin layer (pigmented)
Photographic paper base
Resin layer

Paper for Activation Process

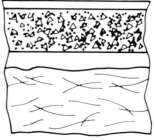

Gelatin overcoat
Silver halide crystals and developing-agent granules in gelatin emulsion
Baryta layer (pigmented)
Photographic paper base

Paper for Stabilization Process

When resin-coated papers are made, the paper base is coated on both sides with resin coatings. The resin coating on the emulsion side is pigmented. The clear coating on the base side of most resin-coated papers is treated so that it will not stick to the surface of other prints in processing, so that it can be marked on with pencils and pens, and so that it will help control curl. Papers made with water-resistant bases have short processing times and are necessary for activation processing.

Developing agents are incorporated into the emulsions for papers that are made for activation or stabilization processing. Such papers can also be tray-developed in regular paper developers.

Black-and-white prints reproduce the tones of subjects in whites, grays, and blacks. Since the color of the original subjects is missing, black-and-white prints must separate the many subject tone differences to give satisfactory reproductions. Also, by selecting suitable surface textures, image tones, and base tints, some of the subject conditions can be suggested. For example, a paper with warm image tone on a cream-white paper base is suitable for portraits and pictures of warm, sunlit subjects such as fall scenes. A neutral-black image tone on a white base can suggest the cold of snow, or the colorless tones of night.

In this Data Book, enough of the technology of photographic papers is presented to give an understanding of such characteristics as speed and contrast, the tonal relationships between the negative and the paper, and the effect of the enlarger on these relationships. In other sections, enough information is provided on paper surface sheen and texture, image tone, base tint, and the dimensional stability of the paper base to make it possible to make intelligent choices among the different available papers for various purposes.

Sensitometry of Photographic Papers

Many successful photographic workers make outstanding photographs without understanding the science of photography. However, there is a scientific procedure that makes clear what happens during photographic reproduction, and that produces graphs to show the tone reproduction characteristics of photographic sensitized materials.

This scientific procedure is called sensitometry, and the graphs that show the characteristics of films and papers are called characteristic curves. Other names given these curves are sensitometric curves, D-log E curves, and H & D curves (after Hurter & Driffield, who first studied sensitometry in the 1890s).

All physical sciences involve measurements. Thermometers are necessary for the study of heat. Temperature units, calories, and thermal units are measures of heat. Voltmeters and ammeters are used in the study of electricity to measure electrical potential and current flow.

Light is the essential energy in photography. The level of light falling on a surface is called illuminance and is measured in units that involve the amount of light, such as footcandles or metre-candles. The brightness of subject tones, usually light reflected from subject surfaces, is measured in candles per square foot—or per square metre. The darkness of photographic tones, both in transparent images (negatives, transparencies) and in reflective images (paper), is measured as density.

Photographic paper emulsions are made of light-sensitive crystalline salts—mostly silver chloride and silver bromide—suspended in gelatin. Slow contact papers are likely to be all or mostly silver chloride crystals, while enlarging papers are nearly all a mix of silver chloride and silver bromide salts. The proportion of one to the other, the way they are formed in manufacturing, the manufacturing step known as ripening, and the addition of various special agents such as optical and chemical sensitizers largely determine the emulsion speed, contrast, D-max (maximum density), and image tone.

Most enlarging papers can be used with amber and red safelights because they are not very sensitive to light of these colors. Selective-contrast papers, which are somewhat more sensitive to longer green wavelengths than are graded papers, generally have a shorter safe time to safelight illumination [recommended KODAK Safelight Filter OC (light amber)]. KODAK PANALURE Papers have a panchromatic emulsion, but have a relatively low sensitivity to light of about 592 nanometres. The KODAK Safelight Filter No. 10 (dark amber) has a peak transmission to match this, giving some safe time.

Special sensitizers are also used to attain and control paper speeds. For example, with the same graded contrast paper emulsion, the higher contrast grades are slower than the lower contrast grades. With KODAK MEDALIST Paper, the four grades have essentially the same speed. This is achieved by using sensitizers.

Reflection Density

As a photographic paper emulsion is exposed to increasing amounts of light, it produces more and more black metallic silver in the emulsion (after development). It is this black silver that provides the tones in the print. Where there is no silver, the white of the paper is seen. Where there is little silver, the tones are light gray. Medium amounts produce

medium grays. At the point when more exposure does not produce any more silver, the maximum black (D-max) of the paper has been produced.

In sensitometry, the degree of darkness in the print image is measured in reflection density units. The white paper has a density of about 0.10, while the maximum black may vary from a density of 1.5 to 2.2, depending on the paper, its surface, and to some degree, its processing.

Pictures are viewed by light that reflects from the picture surface. White paper reflects about 80 percent of the light. It has a reflectance of 0.80. A black with a density of 2.00 reflects about 1 percent of the light—it has a reflectance of 0.01.

The light that is not reflected is absorbed by the black metallic silver. Absorptance, mathematically, is the reciprocal of the reflectance. When the reflectance is 0.80, the absorptance is 1/0.80 or 1.25. The absorptance of a reflectance of 0.01 is 1/0.01=100.

Density is the logarithm to the base 10 of the absorptance. The following table shows some typical equivalent reflectances, absorptances, and densities.

% Reflection	Reflectance	Absorptance	Reflection Density	Tone
80%	0.80	1.25	.10	White
40%	0.40	2.50	.40	Light gray
18%	0.18	5.56	.75	Medium gray
5%	0.05	20	1.30	Dark gray
1%	0.01	100	2.00	Black

Fortunately, densitometers are made to measure reflection density directly so that these calculations are not normally needed in dealing with densities. Further, in the actual process of making enlargements, it is not necessary to know exact density values. It is very useful, however, to have a clear mental concept of density in order to interpret the characteristic curves of various papers.

Exposure of Paper

As indicated earlier, it is exposure to light that produces the reflection densities in the print. Within limits, the more exposure, the greater the resultant density (after processing, of course).

In measured terms, exposure equals the illuminance incident on the paper surface (the brightness of the light) multiplied by the time of exposure.

$$\text{Exposure} = \text{Illuminance} \times \text{Time}$$

The illuminance is measured in metre-candles, also known as *lux*. A piece of photographic paper placed 1 metre from a standard candle has an illumi-

nance of 1 metre-candle, or 1 lux on its surface. If it is exposed to the light for 1 second, it receives an exposure of 1 metre-candle-second, or 1 lux second.

It is customary to deal with exposure as logarithmic values, and log-exposure values are always plotted in characteristic curves. The following table shows the relationship between unit metre-candle-second values and their equivalent logarithmic values. (Note: $\bar{2}.00 = -2.00$)

mcs	log mcs
1/100	$\bar{2}.00$
1/10	$\bar{1}.00$
1	0.00
10	1.00
100	2.00
1000	3.00

The Characteristic Curve

The characteristic curve (D-log E curve, sensitometric curve, H & D curve) of a paper shows how much reflection density is produced by how much log exposure when processed as indicated on the curve.

The horizontal axis of a characteristic curve is calibrated in log mcs units. The vertical scale is calibrated in density units. A curve is produced in a laboratory by giving samples of paper different known log exposures in different areas so that, when processed, a gray scale is produced. The reflective density of each area is measured. A series of points

This is the characteristic curve of a typical paper. The three sections of the curve are identified. In some papers, the actual straight-line portion is very short, but there is an extended region where the line is almost straight that reproduces the midtones evenly.

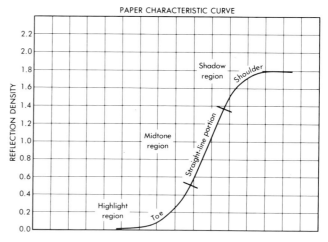

PAPER CHARACTERISTIC CURVE

LOG EXPOSURE (lux seconds)

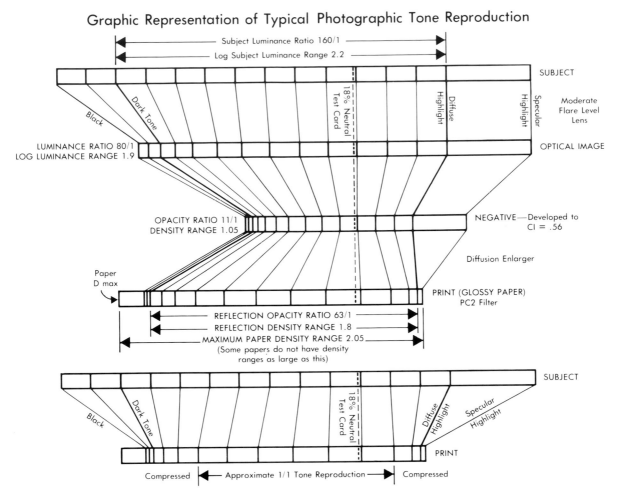

Graphic Representation of Typical Photographic Tone Reproduction

Because of the shape of the characteristic curves of the paper and film, middle tones have a tone reproduction similar to that of the original, while both highlight and shadow tones are compressed. People accept this type of tone reproduction as being normal. See page 121 for the visual effect of ambient illumination on tone reproduction.

is plotted on graph paper. Each point shows the density produced by a given log exposure. These points are connected with a curved line, and it is this line that is the characteristic curve.

The slope of a curve at any point is the "rise" divided by the "run." In the case of a characteristic curve, the rise is the amount of density change in a small segment of the curve, while the run is the change in log exposure of the same small segment.

The slope of any part of the curve indicates how rapidly the density changes with changes in exposure (log exposure). Because of its shape, the characteristic curve can be divided into three general sections: the lower part called the toe, the midsection called the straight-line section, and the upper part called the shoulder.

The Toe: In this crescent-shaped lower portion of the curve, the density change for a given log exposure increases continuously. This is shown because the slope increases continuously—the line curves upward. The toe is the low density region of the curve, and is where the highlights and light tones

are reproduced. Because of the relatively low slope of this portion of the curve, highlight tones are "compressed"—for a given log exposure change; there is little change in density. The tonal separation of light tones decreases as the lower end of the curve is approached. The horizontal section at the left end of the toe is where white is reproduced, and the density value is known as the "base plus fog density," or "gross fog density."

The ability of a paper to separate highlight detail is an important aspect of a paper, and can be estimated from the slope of the curve. A paper with a relatively short toe section provides better separation than a paper whose curve has a long, sweeping toe. However, printing on a paper with a short toe is more critical—there is less latitude in the highlight region, so the highlights must be exposed exactly.

When the need is to have delicate gradation in the highlights, as in a picture of a silken fabric, or in delicate skin tones in a portrait, a long-toed paper may be more suitable.

In general, soft grade papers have longer toes than the higher grades of the same paper. The toes of

A gray scale is often used as a representation of the photographic subject. Most subjects have a variety of tones—the differences between subjects is in the size, shapes and locations of the various tones. A photographic tone is determined both by the object reflectance and the illuminance (brightness) of the light. If a subject area of a uniform reflectance is partly in the sunlight and partly shadowed, the shadowed area will have a lower tonal value than the area in the sunlight.

different papers may differ in length. The tone reproduction of highlights in prints can be changed somewhat by the choice of papers with different toe slopes.

The Straight Line Section. This is the part of the curve on which the important middletones are reproduced. It is the section of the curve that gives the most contrast because its slope is the greatest. Where the straight line is straight, or nearly so, the relationship between the increase in density with increase in log exposure can be described as linear. In this section of the curve, a constant increase in log exposure results in a constant density increase.

In reproducing the tones of a subject, a film compresses all the tones. This is designed to give exposure latitude in the film and to give moderate amounts of film development to keep image sharpness and grain at reasonable levels. In order to bring back the tonal separation, the tones have to be expanded by the paper. For this reason, the slope of the straight-line portion of the curve is always greater than 1. It varies from about 1.4 in grade 1 papers up to over 3.0 in contrast grade 5 papers.

The illustration shows how the tones are compressed and expanded by the various steps of photographic process. It is interesting to note that in normal reproduction, which this illustration represents, the midtones of the subject are actually expanded slightly in the print. This is the result of the slope of the straight-line portion of the paper curve.

The Shoulder: The upper part of the characteristic curve is called the shoulder. This is where the dark tones and blacks are reproduced. The curve slope changes gradually until it becomes horizontal. Where it is horizontal it is the maximum density (D-max) of the paper. Exposure increases no longer result in density increases. Because of the lessening of the slope on the curves, tones reproduced in the shoulder are compressed by the paper.

Types of Characteristic Curves

When a sample of paper is given a series of exposures and processed, and when the densities of the steps are measured and plotted on a characteristic curve on graph paper, this curve, because it applies to a specific test, can be called a *specific* characteristic curve.

Curves published by Kodak, such as those for Kodak films, are *representative* characteristic curves. Such curves are the averaged results from a number of tests on a number of different emulsion runs, and are representative of what a user can expect to get from an emulsion. Representative characteristic curves for some Kodak papers are reproduced on pages DS-18 and DS-19 in the Data Sheet section of this publication. Representative curves do not necessarily represent exactly each batch of paper because of slight manufacturing variations and the effects of storage.

5

The curves shown on this page which illustrate the differences between papers of various contrast grades and different paper surfaces are generalized characteristic curves, and do not represent any particular photographic paper.

When a group of characteristic curves of related materials is plotted on one graph, the curves are shown as a family of characteristic curves. Two families are shown. One family compares the various contrast grades of a generalized paper, while the other compares different surfaces of the same paper. Families of curves are used to make comparisons.

Interpreting Characteristic Curves

Many of the photographic characteristics of a paper can be found by interpreting the characteristic curve of the paper. The following sections discuss what some of these characteristics are.

Paper Surface and Maximum Density: A given paper, but with various surfaces such as semi-matt, lustre, high-lustre, or glossy, yields similar curves, but the maximum shoulder densities are different. The D-max of a paper is primarily dependent on the degree of surface sheen and the basic emulsion. Texture and processing are secondary contributing factors.

Papers vary in the opacity of the maximum silver image they will produce. In general, warm-toned images do not produce as high D-max values as do neutral images. Even within such image tone groups, there are variations in this maximum density level.

The longer the density range a paper can produce, the greater the visual scale possible with that paper. This means richer blacks and greater local contrast between all the tones in the print. Some of the differences between papers are intrinsic in the emulsion itself.

The degree of sheen has a definite effect on the D-max—the greater the sheen the greater the D-max value with the same paper. This is because both in the measurement and in the viewing of prints the illumination is directional. With smooth, high-sheen surfaces like glossy, the surface reflection of the light source generally goes to one side and is not seen. With papers that have a lower sheen level, the surface reflection is more diffuse. Some of the surface reflection goes toward the viewer's eyes, and when being measured, goes to the photocell. This adds light to the D-max, lowering its density value.

Therefore, smooth, glossy, and high-lustre surfaces have the potential for the greatest D-max and hence the longest visual tonal scale.

The family of characteristic curves in the illustration shows the same paper emulsion with different sheens. Typical D-max values with the different sheen levels are illustrated.

Fiber-base F-surface papers are often ferrotyped to provide a more glossy surface. The unferrotyped surface is quite smooth already, so ferrotyping prints made on F-surface papers may not make a significant difference in visual D-max.

If a print is underdeveloped, the potential D-max is lowered. Greatly overdeveloping prints does not, however, significantly increase the D-max, and does increase the chances of raising the fog level in the highlights. Warm-image-tone papers do show a slight increase in D-max with extended development; neutral-tone papers show practically none.

When KODAK Rapid Selenium Toner is used with most neutral-image-tone papers, the image color does not change. However, the D-max generally increases a little. Where long visual scale is an advantage in a print, such toning can be used with both fiber-base and resin-coated papers. (See page 99.)

Paper Surface and Minimum Density: The minimum reflection density on photographic paper is known as gross fog or base-plus-fog density. If a sheet of unexposed paper is fixed without development, washed and dried, and the density measured, the result is the density of the paper base. If another piece of the same unexposed paper is developed normally, fixed, washed, and dried, and the density measured, the result is the base-plus-fog density. In any emulsion, a few unexposed crystals of silver halide will develop without exposure. This is the fog density of the base-plus-fog measurement. Typically, if the paper is handled in the dark, the fog density will be relatively small—on the order of 0.01 or 0.02.

Since all prints are developed, the white of the

Characteristic curves showing the effect of surface sheen on D-max.

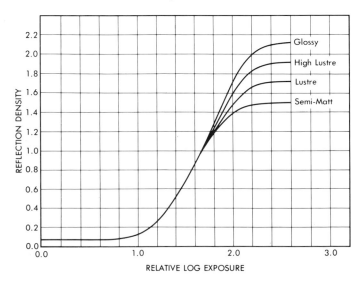

specular highlights and the paper borders have a density equivalent to the base-plus-fog density.

There are two practices used in the measurement and plotting of paper characteristic curves. In one practice, the densitometer is zeroed on a white (base-plus-fog) area, and all densities read above zero. In this practice, all characteristic curves start on the zero-density line—the horizontal axis. Such curves can be called normalized or relative characteristic curves because the density values are relative to the processed paper base. They show what are called *net densities,* which are the absolute densities minus the density of the processed paper base.

The curves shown in this section are absolute characteristic curves that show the minimum densities—usually about 0.10 or slightly less. Reflection densitometers are supplied with calibration patches—a white and a black area with their absolute reflection densities marked. When the densitometer is calibrated with these patches, it measures absolute densities. Such patches are prepared in comparison to a diffuse-white standard material such as barium sulfate.

Contrast: In photography, the term contrast is used in a number of ways. Subject contrast refers to the tonal range of the subject. Lighting contrast refers to the ratio between key and fill light. Negative contrast refers to the density range of the negative image.

Paper contrast is the term used to describe the inherent contrast of the paper emulsion—basically the slope of the characteristic curve.

The contrast numbers give an approximate idea of the paper contrast. It is well known that different kinds and brands of paper bearing the same grade number may have somewhat different inherent contrasts. A photographic printer should know about these differences in choosing a paper for printing a particular negative on a particular enlarger. A skilled worker can assess the density range of a negative and, taking the subject matter into consideration, can then choose the contrast grade of a paper that will make a satisfactory print.

Many workers, however, only occasionally make enlargements and, hence, do not develop such a high degree of skill. For such workers, a measurement method has been devised for fitting the density range of a negative to the contrast of the paper. The use of such a method is discussed in the following sections.

It should be recognized that what is being presented is a mathematical or technical approach to what may be an artistic matter of taste. Not all workers or viewers of photographs like the same degree of contrast in prints. Therefore, while the following method is helpful both in the actual process of enlarging and in learning the characteristics of photographic papers, it is expected that all workers will choose paper contrasts that result in prints whose contrast is satisfactory to their eyes.

Log-Exposure Range: The term "log-exposure range" is used to describe the relationship between the exposure needed to give a faint diffuse highlight tone and that needed to yield a very dark gray just visibly distinguishable from black. Logarithmic units are used because it is log-exposure units that are plotted in characteristic curves.

The density range of a negative is the difference between a diffuse highlight density (high) and a dark tone (low) density that is expected to print just lighter than black.

When the log-exposure range of the paper approximately equals the density range of the negative, the contrast of the print will, in most cases, be satisfactory if the print is being contact-printed or enlarged with a diffusion enlarger. (See section on Enlargers, page 39.) With a typical condenser enlarger, when three-fourths of the log-exposure range of the paper approximately equals the density range of the negative, the contrast of the print will be satisfactory in most cases.

For example, the average log-exposure range of grade 2 paper is 1.05. A negative with a density range of 1.05 will produce a print on grade 2 paper when contact-printed or when enlarged with a typical diffusion enlarger. However, when a typical condenser enlarger is used, grade 2 paper matches a negative with a negative range of $1.05 \times 0.75 = 0.79$. Different makes of enlargers and different enlarger lenses and their cleanliness affect this relationship, so exact matches are found by experiment. A table showing the approximate relationship between the

Characteristic curves showing the differences between paper contrast grades.

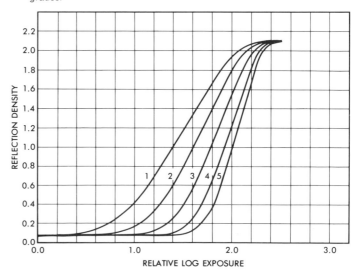

Balthazar Korab

a. Contrast Grade Zero (Two PC 1 filters with Selective-Contrast Paper) b. Contrast Grade 1 c. Contrast Grade 2

The lower contrast grades are usually used to make prints from normal- to high-contrast (high density range) negatives.

negative density ranges and the log-exposure ranges of various contrast numbers of papers appears below.

Paper Contrast Number	Paper Log-Exposure Range	Suitable Negative Density Ranges	
		Diffusion Enlarger	Condenser Enlarger
1	1.15 to 1.40	1.15 to 1.40	0.86 to 1.05
2	0.95 to 1.14	0.95 to 1.14	0.71 to 0.85
3	0.80 to 0.94	0.80 to 0.94	0.60 to 0.70
4	0.65 to 0.79	0.65 to 0.79	0.49 to 0.59
5	0.50 to 0.64	0.50 to 0.64	0.38 to 0.48

As indicated above, these are average figures, and should be adjusted to particular conditions based on experience. The drawing on page 7 shows typical characteristic curves of the five paper grades.

The log-exposure range of a paper is determined from its characteristic curve. In the drawing on the opposite page, log E_A represents the point on the paper curve that is a 0.04 density unit above the density of the processed paper base (base-plus-fog density). Log E_B is the point on the paper curve that is 0.90 x D-max of the paper. The log exposure that produced both of these densities is determined from the characteristic curve. The log E_A value is 0.73, while the log E_B value is 1.93. The log-exposure range of the paper shown is $1.93 - 0.73 = 1.20$, which indicates it is within the contrast-1 category.

Paper Grades in Practice: The purpose of having different paper grades is to permit a user to achieve a print contrast that the user likes, given a particular negative to be printed in a particular enlarger. Generally speaking, the normal negative should print

well on grade 2 paper, while lower contrast negatives will require grade 3 or 4 paper and negatives with higher contrast will require grade 1 paper. If the user is equipped with a densitometer, the above table can be consulted to classify negatives as to the paper they are likely to require. Most workers, however, do not have densitometers and have to judge the contrast (density range) of their negatives by eye.

A negative illuminator, consisting of a translucent glass or plastic sheet with light bulbs or fluorescent tubes behind the sheet and built into a box-like container, is a big help in judging negatives. When a negative is found that prints well on a particular grade of paper, it can be saved and used as a "master" comparison negative. When a set of four comparison negatives has been found, it can serve as a comparison guide for new negatives. A certain degree of trial and review goes into building up this set of negatives.

There are several types of low-contrast negatives, and it is a good idea to find an example of each. The first is the underexposed negative, which is low in contrast because the highlight region did not receive enough exposure to reach a high level of density. The second type is the underdeveloped negative, which has had normal exposure, but is low in contrast due to the lack of adequate development. The third type is the overexposed negative where the highlights have been exposed on the shoulder of the characteristic curve, and therefore have very low tone separation.

Experience and care with building and use of a good set of contrast comparison negatives will help develop judgment so that a worker can usually

d. Contrast Grade 3	e. Contrast Grade 4	f. Contrast Grade 5

The higher contrast grades are usually used to make prints from normal- to low-contrast (low density range) negatives. This series shows prints made on the various contrast grades from a single, normal-contrast negative.

choose the correct grade of paper for each new negative with few errors.

Selective-Contrast Papers: The emulsions on Kodak selective-contrast papers are made so that the contrast changes with a change in color of the enlarging light. Violet light increases the contrast, while yellow light lowers the contrast. KODAK POLYCONTRAST Filters are made to be used on or in the enlarger when printing on one of the selective-contrast papers.

These filters are available in three forms. The KODAK POLYCONTRAST Filter Kit (Model A) contains seven filters mounted in plastic frames, along with a filter holder that can be attached to the enlarger lens. KODAK POLYCONTRAST Acetate Filters are made in sheets and are used in the filter drawers on many enlargers above the negative. They are not made to be used between the lens and the paper. The third type is KODAK POLYCONTRAST Gelatin Filters. They are available in 50 mm (2-inch) and 75 mm (3-inch) squares and are intended for use between the lens

ANSI Standard Paper Curve
This curve shows the technical definitions of such terms as D-max, Log Exposure Range, Density Range, Base Density plus Fog Density (also called Gross Fog Level), and the location of the ANSI Paper Speed point.

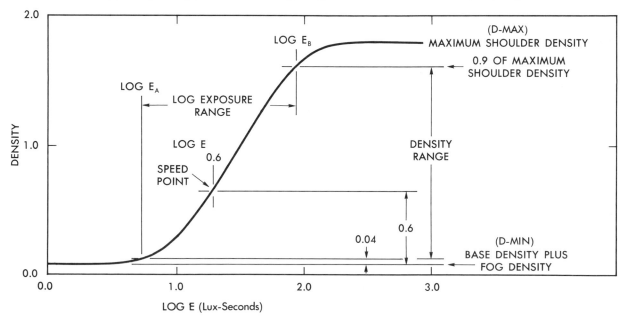

KODAK POLYCONTRAST Filters are used to obtain different degrees of contrast with selective-contrast papers. KODAK Publication No. G-11, *KODAK POLYCONTRAST Filter Computer* is used to find print exposures when changing from one PC filter to another or from one paper to another.

These pictures and all of the "how-to-do-it" pictures throughout this book are by Tom Beelmann.

and the paper.

The filters range from a fairly strong yellow to a deep violet in a numbered series: PC1, PC1½, PC2, PC2½, PC3, PC3½ and PC4. When used with a Kodak selective-contrast paper, the PC1 filter causes the paper to have about the same contrast as a grade 1 paper, and so on. With the ½ step filters, the paper yields seven grades of contrast in ½ grade steps. If a negative prints well on a grade 2 contrast paper, it should also print well on a Kodak selective-contrast paper when the PC2 filter is used.

When printing selective-contrast papers with an enlarger that has a color head, the contrast can be adjusted by dialing the yellow and magenta filters. (The cyan filter is left at its zero setting.) The settings for the magenta and yellow filters for each PC equivalent vary with the type of enlarger light and the filter settings on each type of enlarger.

For low contrasts, the yellow filter is used, al-

though with some enlargers, some magenta filtration is also used. A moderate amount of yellow, in the 30Y to 40Y range, should give an equivalent to a PC1 filtration, while a stronger yellow setting, perhaps 50Y, may give a zero contrast equivalent.

Magenta filtration is required to produce a medium contrast; perhaps 20M may be required. For a contrast 3 equivalent, more magenta is required—perhaps from 90M up to 125M.

Some enlargers do not have enough filtration to reach a contrast 4 equivalent—the maximum magenta setting is usually required to reach the equivalent of PC3½.

The instruction books with some enlargers have recommended settings for various PC equivalents. In any case, a few practical experiments based on the above suggestions should result in a list of settings that will obtain the approximate PC equivalent contrasts with a particular enlarger.

Paper Speeds

Photographic papers vary widely in speed or sensitivity to light. Papers for contact printing are slow and are impractical to use for enlarging with regular enlargers. Enlarging papers are generally faster in speed: warm-tone enlarging papers are usually moderate in speed, as are papers designed for machine printing in rolls, while most regular neutral-image-tone papers are relatively fast. Very fast enlarging papers such as KODABROMIDE, KODAK POLYCONTRAST Rapid, and KODAK POLYCONTRAST Rapid II RC Papers are designed for use when short exposures are needed in high-volume production. They are also useful in making big enlargements from small negatives or when negatives are very dense.

ANSI Paper Speeds: The speed of Kodak papers is given in accordance with the ANSI (American National Standards Institute) Standard: *Sensitometry of Photographic Papers*, PH 2.2-1972. This standard method provides a way to express paper speed with a number that allows a worker to go from one paper to another when exposure conditions for the first paper are known. ANSI paper speed numbers indicate the relative speeds of different papers based on a middle-gray tone comparison. ANSI paper speeds are given as one of an arbitrary series:

1, 1.2, 1.6, 2, 2.5, 3, 4, 5, 6, 8, 10, 12, 16, 20, 25, 32, 40, 50, 64, 80, 100, 125, 160, 200, 250, 320, 400, 500, 650, 800, and 1000.

In this series, the difference between any two consecutive numbers represents an exposure change of ⅓ f-number or stop. Thus, if the speed difference between two papers is three consecutive numbers, say from 32 to 64, the exposure difference

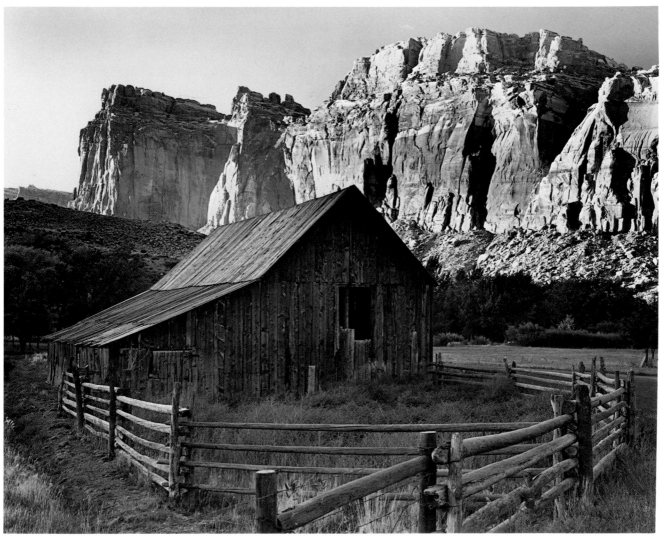

The most satisfactory contrast grade to use is not always the one that matches the negative density range. This print was made from a high-contrast (high density range) negative. If matched with a low-contrast paper, the local contrast in each area of the print is quite low. By printing on a normal-contrast paper, and by burning in the high density areas (mountain and sky), the local contrast is improved, and yet both areas show appropriate tones. (See pages 74 and 76.)

is one stop, which is one full stop or a factor of 2X.

When a negative is printed on different contrast grades of paper, the prints can easily be compared when a midtone is matched in the prints; consequently, ANSI paper speeds are calculated from the amount of exposure required to produce a density of 0.60, according to this equation:

$$S = \frac{10^3}{E_{0.6}}$$

Where S is the ANSI paper speed, 10^3 is 1000, and $E_{0.6}$ is the exposure in lux seconds (metre-candle-seconds) required to obtain a density of 0.60 above the base-plus-fog density.

Using Speed Numbers: ANSI paper speed numbers are useful in photographic printing for determining approximate exposures when you change from one kind of paper to another, or from one contrast grade of paper to another. The ANSI speeds of selective-contrast papers are measured with KODAK POLYCONTRAST Filters, so the ANSI speed numbers can be used in going from one PC filter to another with selective-contrast papers.

If you know the exposure with a given enlarger at a given magnification and f-number that produces a correctly exposed print on KODABROMIDE Paper, Grade 2, exposure for another grade can be calculated. Multiply the known exposure time in seconds by the ANSI speed number of the paper you used (500); then divide the result by the ANSI speed number of the paper you are changing to. If the

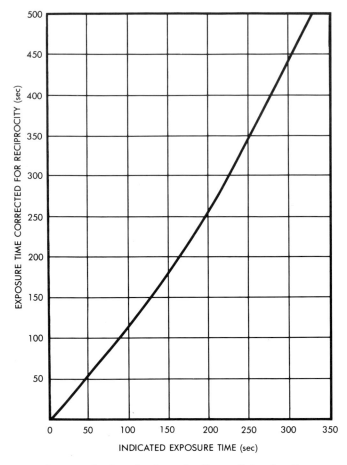

Average Reciprocity Curve for KODAK Enlarging Papers

paper is KODABROMIDE Paper, Grade 4, the ANSI speed is 160. Assume the original exposure time is 10 seconds.

$$\text{New exposure time} = \frac{10 \times 500}{160} = 31.25 \text{ seconds.}$$

KODAK Publication No. R-20, *KODAK Black-and-White Darkroom DATAGUIDE* contains an enlarging dial that performs this calculation. It also calculates exposure time changes when magnification or f-numbers or both are changed.

The ANSI paper speed numbers given in the Data Sheet section of this book are for the average product. Exposures calculated by means of these numbers may not be exactly correct because exposure in printing is critical and because aging, especially in adverse storage conditions, may alter the characteristics of the emulsion, including the speed. Further, the subjective nature of the print may require that more or less exposure be given to obtain a desired effect. Consequently, speed numbers provide a starting point in determining correct exposure, and a basis for comparing the relative speeds of different papers. Once the actual speed of a box of paper has been found, the determinations for the remaining sheets in the box should remain fairly constant for a reasonable period of time (months), depending on the storage conditions.

Many workers are using photometers (enlarging meters) to determine exposure time. When integrating methods are used, the ANSI speed numbers can be used directly in such photometry. For spot measurements, speeds called shadow speeds or highlight speeds are required. These can be approximately calculated using the ANSI speed numbers as a starting point. This subject is covered in the section entitled "Enlarging Meters."

Reciprocity Characteristics

The speeds of photographic papers remain fairly constant as long as moderate exposure times (less than 20 seconds) are used. When exposure times are longer than this, the reciprocity effect causes an apparent loss of paper speed.

Thus, if in calculating exposure times the times get long, a correction must be made in the exposure time to correct for the reciprocity effect. The graph shows the average effects of reciprocity for Kodak black-and-white enlarging papers by plotting the uncorrected exposure times against exposure times corrected for reciprocity.

If you calculate the time of an exposure to be 100 seconds, for example, the graph shows that the exposure time you should actually give to correct for the reciprocity effect is 113 seconds.

The exposure dial mentioned above automatically corrects for reciprocity. The corrections are designed into the time scale, so no additional correcting should be made.

As with paper speeds, the reciprocity correction curve represents average product and is useful in getting close to the right exposure. However, there are variations from one paper to another, and from one batch of paper to another, as well as variations due to aging and improper storage. For the finest quality work, adjustments may be required based on results.

Finding Corrected Exposure Times

The photographic reciprocity law states that exposure equals the intensity of light falling on an emulsion times the time of exposure.

$$E = I \times T$$

With photographic papers this holds reasonably true up to exposure times of 20 to 30 seconds. For instance, an exposure of 20 seconds at f/8 will result in essentially the same print density as an exposure of 10 seconds at f/5.6. However, when exposure times exceed thirty seconds, the density may lessen. For example, an 80-second exposure at f/16 in this

example, might produce slightly less density than the 10 seconds at f/5.6 exposure, although the reciprocity law says that they would be the same. This is due to the reciprocity characteristics of the photographic paper.

In the table below, the exposure series out of which the above examples were taken, shows the additional exposure needed to produce the same print density with a typical photographic paper.

Aperture	Exposure Time	Exposure Correction Additional Exposure	Corrected Exposure
f/4	5 sec	.01 sec	5.01 sec
f/5.6	10 sec	.05 sec	10.05 sec
f/8	20 sec	.25 sec	20.25 sec
f/11	40 sec	1.30 sec	41.30 sec
f/16	80 sec	6.50 sec	86.50 sec
f/22	160 sec	33.00 sec	193.00 sec
f/32	320 sec	169.00 sec	489.00 sec

As can be seen in the table, the correction necessary for the longer exposures becomes significant. In making big enlargements and murals, this factor must be considered, especially if photometry is used to calculate exposures, or if a magnification equation is used. The average corrections for various exposure times for Kodak papers is shown in the graph on page 12.

This curve gives an idea of the amount of correction needed, but because it is an average curve, it will not be exact for every paper.

One use of this graph is when changing from one exposure time to another when both times are long. An exposure of 125 seconds at f/4 makes a print with good density. However, it is decided to go to f/5.6 to make the print a little sharper. If the time were just doubled to 250 seconds, the print would be light because reciprocity was not considered. The way to solve the problem is this. The corrected time is 125 seconds. On the graph, the uncorrected time is found to be about 110 seconds. This is doubled for the aperture change, giving 220 seconds uncorrected time at f/5.6. The new exposure time, corrected for reciprocity, is found on the graph to be about 290 seconds.

Another effect of long exposures is to lower the print contrast somewhat. It is also felt that viewing a print from a distance, as you would do with a photomural, lowers the apparent contrast of the print. For these two reasons, a higher grade of paper is usually needed to make a very large print than is used to make a normal size print of the same negative. The graph above shows actual lowering of contrast of a Kodak paper as a result of a long exposure time.

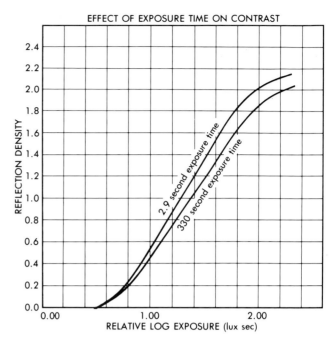

Effect of Exposure Time on Contrast

Exposure and Development Latitude

Black-and-white films have a fairly wide exposure and development latitude; photographic papers have more limited latitude. The amount of exposure error that can be compensated for by varying the developing time is limited—it is more with some papers than others. For production level volumes of printing, some latitude is desirable for the sake of economy.

Exposure Latitude: Some papers develop to nearly full contrast in a relatively short time and, as development is continued, gain in density but not very much in contrast. Such papers are said to have exposure latitude because if the exposure is a little more than correct, the print can be recovered from the developer in a relatively short time without seriously affecting the print quality. If the print is slightly underexposed, it will reach an adequate density level by being left in the developer for longer than the normal time. It will not have gained greatly in contrast. KODAK EKTALURE Paper is one such paper. The illustration shows a family of curves of paper at different developing times. The central curves are nearly identical except for their position on the log-exposure scale. When the development time is very low, the contrast is lowered and the D-max is reduced. With excessive development, the D-min level is raised with fog. The curves in the central area show the exposure latitude of the paper. When a paper behaves in this manner, the curves are said to "walk over" because they change position without greatly changing shape or slope.

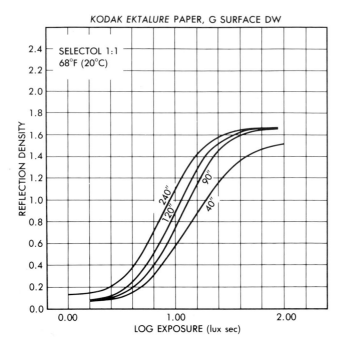

KODAK EKTALURE PAPER, G SURFACE DW

SELECTOL 1:1
68°F (20°C)

Y-axis: REFLECTION DENSITY (0.0 to 2.4)
X-axis: LOG EXPOSURE (lux sec) (0.00 to 2.00)

Curves labeled: 240", 120", 90", 40"

Changes in development time affect print contrast more with warm image-tone papers than with cold image-tone papers. Gross underdevelopment leads to a low D-max and possible image mottle, while gross overdevelopment leads to chemical fog. Within a moderate time range, the density and contrast can be varied to compensate for variations in print exposure.

Development Latitude: When many prints of the same subject are being made, or when photometry is being used to control enlarging exposure, it is convenient to have a paper in which image density and contrast will not change greatly with changes in developing time. Such papers are said to have development latitude because the developing time is not critical. KODABROMIDE Paper has excellent development latitude.

Development Time Limits: On each of the paper Data Sheets in the center of this book, a recommended developing time is given, as well as a useful developing time range. When high print quality is required, it is best to expose the paper so that the image reaches the correct density in the recommended developing time, or in a slightly longer time. "Pulling" the print before the recommended time has been reached, or "forcing" the development to gain enough density, may lower the print quality. (See the section entitled "Print Quality" on page 121.)

Color Sensitivity

Contact papers usually have emulsions that are sensitive to ultraviolet radiation and blue light. Graded enlarging papers are sensitive to UV radiation and blue light, and to green light of some wavelengths. They are partially orthochromatic. Selective-contrast papers, because they depend on separate sensitivity to green and blue light to control contrast, are sensitive to UV, blue, and green light of wavelengths up to about 610 nanometres.

Several papers with panchromatic sensitivity are available, primarily for making black-and-white prints from color negatives. KODAK PANALURE Papers have panchromatic sensitivity. This means that they are sensitive to all colors of light.

Since the safelight that can be safely used with a paper depends both on the color sensitivity and the emulsion speed of the paper, it is strongly advised that the safelight filter recommended for each paper be used. Use of an improper filter, one that transmits some light to which the paper is sensitive, results, first, in a lowering of contrast and print quality, especially in the highlights, and eventually, if the exposure to the improper safelight is long enough, to actual safelight fog. The illustration shows a comparison of spectral sensitivity curves for three types of paper, with the transmission curves for recommended Kodak safelight filters. The relative sensitivity of the papers to various wavelengths of light can be seen, as well as the transmission characteristics of the corresponding safelights. (For further details about safelights see the section "Darkroom Lighting" on page 36.)

Latent Image Keeping

Most enlargements are developed shortly after they are exposed, so that the period of time the latent (exposed) image has to "keep" is a relatively short one. However, when many prints are being exposed with processing to be done later, the length of time between exposure and development is increased. How well the latent image keeps becomes important if the densities of the prints are to match the test print.

Most papers tend to lose some of the latent image with a relatively long time between exposure and development. If a group of prints is to be exposed one day and processed the next, for example, the prints would be lighter than the test print made the day before. Experimentation will tell you how much more exposure will be required to compensate for this loss of density.

There are some papers, however, where the density of the image increases with a long keeping time between exposure and development. Less print exposure will be required with these papers if there is to be an extended period between exposure and development.

Because of all the variables involved, there is no exact way to predict the amount of change, so it is wise to predict that there will be change and to run tests to find the correction needed.

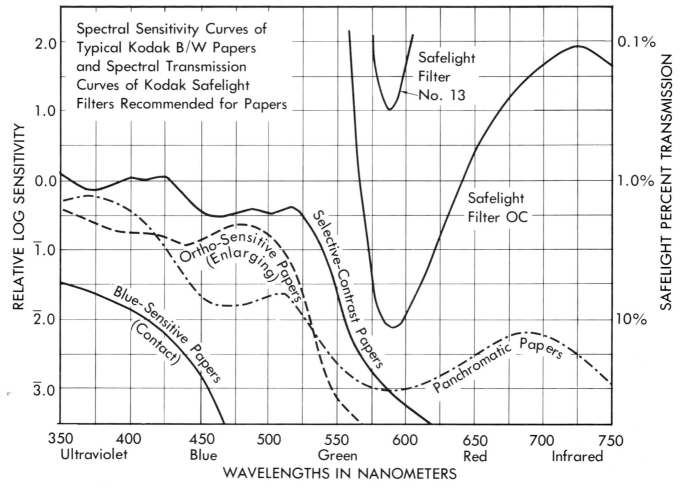

Spectral Sensitivity Curves of Typical Kodak B/W Papers and Spectral Transmission Curves of Kodak Safelight Filters Recommended for Papers

RELATIVE LOG SENSITIVITY

SAFELIGHT PERCENT TRANSMISSION

Safelight Filter No. 13

Safelight Filter OC

Ortho-Sensitive (Enlarging) Papers

Selective-Contrast Papers

Blue-Sensitive Papers (Contact)

Panchromatic Papers

350	400	450	500	550	600	650	700	750
Ultraviolet		Blue		Green		Red		Infrared

WAVELENGTHS IN NANOMETERS

The silver halide crystals which provide the paper with its sensitivity to light are inherently sensitive to blue light and ultraviolet radiation. Their sensitivity is extended into the green and red regions by the use of spectral sensitizers. The transmission curves of the two safelights recommended for papers (filter OC for most papers, No. 13 for panchromatic papers) are included to show why the time a paper can be safely exposed to safelight illumination is limited.

Physical Properties of Photographic Papers

Paper Base

The paper base, or support, used in the manufacture of high-quality photographic paper must be free from any substances that might affect the unprocessed emulsion, the chemical processing, or the silver image after processing. The paper must be compatible with the coatings placed upon it. The fibrous structure must have wet strength, so that it will withstand immersion in the various processing solutions, as well as prolonged washing after processing. The paper used as a base for Kodak photographic paper meets these stringent requirements.

In conjunction with producers of wood pulp, Eastman Kodak Company developed a technique for making pulp that has the purity and strength necessary for producing high-grade paper base. The base paper is made from a combination of different pulps to achieve the necessary chemical and physical properties.

To make sure that the paper base will last as long as the silver image that it carries, Kodak workers make thorough tests at every stage in manufacture —from wood pulp to the finished paper.

Modern manufacturing equipment and methods are used by Kodak to provide the highest possible quality in its paper products.

Les Smades

The paper base is rolled up in large rolls after being inspected by transmitted light.

Base Weights: As Kodak uses the term, the weight of a paper is an indication of its thickness. Papers are classified as lightweight, single weight, medium weight, and double weight.

Lightweight stock is a thin paper that makes it suitable for the illustrative pages in manuals or reports, where thickness is a prime consideration. To make the finished product even thinner, and to make it foldable, lightweight papers are made without a baryta layer between the paper and the emulsion.

Single-weight papers are generally used for prints up to about 8 x 10 inches (20.3 x 25.4 cm) in size. Prints on double-weight paper are easier to handle and to process in larger sizes. However, this is a question of preference and depends on the use for which the prints are intended, and whether they are to be mounted or not. An exception is KODAK Mural Paper, which is made with an extra strength single-weight base to withstand the handling and folding necessary in making big enlargements, as well as to facilitate making splices that have low visibility when photomurals are made in more than one piece.

Medium-weight stock is generally used for resin-coated papers (see below) and special-purpose papers such as those made in rolls for machine printing and continuous processing.

As mentioned above, double-weight paper base is used to make papers for large-size prints. For example, all KODAK EKTALURE Paper is made in double-weight base because it is used largely for printing portraits and exhibition prints. It may also give an awareness of increased value because of the substantial thickness of the paper base. Double-weight stock is also useful for making prints that are likely to receive considerable handling.

Water-Resistant Bases: Papers with water-resistant bases shorten the print processing time significantly, provide considerable dimensional stability to prints, and make possible activation processing in such processors as the KODAK ROYALPRINT Processor, Model 417, which processes prints in slightly less than a minute.

In regular tray processing, the overall processing time is reduced because the paper base does not absorb water and the chemical solutions to the extent that fiber paper base does. Total develop, stop, fix, and wash time is typically 7 to 8 minutes compared to over an hour for processing fiber-base papers, or a half hour if KODAK Hypo Clearing Agent is used.

Water-resistant paper bases are usually medium weight and are coated on both sides with a resin coating. The coating under the emulsion is pigmented to provide the paper tint. On the base side, the resin layer of most RC papers is treated to prevent prints sticking together in a tray of solution and to permit easy marking on the backs of prints. KODAK RESISTO Papers are coated differently than papers with RC in their names. Materials are added to RC papers during manufacture that give the resin coatings resistance to the effects of radiation. (See page 105.)

Base Tints: The tint is the color of the paper stock or a composite of the color of the paper and the coatings applied to it in manufacture, especially the baryta sub-layer on fiber-base papers, or the pigmented resin layer on water-resistant papers. A white-base paper can vary from the cold white of KODABROMIDE Paper to the cream-white of a portrait paper such as KODAK EKTALURE Paper, G Surface. Cream-white is considerably warmer than the white or warm-white paper bases. It is considered suitable for portraits and pictorial subjects where a feeling of warmth is desired.

"Cold" in reference to a paper tint refers to pure neutral white, or to white with a very slight blue cast, while "warm white" and "cream-white" mean that the base has a slightly stronger color than the white.

Fluorescent Brighteners: Fluorescent material is sometimes added to one or more layers of a paper to give extra brightness to the prints, especially when they are viewed in illumination that is relatively high in ultraviolet radiation. The extra brightness is seen in the whites of prints where the UV radiation causes the brightener to fluoresce. Under incandescent illumination, which is low in UV radiation, the whites appear normal. The effect is moderate and may not be particularly noticeable unless a print on a brightened paper is compared, side-by-side, with a print on a nonbrightened paper.

The brightener may tend to leach out of the paper if the "wet" time is extended. Prints that have been

processed for different lengths of time may appear to have different degrees of brightness—and to the eye this can appear equivalent to different degrees of grayness.

Several of the water-resistant papers contain brighteners—and with the short processing times achieved with these papers most of the brightening effect is retained. With fiber-base brightened papers, use of KODAK Hypo Clearing Agent to reduce the wash time minimizes the loss of the brightener.

Dimensional Stability of Paper Base: In photographic work, the term "dimensional stability" refers to the changes in size that materials such as papers and film undergo during processing, washing, and drying, as well as the changes in size that take place in finished prints due to changes in relative humidity and temperature.

Generally speaking, paper is the least dimensionally stable of all the sensitized materials used in photography. When paper is soaked with liquid (chemical solutions or water), it expands directionally according to the amount of liquid absorbed. After drying, the paper may or may not return to its original dry size. Prints that are dried by ferrotyping tend, to a large extent, to maintain their wet size. Prints that are air-dried return to a size near the original dry size of the paper. For most practical purposes, the changes in size that take place in photographic paper when it has been soaked are fairly constant. Paper is manufactured in rolls, and when the paper is wet, it expands more across than lengthwise. As a broad guide, the paper base expands about 1 inch across the width of a 40-inch roll. The lengthwise expansion is about 1 inch in every 12 feet of paper.

A particular box or package of paper may have been cut lengthwise or crosswise of the roll—but all the paper in one package or box will have been cut in the same direction. If size is important, a test can be run. If a 10-inch dimension has expanded about ¼ inch, that dimension is crosswise of the roll. If it expands about ¹/₁₆ inch, it is lengthwise. KODAK EKTAMATIC SC Paper is always cut so that the long dimension corresponds to the length of the roll. The short dimension of the paper enters the processor first to provide proper transport through the processor.

In most photographic work where paper is being used, dimensional changes are relatively unimportant. However, in some applications, such as making photomurals in several sections that are to be wet-mounted as one picture, the wet stretch should be calculated and the enlarged image made correspondingly smaller. The water-resistant papers can be considered to have no wet stretch for all normal uses.

The dimensions of a sheet or roll of fiber-base paper may change as much as 0.3 percent with a change in relative humidity of 10 percent. This amounts to about ¹/₃₂ inch in a 10-inch dimension or ¹/₁₆ inch in a 20-inch dimension.

Kodak papers are set and packaged in equilibrium with average conditions. If darkroom conditions are very humid, or very dry, as in a heated house in the winter, size changes due to these extremes of relative humidity can cause deficiency when using exposing equipment with fixed paper guides. Kodak papers are cut to sizes and within tolerances specified by ANSI standards so that they may be slightly smaller than, but no larger than, the normal sizes when cut (American National Standards Institute, Inc., 1430 Broadway, New York, N.Y. 10018, Standard PH 1.12-1974). Under very high humidity conditions, they may slightly exceed the normal size.

Finished prints show the same variation in size with relative humidity. For this reason, prints mounted under overlay openings should be attached at only one edge. If taped down on all four sides, the print may show a bulge or buckle if the relative humidity gets high. Dry-mounting is an alternative method of mounting prints to retain flatness.

Image Tone: The term "image tone" refers to the hue or color of the silver image. The color varies from a brown-black through a warm black and neutral black to a blue-black. Image tone is largely determined by the size of the silver grains that make up the image, but its appearance is influenced by the paper base tint.

The basic size of the silver grains is determined in the emulsion manufacture, but the image tone is influenced by many factors, such as the developer,

This computer-controlled densitometer aids in maintaining quality control of the sensitometric characteristics of Kodak photographic papers.

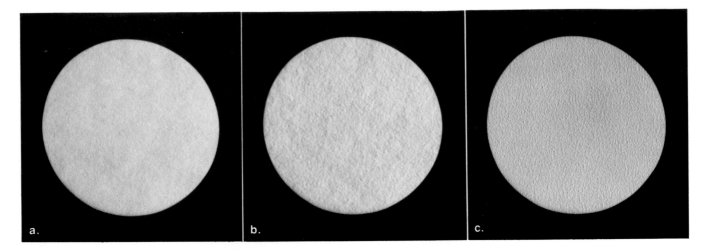

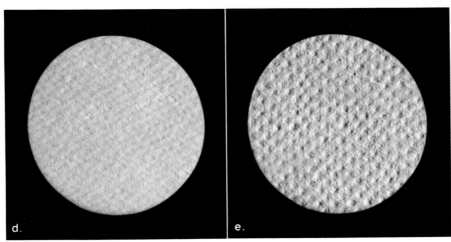

These enlarged views show the various textures of Kodak papers. The photographs are magnified several times. a. A, N, F—Smooth b. E, G, K—Fine-grained c. E—Lustre-Luxe® d. R—Tweed e. X—Tapestry. Actual samples are provided in KODAK Publication R-20, *KODAK Black-and-White Darkroom DATAGUIDE.*

the developing time and temperature, fixing time, and drying temperature. These factors tend to alter the character of the silver grains and consequently the image tone of the print. Cold-image-tone papers tend to have a fixed image tone that is not affected very much by these factors. On the other hand, warm-image-tone papers are affected considerably by them. If it is desirable to maintain a constant image tone on a group of prints on a warm-image-tone paper, it is necessary to hold these factors constant.

The uses of different combinations of base tint and image tone are discussed in the section "Choosing a Paper," starting on page 24.

Paper Surface Characteristics

In addition to image tone and base tint, photographic papers differ in two other characteristics—sheen and texture.

Sheen is based on the degree of specularity of the surface reflection. The reflections from a glossy surface have a high degree of specularity—the surface is shiny; it has a high degree of sheen. On the other hand, a semi-matt paper has a surface that diffuses reflected light; it has a low level of sheen. Kodak papers have the following degrees of sheen:

Glossy
High Lustre
Lustre
Semi-Matt

Texture is a description of the embossed pattern, or lack of pattern, on the paper surface. Some papers have a smooth surface without texture. Others have a fine-grained surface—which is not representative of a cloth or other surface. Still others have a regular pattern that is a copy of the surface texture of a close woven cloth as in a silk surface, or large textured as in a tweed or tapestry surface. The following surfaces are available in various Kodak papers:

Smooth
Fine Grain
Tapestry
Tweed

Kodak uses a letter system to designate the paper surface characteristics of sheen and texture. A simple letter combines both characteristics. F, for example, designates a paper that has a smooth, glossy surface, while J designates a paper that has a smooth, high-lustre surface. The following list describes currently available Kodak paper surfaces.

Surfaces of KODAK Paper

F—Smooth Glossy: Fiber-base papers with an F surface can be ferrotyped to produce a high-gloss surface. Such surfaces yield dense blacks (high D-max) and therefore provide a long visual scale and long density range. F-surface water-resistant papers produce a high-gloss surface without ferrotyping and must not be ferrotyped.

J—Smooth High Lustre: This surface is also smooth and has a sheen only slightly less than that of an F surface. It thus yields a visual scale and D-max only slightly less than that of F-surface papers.

A—Smooth Lustre: This paper has a smooth surface, like the J surface, but has a normal level of lustre. A-surface papers are on lightweight paper base and have no baryta undercoat so that prints made on this paper can be folded without cracking. Prints are also excellent for binding into volumes such as technical reports.

N—Smooth Semi-Matt: This paper is also smooth surfaced, but has somewhat less sheen than papers classified as lustre. It makes prints that are suitable for exhibition where surface reflections are a problem. N surfaces take pencil, brush, and air-brush retouching well, so when prints are being made for reproduction and require extensive retouching, N-surface papers are a good choice.

E and G—Fine-Grained Lustre: These letters classify papers with a slightly pebbled surface with a normal sheen. The difference between the two letters signifies a difference in base tint. E-surface papers are on a white or warm-white base, while G-surface papers are on a cream-white base. Both of these surfaces are a good choice for pictures where a smooth surface is not needed, and where a more strongly textured surface would interfere with the reproduction of fine detail in the picture. They are widely used for printing portraits.

K—Fine-Grained, High Lustre: The texture of K-surface papers is the same as E and G surfaces, while the sheen is the same as J-surface papers. This paper is excellent for exhibition prints because it yields a long visual scale with a long density range. The tint is a warm white.

R—Tweed Lustre: This paper surface has a rough surface that tends to subdue fine detail and to emphasize large masses and planes in the subject; hence, it is excellent for big enlargements and large head-and-shoulder portraits. KODAK Mural Paper is made in this surface for this reason. KODAK Portrait Proof Paper also has an R surface so that facial imperfections are subdued in proofs printed on it.

X—Tapestry Lustre: X-surface papers are textured with a canvas-like pattern suitable for large portraits and broad pictorial effects. As with the R surface, the tapestry texture tends to subdue fine details.

All Kodak papers are not available in all surfaces. The table on page DS 2 in the colored Data Sheet section lists the surfaces currently available in each Kodak paper. With this wide variety of sheens, textures, tints, and image tones, there is available a wide choice of papers for most black-and-white photographic purposes.

Not only can the practical considerations of how a print is to be used be accommodated, but, in addition, the artistic considerations of potential print lighting conditions and the ability to enhance the mood of the picture can be influences in choosing the correct paper.

While Kodak maintains very close control on its manufacturing processes, as in all manufactured products, there are slight batch-to-batch variations in paper characteristics.

Kinds of Photographic Papers

Many varieties of photographic papers are manufactured by Kodak to suit a wide gamut of applications in science, industry, graphic arts, map making, and photorecording as well as the commercial and professional uses of portraiture, photojournalism, advertising, and illustration, and the more artistic pursuits of exhibition and fine-arts photography. The kinds of papers covered in this Data Book are those generally used in professional and amateur photography, although many of them have applications outside these fields. If you need information about Kodak papers for special applications not mentioned in this publication, write to Customer Technical Services, Eastman Kodak Company, Rochester, NY 14650.

In earlier sections, the basic sensitometric and physical characteristics of papers were discussed. In this section, papers are divided into categories based on variations in these characteristics.

Contrast of Papers

There are many contrast controlling factors in the black-and-white photographic process, starting with the subject and its lighting. The camera and lens are factors, as is the type of film. The photographer may use development control to compensate for these factors. Even so, there are always variations in contrast (and its measure, density range) in the negatives to be printed. The enlarger is also a contrast-controlling factor.

To compensate for these factors, most photographic papers are made in various degrees of con-

trast, or so that their contrast can be changed by the use of filters. When the paper contrast is properly matched to the negative image contrast, a print results with good technical quality.

Some papers have graded contrast. They are manufactured with predetermined contrast and are numbered. Several contrast grades are needed to match negatives of various contrast levels. Selective-contrast papers are made with contrast that can be varied by the use of filters. A few papers, such as those used for portraiture, are made in only one contrast grade.

Contact and Enlarging Papers

Contact printers generally have a high level of illumination at the printing aperture. In order to keep exposure times within reason, contact-printing papers are made with a relatively low speed. It is not practical to use contact papers for enlarging or with an enlarger as a light source.

Enlargements are imaged through lenses—usually set at a moderate aperture such as f/8—and the image is larger than the negative. The light illuminating the negative is therefore spread over a larger area, thereby diminishing its brightness. To keep exposure times relatively short, enlarging papers are made with a higher speed than contact papers. Some enlarging papers have a moderate speed—others have a high speed. Because there are choices in speed, it is convenient to select a paper with a speed that matches the type of enlarging being done.

The following table presents descriptive paper-speed terms with a range of paper speeds.

Speed Description	ANSI Paper Speed
Contact Speed	.6 to 16
Slow Enlarging Speed	20 to 50
Medium Enlarging Speed	64 to 125
Fast Enlarging Speed	160 to 320
Very Fast Enlarging Speed	400 to 500

In most graded papers, the low-contrast grades have higher speeds than the higher contrast grades. An example is KODABROMIDE Paper:

Paper Grade	No. 1	No. 2	No. 3	No. 4	No. 5
ANSI Paper Speed	500	320	200	160	125

No. 1 grade is a very fast enlarging paper, while No. 5 grade is a medium-speed paper.

There are exceptions. The grades of KODAK MEDALIST Paper, for example, have speeds fairly close to the same value and range only from speeds of 125 to 200. Grades 1, 2, and 3 of KODABROME II RC Paper have the same speeds, while grades 4 and 5 have less speed than the other three grades.

With selective-contrast papers, the speed varies with the PC filter used. Part of the speed change is caused by the difference in speed in the green- and blue-sensitive parts of the emulsion, and part is due to the filter factor of the filter being used. They are fastest when used with no filter, and slowest when used with the deep violet colored No. 4 filter.

Portrait Papers

While portraits can be printed on almost any photographic paper, the papers with a warm image tone and tint are usually chosen to impart a feeling of life and warmth to pictures of human subjects.

A wide variety of surfaces is available in several Kodak papers, such as EKTALURE, Mural, Portrait Proof, and PANALURE Portrait Papers.

Group portraits and those that image small faces are best printed on smooth or fine-grained lustre surfaces in order to retain the fine detail. Large-sized portraits may benefit by being printed on a rougher-surfaced paper, which tends to break up grain and the effects of retouching on the negative.

KODAK EKTALURE Paper, in four surfaces, available in sheets and rolls, is designed for high-quality portrait printing by either manual or machine production methods.

KODAK Mural Paper, in two contrast grades and one surface, is suitable for large portraits as well as murals.

KODAK Portrait Proof Paper, while designed for making proofs, is also used by some workers for finished portrait prints.

KODAK PANALURE Portrait Paper is designed for making black-and-white portrait prints from color negatives.

Selective-Contrast Papers

Most photographic papers are made with one emulsion, which limits their contrast within a fairly narrow range. The contrast of warm-image-tone papers can be varied somewhat by changing the developer or the developing time, or both. The contrast of most neutral-image-tone papers is more fixed, and changing the developing time changes the overall density without having an appreciable effect on the contrast.

Selective-contrast papers print as though they are made with two emulsions. One is a blue-sensitive, high-contrast emulsion while the other is an orthochromatic (blue and green) sensitive emulsion with low contrast. By exposing the paper through KODAK POLYCONTRAST Filters, various proportions of the two emulsions are exposed. When the filter color is

A high-lustre, fine-grain surface on a warm image-tone paper such as KODAK EKTALURE Paper, Surface K, is excellent for display portrait prints. This is a fine example of the type of informal environmental portraiture currently popular as an alternative to the more formal studio portraiture that has been successful for many years.

Don Maggio

yellow, which absorbs blue light, the green-sensitive emulsion is exposed, which gives low contrast. When printed through a violet filter, which absorbs green and transmits blue, the blue-sensitive emulsion is exposed, which gives high contrast. When exposed through light-colored filters, or none, both emulsions are exposed, which gives medium contrast.

The contrast range available is approximately equal to grades 1 through 4, and the PC filters are available in seven steps, which include the half-grade steps 1½, 2½, and 3½. In most cases, this gives seven finely graded steps of contrast. With some papers, however, the difference between the contrast obtained with the PC3½ and PC4 filters is so slight that only six steps can be considered valid.

One of the advantages to selective-contrast papers is that only one box of paper need be stocked to give the various contrast grades. This reduces inventory costs, and the possibility of seldom-used grades deteriorating with age.

Kodak selective-contrast papers are available in fiber-base and water-resistant paper base, and are available for tray and tank development, continuous-machine processing, activation processing, and stabilization processing.

KODAK Polycontrast Filters: The KODAK POLYCONTRAST Filter Kit (Model A) consists of seven filters (PC1 through PC4 in ½-grade steps) mounted for use at the enlarging lens. A universal filter holder is included in the kit. KODAK POLYCONTRAST Gelatin Filters are also available for use in image-forming beams. KODAK POLYCONTRAST Acetate Filters are sold in larger sheets (up to 11 x 14 inches) for use over the lights in contact printers or between the light source and the negative in enlargers. The acetate filters should not be used in image-forming beams, such as over the enlarging lens, because they are not optically homogeneous and can diffuse the projected image.

Graded-Contrast Papers

Kodak graded-contrast papers offer different advantages than selective-contrast papers. Both KODAK AZO and VELOX Papers, which are contact-speed papers, are graded contrast.

Since graded papers do not require filters to vary the contrast, graded papers can have great speed, especially at the soft end and hard end of the contrast range. For example, KODABROMIDE Paper, contrast No. 1, has an ANSI paper speed of 500, which is twice as fast as the fastest selective-contrast paper with a PC1 filter. KODABROMIDE Paper, No. 4, has an ANSI speed of 160 compared to an ANSI speed of 50 for KODAK POLYCONTRAST Rapid Paper with a PC4 filter.

Another difference is in characteristic curve shape at the higher contrasts. A grade 4 paper is likely to have a fairly short toe and long straight line, while a selective-contrast paper with a PC4 filter may have a curve with a long toe and short, very steep straight line. Thus the two types of paper have different tone reproduction characteristics. Where a more even tone expansion is needed, the graded paper generally works best. Where it is desirable to have a greater expansion of dark tones than the light tones, the selective-contrast paper, with a PC4 filter, may work best.

If an extremely high contrast is needed, it is available in graded papers as contrast No. 5. Such contrast is desirable for very low contrast negatives, or for special effects work such as line prints.

Graded-contrast papers are available in both fiber base and water-resistant paper base. They are also available for tray and tank processing, continuous-tone processing, and activation processing.

Papers for Stabilization Processing

See page 106 for a diagram showing stabilization processing, and for an outline of the process.

KODAK EKTAMATIC SC Papers are designed for stabilization processing in two-bath processors such as the KODAK EKTAMATIC Processor, Model 214-K. These are selective-contrast papers. (See above.)

Stabilization is a method of processing black-and-white prints much more quickly than normal tray processing. The processing time of the EKTAMATIC Processor is about 15 seconds for an 8 x 10-inch print. Prints are damp dry when they leave the machine, but are relatively insensitive to light, and they air-dry in a few minutes at room temperature.

The emulsion of KODAK EKTAMATIC SC Paper is a conventional selective-contrast emulsion with the addition of incorporated developing agents. When the exposed print is activated, the highly alkaline activator enters the emulsion quickly, dissolves the developing agents, and forms a very active developer which develops the image quickly. A stabilizer converts the undeveloped silver halide crystals to relatively stable, colorless compounds. These compounds remain in the paper and are not removed as they would be in a conventional fix-wash process. Consequently, while stabilized prints are light-fast, they do not keep for a long time. However, since the purpose of most stabilized prints is for such short-term usage as making halftones, long-term keeping is not a factor.

However, the life of stabilized prints can be extended by fixing and washing them in the customary way. This can be done immediately after stabili-

zation processing, in several days after their short-term usage, or at any time before the stabilized image begins to show signs of deterioration.

The life of a stabilized print depends on several factors—primarily the relative humidity and temperature at which it is stored. The life may be as short as several days to as long as several months, depending on conditions. If a stabilized print is exhibited or left out in a high UV light source, the life is shortened even more. However, prints made on EKTAMATIC SC Paper and processed in a KODAK EKTAMATIC Processor, Model 214-K, can be expected to keep for several months if the processing chemicals are relatively fresh and the storage conditions are favorable (low-light level, low-to-moderate temperature, and low relative humidity). Stabilized prints should not be stored with prints that have been fixed, washed, and dried.

As indicated above, the life of stabilized prints can be extended after their initial purpose has been served. The following aftertreatment is recommended: fix prints for 8 to 12 minutes in an ordinary print fixing bath (or 4 to 6 minutes in each of two successive fixing baths), and then wash and dry or ferrotype in the usual manner. To reduce washing time and to save water, use KODAK Hypo Clearing Agent as directed on the package.

The papers listed below for activation processing also have incorporated developers in the emulsion and some workers have used stabilization processing for them. Kodak does not recommend this for three reasons:

1. Different emulsion characteristics make it difficult to get uniform development across the surface of the print in many stabilization processors.

2. There is less than the normal amount of image development, leading to lower contrast and lower D-max.

3. The life of the stabilized image is much shorter than that of prints on EKTAMATIC SC Paper—and may be as short as minutes. This is because of the small amount of stabilizer left in the print because of the resin coatings.

Papers for Activation Processing

The KODAK ROYALPRINT Processor, Model 417, is designed to process water-resistant papers with incorporated developers in their emulsions. The process is properly called activation-conventional processing because development is in an activator, but the prints are stopped, fixed, washed, and dried in the processor. Because of the special chemicals, elevated temperature in the fixer and wash, and high-turbulence jet agitation, the process time for an 8 x 10-inch print is less than a minute, dry to dry. The prints are as stable as conventionally processed prints on the same papers. These papers can also be tray-processed in the usual print developers, stop baths, and fixers. Because the papers are water-resistant, the processing time is considerably shorter than with fiber-base papers. (See *Processing Water-Resistant Papers* on the last colored data sheet in the center of the book.) The following KODAK Papers are made for activation processing.

When printing color negatives, a gray-tone rendering that is a closer approximation to the visual brightness of the subject colors can usually be obtained by the use of one of the KODAK PANALURE Papers. The left illustration was printed on a normal enlarging paper while the right illustration was printed on KODAK PANALURE II RC Paper. (See page 95.)

John Griebsch

POLYCONTRAST Rapid II RC—A water-resistant, developer-incorporated, selective-contrast paper.

KODABROME II RC—A water-resistant, developer-incorporated, contrast-graded paper.

PANALURE II RC—A water-resistant, developer-incorporated paper with a panchromatic emulsion.

PREMIER II RC—A single-grade, water-resistant, developer-incorporated paper for automatic printing, available only in rolls.

For further details on the activation process, see KODAK Publication No. G-6, *B/W Print Processing with the KODAK ROYALPRINT Processor.*

Panchromatic Papers

When color negatives are used to make prints on graded papers, which are primarily sensitive to blue light and ultraviolet radiation, the tone rendering in the prints is often unsatisfactory. KODAK PANALURE Papers are made with panchromatic emulsions, which give a gray-tone rendering of colored subjects approximating their original brightness. The effect is similar to that of the subject photographed on panchromatic film. PANALURE Papers are made in a single contrast grade, suitable for printing typical, fully exposed color negatives. Being panchromatic, these papers must not receive very much safelight illumination.

Kinds of KODAK PANALURE Papers: There are three kinds of KODAK PANALURE Paper. Two are on fiber-base stock, while one is on a water-resistant base.

KODAK PANALURE Paper, F Surface, Single Weight. This is a fiber-base paper with a warm-black image tone on a white-tint base. The surface can be ferrotyped for a high gloss.

KODAK PANALURE Portrait Paper, E Surface, Double Weight. Has a brown-black image tone with a white-tint base. The surface is fine-grained lustre, also fiber-based.

KODAK PANALURE II RC Paper, F Surface, Medium Weight. Has a warm-black image tone on a resin-coated white-tint base. The surface dries to a glossy surface without ferrotyping. Designed for activation processing.

A fourth panchromatic paper is:

KODAK RESISTO Rapid Pan Paper, N Surface, Single Weight. Neutral emulsion on white-tint, water-resistant base. Designed for making color separation prints from color negatives, but can be used to make regular prints.

Special KODAK Printing Materials

Kodak manufactures two products with which prints are made that do not fit the paper categories given above.

KODAK Direct Positive Paper is a fast orthochromatic-sensitized, water-resistant paper designed for reversal processing. The paper yields direct positive images. The principal use of this material is in coin-operated machines that produce a short series of small "passport" type portraits on a short strip while the customer waits. It is also used in view cameras, in sheet form, by photographers to take pictures of tourists at well-visited points of interest. Further, it can be used to make direct positive enlargements from color transparencies. Such prints are more suitable for identification and filing uses than for pictorial purposes. For usage and processing instruction, see KODAK Pamphlet No. G-14, *Direct Positive Photography with KODAK Direct Positive Paper.*

KODAK TRANSLITE Film 5561 is designed for making black-and-white transparencies for display use or for decoration. The material has a translucent-type base similar to fine-ground glass. It has photographic-paper-type emulsions on both sides of the base to permit long-scale images. The projection-speed emulsion permits making enlargements in the same way as paper-print enlargements are made. Transparencies made on TRANSLITE Film can be hand-colored directly with no special surface preparation. They can also be toned in toners made for toning photographic paper prints.

Choosing a Paper

In black-and-white printing, the choice of a paper is often dictated by the purpose for which the photograph is intended. If the print is made simply to convey information, the choice of papers is relatively simple. In portraiture and pictorial photography—where artistic considerations, as well as your own individuality, are important—you are at liberty to use any combination of surface texture, sheen, base tint, and image tone that supports the impression you wish to convey. Some of the following suggestions about the use of paper characteristics are of a general nature; they can, of course, be modified to suit particular subject matter and your own preferences.

Papers for Copying and Reproduction: For these purposes, always use a smooth-surface paper, such as glossy or smooth lustre, because any surface pattern will be reproduced as an undesirable granular effect. A white-base paper, with a neutral-black or a

N-surface paper is a good choice for printing copy negatives when retouching is to be done as part of a restoration process.

R- or X-surface papers are suitable for many portraits because the texture enhances the appearance of the print. The texture also provides tooth for applying oil colors. These papers may also be used to minimize retouching because the texture tends to hide flaws and grain.

F-surface glossy papers are unsurpassed for prints to be reproduced by photomechanical means (halftones). Unless otherwise stated, all of the reproductions in this publication were made from glossy prints.

Papers with J, K, or E LUSTRE-LUXE® surfaces make fine prints for display purposes. They have nearly the same long tonal range as glossy papers with less specular reflection.

25

warm-black image tone, is preferable. Prints on a paper containing a fluorescent brightening agent are satisfactory for reproduction, but the brightener serves no useful purpose in photomechanical work. If printed on F-surface regular paper, the prints can be either ferrotyped or left unferrotyped. If the prints are to be airbrushed with opaque watercolors, do not ferrotype.

Good-quality prints containing plenty of high-light and shadow detail reproduce well. By the same token, any shortcomings in the print, such as too high or too low contrast, or too little or too much density, will be more difficult to reproduce with a satisfactory tonal scale.

However, the halftone reproduction process compresses tones because the density range of printed halftone reproductions is less than that of a print on glossy paper. For this reason it is important to have adequate local contrast in prints for repro-duction. One method of achieving this is to print the negative on a paper that has one grade more contrast than normal and to maintain the highlights by burn-ing in and the shadow detail by holding back in making the enlargement.

Pictures reproduced with coarse halftone screens and printed on newsprint have a very low density range. In addition, much detail is lost as a result of the coarse screening. For this reason, pictures made for this type of reproduction should rely on mass effect rather than detail, and the masses should be separated by ample local tone contrast.

Papers for Commercial Photography: Since many photographs of commercial and industrial subjects are required to convey information, they are best printed on a smooth-surface paper for the best ren-dering of detail. Ferrotyped glossy prints are usually the most suitable because the high gloss yields the longest density range of which photographic paper is capable. Thus the visual contrast, and therefore the clarity, of fine detail is enhanced. When large commercial pictures are needed for display or deco-ration, they are usually printed on a fine-grained lustre surface, because surface reflections may be troublesome with glossy and high-lustre surfaces. Incidentally, large prints for display should be printed on paper with somewhat higher contrast than you would use for smaller ones, because prints tend to appear flatter when viewed from a distance.

Papers for Portraiture: As a general rule, portraits are most pleasing when printed on a paper with a warm-brown image that lends warmth to the skin tones. Choose a base tint that complements the sub-ject. For example, bridal portraits and those in which the sitter is wearing white clothing are best printed on white-base paper such as KODAK

POLYCONTRAST Paper, J surface. KODAK EKTALURE Papers are made with both warm-white and cream-white bases that enhance the skin tones of portraits. For head-and-shoulders portraits in which, of course, the face occupies a large part of the picture area, a paper with a cream-white base is recommended.

For large head-and-shoulders portraits, a rough-textured paper can be used; tweed lustre is a good choice. This surface helps to break up retouching and grain, particularly when the negative is en-larged considerably. Small portraits and those con-taining small heads, as in a group portrait, should be printed on a smooth or fine-grained semi-matt or lustre paper to avoid breaking up the features.

The most suitable surface sheen to use depends on the subject and on the size of the portrait. Small portraits, portraits of children, and wedding pic-tures look well on a high-lustre surface such as that provided by EKTALURE Paper, K surface. Smooth and fine-grained surfaces should be avoided when much spotting or finishing is required, or when retouching shows in an enlargement.

For general purposes in portraiture, a paper with a fine-grained semi-matt or lustre surface is appro-priate. It is an unobtrusive surface, excellent for small- and medium-size portraits, and easy to spot or finish. Kodak G and E, fine-grained lustre papers for portraiture, can be hand-colored if desired.

Papers for Pictorial and Fine Arts Photography: The wide variety of photographic papers available from Kodak offers many possibilities for creative print-ing. These are combinations of base tint, image tone, texture, and surface sheen. Also, the various Kodak toners offer additional possibilities of image tone choices with each paper.

Many photographers use one type of paper for all the prints in one body of work, to unify the work as a whole. The type paper can be chosen on the basis of the subject matter or theme. For instance, a warm-tone paper on a cream base with a lustre surface might be used if the subject matter is people and a feeling of warmth is intended. Cityscapes, architec-ture, or purely design-oriented photographs can be printed on a colder-tone paper with a glossy surface if a more neutral and longer tonal scale image is desired. The Lustre-Luxe® E surface is available on some Kodak papers and offers similar tonal qual-ities, but has less glare when being exhibited where lighting cannot be controlled to subdue reflections.

Fine-arts photographers may choose a glossy sur-face paper with a white base for exhibition prints. A glossy surface, ferrotyped or dried matte, offers the longest tonal range, the deepest black, and the sharpest representation of fine detail of any paper surface. High-lustre surfaces are also used. When

Papers for fine-arts prints are usually chosen to be compatible with the subject matter and the treatment desired. Mr. Miller prefers a white-base tint, E-surface paper for his geometric-style exhibition prints. He made an F-surface print, however, for this reproduction.

Charles Miller

exhibition prints are hung in a gallery, the lighting is usually controlled so that reflections from a glossy surface do not become a problem.

When prints are being prepared for exhibition or for sale as fine art, proper care is almost always taken to insure the continuing quality of the print.

At the time of writing, this might mean the choice of a fiber-base paper. Tests run by Kodak indicate that when prints are displayed for long periods, displayed in sunlight, framed under glass, or stored in a contained or uncontrolled environmental condition, fiber-base papers can be expected to have a longer useful life than resin-coated papers. Care in mounting and matting exhibition prints helps to protect them, adds to their value, and complements their appearance. An overmat is necessary if prints will be framed. Archival quality mat board is necessary to prevent harmful compounds from migrating onto the print as is likely to happen with low-grade mounting board. For more information, see the sections "Processing for Image Stability" and "Mounting."

Descriptions of KODAK Papers

Enlarging Papers

EKTALURE: A brown-black image-tone paper designed for portraits and display prints. This is a fiber-base paper available in several surfaces, all on double-weight paper base. The speed of EKTALURE Paper, along with its warm characteristics, makes it suitable for both machine and manual printing. Available in sheets up to 20 x 24 inches (50.8 x 61 cm). For even larger prints, this paper can be purchased in rolls 40 inches (101.6 cm) wide. The K-surface

(fine-grain, high-lustre) EKTALURE Paper has exceptionally long scale, and is widely used for fine-arts exhibition prints. Tones readily in all Kodak toners. Comes in only one contrast, but a lower contrast can be obtained with a special low-contrast developer.

EKTAMATIC SC: Recommended for activation-stabilization processing in two-solution machines such as the KODAK EKTAMATIC Processor, Model 214-K. It can also be tray-processed in regular print-processing solutions. EKTAMATIC SC Paper is a fiber-base, projection-speed, developer-incorporated, selective-contrast paper, and is available in F, N, and A surfaces. This paper is widely used for extremely short-time processing where the prints are needed quickly to make halftones for publications with short deadlines. When this paper is tray-processed, it produces a long visual scale and a relatively high D-max.

KODABROME II RC: A fast, contrast-graded, warm-black image-tone developer-incorporated paper made on a water-resistant base primarily for activation processing. It can also be conventionally processed. It is available in sheets up to 24 x 30 inches (61 x 76 cm) and rolls from 3½ to 40 inches (9 to 101.6 cm) wide. KODABROME II RC Paper can be machine-printed in rolls and processed using the KODAK ROYALPRINT Roll Feed Adapter in conjunction with the KODAK ROYALPRINT Processor, Model 417. In sheets, it offers the advantages of short exposure times and short processing times [two 8 x 10-inch (20.3 x 25.4 cm) prints, 55 seconds dry to dry] in a graded paper (grades 1, 2, 3, 4, and 5*) which makes it particularly useful for many professional, commercial, industrial, press, and amateur applica-

*Changed from previous contrast grade names: Soft, Medium, Hard, Extra Hard, Ultra Hard.

tions. The speeds and contrasts are somewhat higher when the paper is tray-processed. The No. 5 paper has extremely high contrast. It is suitable for linework, as well as for the continuous-tone printing of very low contrast negatives.

KODABROMIDE: A fast, graded enlarging paper with a neutral-black image tone, both in single weight and double weight, and in E and F surfaces. Recommended for high-volume production where a fiber-base paper is desired. The F-surface paper has been widely used for many years to make prints for halftone reproduction. KODABROMIDE Paper has excellent development latitude, which helps to maintain uniform contrast and image tone with reasonable variations in development time.

MEDALIST: A fast, general-purpose, fiber-base enlarging paper. It comes in single weight (F surface) and double weight (F and G surfaces) in several contrast grades. MEDALIST Paper has a warm-black image tone suitable for many commercial, industrial, and pictorial uses. It is especially useful when negatives being printed vary widely in contrast and density.

Mural: A fast, special-purpose, warm-black image-tone paper recommended for big enlargements and photomurals. The single-weight paper base is tough, so that it withstands the handling necessary in making prints, and makes overlap joints less visible. The tweed, semi-matt surface of this paper is easy to spot and tends to break up image grain. It is also excellent for hand coloring. Mural Paper is available in rolls up to 54 inches (137 cm) in width.

PANALURE: A fiber-base panchromatic paper for making high-quality prints from color negatives. PANALURE Paper has a warm-black image tone and is available in F surface only. Normal papers tend to print blue subject tones lighter than they appear and red subject tones darker than they appear. When color negatives are printed on any of the three KODAK PANALURE Papers, the gray-tone rendering of colors approximates their visual brightnesses. Filters used for black-and-white photography (red, yellow, green, etc) can be used to achieve filter effects when printing on these papers.

PANALURE Portrait: Has characteristics similar to those of PANALURE Paper, but this paper has a warm-black image tone and an E surface suitable for portraits and display photographs.

PANALURE II RC: A resin-coated, developer-incorporated paper with a panchromatic emulsion. This F-surface paper is designed to print color negatives for making prints that are processed by the activation process in such processors as the KODAK ROYALPRINT Processor, Model 417. It can also be tray-processed. The F surface produces a glossy surface without ferrotyping.

POLYCONTRAST: A general-purpose, fiber-base, selective-contrast paper with a warm-black image tone for many applications. Contrast control is maintained through the use of KODAK POLYCONTRAST Filters. This paper is available in A, F, G, J, and N surfaces.

POLYCONTRAST Rapid: A very fast paper similar to POLYCONTRAST Paper, available in F, N, and G surfaces. Its high speed makes it valuable for fast production of enlargements from small negatives, and for reducing printing time when printing dense negatives. As with POLYCONTRAST Paper, contrast is controlled with POLYCONTRAST Filters.

POLYCONTRAST Rapid II RC: A selective-contrast, developer-incorporated, water-resistant paper with a warm-black image tone that combines the advantages of POLYCONTRAST Rapid Paper with the very short processing time provided by activation processing in a processor, or short processing times using regular tray-processing methods. The warm-black image on a white base makes this paper suitable for many industrial, commercial, and professional uses. Available in F, N, and Lustre-Luxe E surfaces. The F surface dries to a gloss without ferrotyping. The N surface is suitable for display and takes retouching readily. The Lustre-Luxe E surface is excellent for portraits and for exhibition prints. Good dimensional stability. Warm image tone.

Portrait Proof: A developing-out, fiber-base paper designed for making proofs of black-and-white portrait negatives. It has a rough surface that tends to subdue grain, facial lines, and blemishes in unretouched portraits. This paper tones readily in all Kodak toners, so is often used for exhibition prints where a toned image color is desired. Available in sizes up to 11 x 14 inches (28 x 35.6 cm), in single weight. Projection printing speed.

Other KODAK Papers

AZO: A general-purpose paper for contact printing. The image tone is neutral-black, and the tint is white. This paper is available in contrasts 1, 2, 3, 4, and 5 in F surface, and contrasts 2 and 3 in E surface. It is a contact paper primarily for professional use. Yields high-quality prints suitable for display and reproduction, and is recommended for most purposes in commercial, industrial, and illustrative photography where a contact-speed paper is required. Single- and double-weight bases.

KODABROME II RC Paper offers many advantages for prints being made to be reproduced by a halftone process. Its high D-max and long tonal scale result in prints of a high quality for acceptance by art directors and clients, and provide an excellent image for the halftone process. The duotone printing process by which this book was printed does a fine job of showing rich blacks, smooth gradations, and overall high quality of the original print.

AD-TYPE: A special-purpose contact-speed paper on lightweight base, available in A surface only. This is a paper that folds without cracking. This makes it suitable for French-fold cards, as well as for illustrations to be included in manuals or reports. If prints are to be mailed, the lightweight base of AD-TYPE Paper may save on postage charges.

VELOX: A contact-speed paper designed primarily for amateur and commercial photofinishing. This paper yields a blue-black image. Available in F surface, white tint, fiber base, single weight only. Especially appropriate for contact prints of large snapshot negatives.

PREMIER II RC: A high-speed, resin-coated, developer-incorporated paper designed for machine printing and activation or continuous processing. This paper is available in F and E surfaces. The F surface is used primarily for moderate enlargements of the photofinishing type, and dries to a gloss without ferrotyping. The E surface is used for black-and-white package prints that are important in school photography and high-volume portrait work. It is available in rolls only and in medium contrast.

VELOX UNICONTRAST: A long-scale, fiber-base, F-surface paper for machine printing. Available in rolls and standard R- and S-print sizes. Designed for photofinishing work where all ranges of negative contrast are printed on one paper grade.

Studio Proof: A printing-out paper for contact-proofing portrait negatives. The reddish brown image appears directly upon exposure to a high-intensity source rich in ultraviolet radiation, and does not require processing. The emulsion turns dark upon prolonged exposure to normal room illumination so that the image gradually disappears. This is why the paper is only suitable for proofing.

RESISTO: A contact-speed paper on a water-resistant base, primarily designed for use in the production of maps. Available in N surface, this paper has excellent dimensional stability and the short processing times associated with water-resistant base papers.

RESISTO Rapid Pan: Made specifically for making color separations from color negatives for photomechanical color reproduction. However, it can also be used to print color negatives to obtain prints with a gray-tone rendering of colors approximating their visual brightness. The base is water-resistant, giving excellent dimensional stability and short processing times. Has smooth surface similar to N; available in 8 x 10-inch (20.3 x 25.4 cm) size.

Handling and Storage of Photographic Paper

Careful handling of photographic paper is essential for good quality and economy. Proper storage makes sure that the quality and uniformity of the photographic paper will be maintained until you are ready to use it. Adverse storage conditions can cause deterioration in both the physical and photographic properties of the paper. A few simple precautions can prevent deterioration that could result in a loss in quality and economy.

Handling Paper

Photographic paper should be handled very carefully, particularly in processing. Avoid cracking the emulsion of the paper. If reasonable care is not taken, cracks can occur when putting dry paper into the developer solution. A dry gelatin emulsion is somewhat brittle, but when it becomes wet it is more pliable. However, when wet it is more susceptible to scratches and abrasions. Both wet and dry photographic paper should be handled carefully. Cracks from rough handling may not show up until the print is dry.

Trays for processing solutions should be kept clean. Marks on prints from dirty trays can be very difficult to remove. When print tongs are used, the tips should be kept clean to prevent marks on the print.

Paper should be handled by the edges before it is processed. Finger marks from hands wet with processing solutions or from oily hands can show up in the final print as black or white marks. Keeping wet and dry darkroom areas separate is important so that

Kodak papers should be expected to retain their sensitometric characteristics for several years when kept in cool, low-to-moderate relative-humidity storage conditions. When refrigerated, a warm-up period should be allowed before the paper is unwrapped to avoid condensation.

splashes will not contaminate the dry work space, easel, or unexposed paper. A good procedure is to keep paper in the box in the original wrappings or in a paper safe with the lid closed until it is to be used. This prevents accidental white-light fogging or safelight fogging. Paper should not be stored in lighttight drawers, but should be returned to its original wrappings for storage to avoid excessive curling and possible image deterioration. When handling paper it is best to keep the emulsion facing down as much as possible and out of the direct light of the safelight. Keeping the paper emulsion side away from the safelight as much as possible increases the safe time under safelight illumination. For further information regarding the safety of safelights see the section "Testing Safelights."

When it is necessary to write on the back of a fiber-base print, a soft lead pencil should be used with *light* pressure. Otherwise, cracking of the emulsion may occur. Also, a slight desensitization where the pencil pressure was applied may occur if the paper is marked prior to exposure, which can result in the writing appearing on the image side as reversed, white writing. Special felt-tip pens with fast-drying waterproof ink are recommended for marking the back of prints being made on water-resistant papers.

Storing Paper

The conditions under which photographic paper is stored can influence the keeping qualities of the paper. Care must be taken to avoid high temperatures and extremely high or extremely low relative humidity. The combination of high temperature and high humidity can hasten the aging of photographic paper emulsions, causing changes in sensitometric characteristics. High temperature and relative humidity can also encourage the growth of fungus on the gelatin. The packaging materials may also be damaged by long exposure to severe conditions. Extremely low relative humidity can cause the emulsion to become very brittle and have a very strong curl. Difficulty in handling is increased.

Following is a list of recommended storage conditions and procedures for photographic paper:

1. Avoid temperatures above 70°F (21°C). For prolonged storage 40 to 50°F (4 to 10°C) is recommended for paper in the original container.

2. Very dry or very damp environments should be avoided. A relative humidity of 40 percent is suitable. At relative humidities above 60 percent a dehumidifier should be used. Small quantities of paper can be sealed in a plastic bag with a desiccant such as silica gel.

3. Photographic paper should not be exposed to fumes or gases from paint, solvents, lacquer, internal-combustion engines, or the fumes from sepia sulfide toners.

4. Photographic paper should be stored at a distance from x-ray sources and all radioactive material.

5. To avoid damage to paper boxes and the paper inside, do not make tall stacks of boxes.

6. Rotate the stock so that older boxes of paper are used first. Because of the usual long keeping life of photographic papers, Kodak no longer prints expiration dates on paper boxes.

7. If boxes of paper are refrigerated at about 40°F (4°C), they should be allowed to come to darkroom temperature before opening. This avoids condensation of moisture on the emulsion when a cold sheet of paper is exposed to the air. The paper should be rewrapped in its original packaging material when placed back in storage to protect it from light and from adverse environmental conditions.

Most Kodak papers are available in sheet form in the 5 x 7 or 8 x 10 proportions. Many prints are printed in other aspect ratios such as square, or in a long, narrow panel format as the picture below. Many Kodak papers can be purchased in roll form, such as 40 inches by 100 feet, so that it can be cut to any desired format.

Norm Kerr

31

DARKROOMS AND ENLARGING EQUIPMENT

Characteristics of a Good Darkroom

A darkroom about 8 x 10 feet (2.5 x 3 metres) is usually large enough for a single operator to work in comfort and will hold a normal amount of equipment. If, however, prints in large quantities are to be made by several operators working at the same time, a larger darkroom is required. In such situations, it is common practice to have one operator process the prints exposed by several "printers," so the enlarging room is "dry" with a pass-through to the "wet" room where the prints are processed. In other labs, the printer is responsible for both enlarging and processing, so each worker's area is both dry and wet.

For the photofinishing type of enlargements, semiautomatic printers expose the enlarged images of negatives onto paper in rolls. The rolls are put through continuous paper processors where the paper travels as a web on rollers. Processing times are controlled by the web speed, the depth to which the paper goes into the solutions, and the number of immersions into the solutions. A drying drum at the end finishes the process, and the paper web is rolled up after drying. Rolls of paper can also be processed on the KODAK ROYALPRINT Processor, Model 417, equipped with a KODAK ROYALPRINT Roll Feed Adapter. The design of darkrooms for photofinishing operations is beyond the scope of this book. See KODAK Publication No. K-13, *Photolab Design*.

An Individual Darkroom

The darkroom for a single worker must have a place for the necessary equipment, storage of papers, storage of trays, and adequate sink and counter space. Further, it must be designed for convenience and comfort. The following suggestions are given for the design:

1. Place the enlarger in the dry area where it will not get splashed, but only a short distance from the sink—4 feet (1.2 metres) is a good distance.

2. Place sink faucets and wall switches so that they can be easily reached. Ground all switches and outlets for safety. Provide all white-light switches with devices to prevent accidental activation.

3. Bench tops and the bottom of the sink should be at a convenient working height—32 inches (71 cm) is average, but this should be adjusted to suit individual heights.

4. The floor covering should be waterproof, easy to clean, and resilient for foot comfort.

5. A light-trap entrance provides many advantages. It permits coming and going without allowing white light to enter, and carrying things in and out with both hands. It helps reduce dust that the use of curtains entails, and helps with ventilation.

6. Sufficient electrical outlets provide convenience. They may be needed for white lights, safelights, the enlarger, a photometer, a ventilating fan, one or more timers, etc. The switch for white light should be just inside the entrance, and placed relatively high. The switch for overall safelight illumination should be placed at the normal level, about 45 inches (110 cm) above the floor, directly under the white-light switch.

7. Provide a smooth, dust-tight ceiling. Cover pipes with boxes. Provide under-counter or under-sink storage for bottles of processing solutions, trays, papers, and accessories. Provide shelves above the sink for graduates, containers of solutions, thermometers, etc.

Darkroom Floors

Asphalt tile in one of the darker colors makes an excellent darkroom floor. It is waterproof, does not shrink, wears well, and is resilient enough to provide a water seal at the floor edges. Asphalt tile also stands up well under spills of various processing solutions. If the floor base is wood, it should be covered with an underlayment for the asphalt tile. Such tile can be applied directly onto a concrete floor.

Another good choice of floor material is vinyl-asbestos tile. It wears well, and is more resilient than asphalt tile.

Most grades of vinyl tile are unsuitable for darkroom floors because they tend to shrink, leaving gaps between the tiles, and are fairly soft so that they do not wear as well as the asphalt and vinyl-asbestos tiles.

Porous floors, such as wood, soak up spilled chemicals, and release powdered chemical dust into the air when the chemicals dry. With the wetness associated with print processing, the wood can rot in a few years. If the darkroom is on an upper floor, spills can seep through the wood and drip into the rooms below.

Concrete is very hard on the feet. Further, it is attacked by fixer, and deterioration is started. Protection from fixer can be provided by a good-quality latex cement-floor paint.

With any type of floor, it may be convenient to use sponge rubber floor mats in front of the enlarger and

SUGGESTED PRINT DARKROOM LAYOUTS

HOME DARKROOM

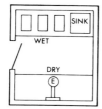

HOME DARKROOM

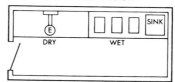

HOME DARKROOM

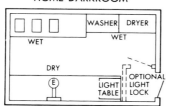

SMALL COMMERCIAL DARKROOM

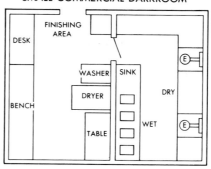

NEWSPAPER DARKROOM
WITH ACTIVATION PROCESSOR

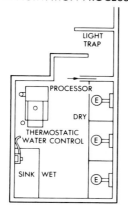

COMMERCIAL DARKROOM WITH
ACTIVATION PROCESSOR

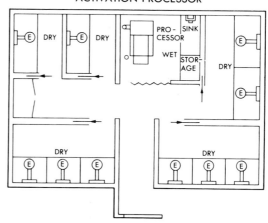

the sink to supply additional foot comfort. The pads can be washed out to remove dirt and chemical spills.

Walls and Ceilings

Materials for the walls and ceiling vary with the construction of the building. Whatever the material, it should be made light-colored. White is fine for the ceiling because white reflects the light of indirect safelights satisfactorily. The walls can be a light tan or yellow because they reflect the amber color of the safelight almost as well as white, yet do not show dirt as easily. A semigloss latex paint of the type used in kitchens and bathrooms will provide a surface that wipes clean easily. The wall area behind the enlarger and the ceiling area above the enlarger should be painted a flat black to absorb any stray light from the enlarger. All the surfaces of the light-trap entrance and any ventilating openings should also be flat black. If it is necessary to use an oil-base paint, a period of one month should be allowed for thorough drying before the darkroom is used. Oil-base paint fumes can be harmful to film and print images.

The wall behind the sink should be made waterproof. This can be done with a waterproof paint, such as an epoxy paint, or a piece of plastic countertop covering can be fastened to the wall with contact cement.

If a new darkroom is being built within existing space, new walls can be made of plasterboard and painted. It is even easier to use light-colored prefinished wood wall panels that do not have to be painted.

When the ceiling is unfinished, as in a basement, a drop ceiling can be installed. The 2 x 4-foot (60 x 120 cm) panels should be opaque. Inexpensive panels can be made from 1/8-inch (3 mm) floor underlayment (untempered hardboard) and roller-painted with a white latex semigloss interior paint, such as a kitchen ceiling paint.

Ventilation and Air Conditioning

Air control is important both for comfort reasons and for the proper conditions to process photographic paper. The three factors involved are air movement, temperature, and relative humidity.

A small unventilated darkroom can become stuffy if a worker spends hours in it. It is even worse if he is a smoker. Exposed trays of processing solutions and a print washer swirling water can raise the humidity level until the air becomes uncomfortable, especially if the temperature is elevated. Movement of the air in and out of the darkroom can provide a protection against these discomforts.

It is better to have a filtered ventilating fan that pulls air into the darkroom. A fiber-glass filter removes the dust, and by pulling the air into the room, the air pressure is greater inside than out so that dust will not be drawn in through cracks. The fan should be able to completely change the air once every 8 minutes.

In general, temperatures between 68 and 75°F (20 and 24°C) and a relative humidity of about 45 percent are compatible with enlarging and processing, and are comfortable to most people. (Bulk storage of paper should be elsewhere. Recommendations are given in the section "Handling and Storage of Photographic Paper.")

In tropical or subtropical climates, or when the darkroom is located directly under a roof, use of an air conditioner is advised to maintain the air temperature given above.

Dust Control

Dust can be a costly nuisance in enlarging. Effort made to control dust results in cleaner prints with fewer "dust spots" to spot in and consequently saves time.

The filters in the air intake or the air conditioner should be cleaned regularly. Any building contains lint, dust, and dirt, some of it coming in from outdoors and some being generated by clothing, rugs, draperies, hair, etc. It becomes airborne with the movement of air and with the movement of people. Particles settle on all horizontal surfaces, even on vertical surfaces.

Good housekeeping is the best way to minimize dust problems. Dust cloths may pick up some of the dust, but they just spread it around. A good canister-type vacuum cleaner, with a bare-floor attachment and small brush attachment for counter tops and shelves will pick up the dust without scattering it. An occasional washing of shelves and counters and mopping of the floor will further aid in keeping dust out of the darkroom.

If dust is a big problem, either because the work is very sensitive to dust, such as in making murals, or if the general area around the darkroom is very dusty, an air cleaner can be installed. These units are independent of the general air-circulation equipment, and operate either by mechanically filtering the air or by using electrostatic attraction of air particles.

A particularly bothersome type of dust is chemical dust. Such dust comes from mixing dry chemicals to make processing solutions, or from allowing spilled processing solutions to dry without adequate mopping up and rinsing.

If possible, mixing dry ingredients to make processing solutions should be done outside of the darkroom. If mixing must be done in the darkroom, every care should be taken in handling the dry in-

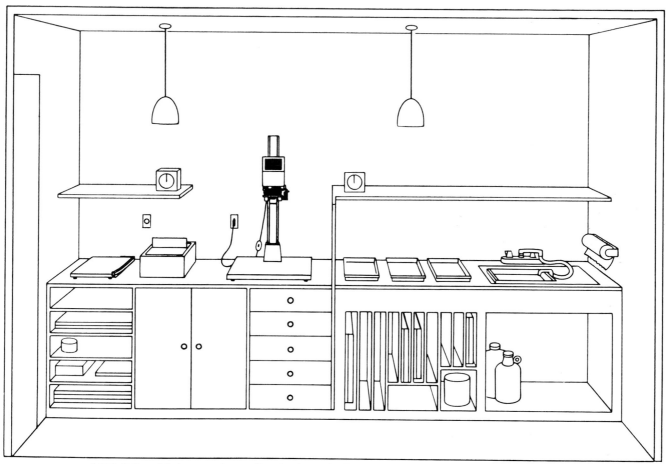

A well-designed darkroom makes quality enlarging easier. The use of the right materials makes dust elimination an easier task. Proper placement of safelights makes working in the "dark" safer and simpler, while lowering the chances of safelight fog. Separation of the dry and wet areas reduces chances of paper damage from splashes. Having enough walk space avoids a cramped atmosphere, while having the work spaces reasonably close together saves steps and time.

gredients to avoid causing a cloud of chemical dust. One way to avoid this problem is to use liquid-concentrate processing chemicals, such as KODAK EKTAFLO Developer, Type 1 or Type 2, Stop Bath, and Fixer, all of which are concentrated liquids supplied in flexible containers. The liquid is drawn off directly into a graduate through plastic tubing, and diluted to make the working solution.

Darkroom Sinks

A suitable sink is a necessary part of the darkroom. A convenient sink will be large enough to hold three trays of the largest print size to be made, plus extra space between trays to avoid contamination. Space should also be allowed for draining water, hand washing, and other purposes. The sink can have an upper level arrangement at one end to hold the print washer, or the washer can be placed on a bench top next to the sink in such a way that it drains into the sink. Some sinks have a print washer built in as part of the sink.

The sink should have at least two sets of faucets. One can be a typical hot-cold combined faucet, and the other can be a thermostatically controlled mixing

faucet for print washing. (If color prints are also made in the darkroom, this is especially useful.) The faucets should have a hose-bib nozzle so that hoses can be attached. The nozzles should be high enough above the sink floor so that the tallest darkroom bottle to be used can be filled from the faucet.

Sinks are made of many materials. In the past, sinks were made of a water-resistant wood such as cypress or teak, and lined with sheet lead. Currently sinks are made of stainless steel, of fiber glass, or of molded polypropylene. There are a number of firms that specialize in manufacturing darkroom sinks in sizes from about 18 x 48 inches (45 x 120 cm) up to 30 x 96 inches (76 x 244 cm) or larger.

Some handy workers make their own sinks. The most popular type of homemade sink is made of marine plywood and lined with fiber glass. Materials can be purchased from marine supply houses, because the fiber-glass-resin method is used to make and repair boats.

It is a good idea to have duckboards at the bottom of the sink to place the trays on. One type is made of spaced strips of wood fastened to spacers with brass

screws. Cypress wood, or pressure-treated soft-wood (to a pressure of .40 psi) that resists rot, makes satisfactory duckboards. Another type is made of corrugated fiber-glass panels used for patio roofing. This material is cut to size, and holes are drilled at intervals for drainage.

Work Surfaces

Sturdy tables can be used as the dry benches for enlarging. If a darkroom is being built, however, it is useful to build counters with storage cabinets and drawers for storage. Such benches can be built from scratch, or prefabricated counters made for kitchen use can be purchased in units and assembled.

The plastic material used on kitchen counter tops is quite serviceable but its slippery nature can cause the enlarger to move easily. Sanded plywood can be painted or varnished to make a suitable surface, or covered with a smooth linoleum or vinyl floor covering held in place on the plywood with a contact cement. Cabinets used to store films and papers should not be constructed of plywood. The adhesives used in their manufacture may give off formaldehyde fumes, which are harmful to sensitized materials. Solid wood or metal should be used.

For most uses, the enlarger is simply placed on the bench top. If enlargements are to be produced bigger than can be accommodated by the enlarger, the bench can be made with a movable section of counter top. A series of wood strips are placed in this section so that the surface can be placed at a variety of positions lower than the bench top to give the enlarger a longer throw for greater magnifications. The enlarger is removed from its base and either fastened to the wall behind the bench, or a short piece of counter top is left at the back of the bench just wide enough to accommodate the enlarger column base.

Building a light table into the bench top provides a convenient method of evaluating negatives. An alternative is to purchase a thin light table that stands about 1½ inches high and use it on the bench top near the enlarger. A unit could possibly be used both as a light table and a contact printer. Built into the bench top, it could be used to judge negatives as well as to make contact prints.

A lighttight drawer to hold photographic paper is a handy addition to the bench. It can be built to hold the layout paper used frequently, and makes the paper easy to get at. The size can be varied to fit the circumstances. Painting the entire interior black helps achieve lighttightness. Such a drawer should be built of solid wood, not plywood.

Darkroom Lighting

Darkroom illumination is an intrinsic part of darkroom planning. The number of white lights and safelights, their type, and their location must be determined before the wires are run.

There should be enough white light in the darkroom to work comfortably when mixing solutions, washing prints, sorting negatives, and all the other work that does not require safelighting. It is generally wiser to use incandescent lamps rather than fluorescent because of the tendency of the fluorescent powder in some tubes to glow after the lamps have been turned off.

Two special white lights are useful. One is the light table mentioned above for looking at negatives. The other is a moderately bright light over the sink to evaluate the density and quality of prints in the fixer. It is a convenience to have this light equipped with a fast switch so that it can be turned on when the hands are wet. Because of dampness and spills inevitable in a darkroom, shock is always a potential danger, making it advisable for all electrical wire to have a third wire for grounding, and the switch, enlarger, and other equipment should be grounded with this third wire.

Basically, a safelight is a filtered light that contains little light of wavelengths to which the sensitized material is sensitive, yet contains wavelengths to which the eye is sensitive. With most photographic papers, this means light that contains no blue or green light or UV radiation, but contains yellow and some red light. (See diagram on page 15.) The KODAK Safelight Filter OC (light amber) is considered safe for most papers except the panchromatic papers. KODAK Safelight Filters OA (greenish yellow) are recommended for contact papers, while No. 13 safelight filters are recommended for the panchromatic papers.

Actually, red safelights, such as KODAK Safelight Filters No. 1A, No. 1, and No. 2, are safe for papers (except panchromatic), but most workers find that they cannot adequately judge the density of a developing print under the red illumination.

Both indirect and direct safelights are used. Indirect lights are hung from the ceiling and aimed upward. In the 8 x 10-foot (2.5 x 3 m) darkroom, this means one indirect safelight. A 25-watt bulb is recommended for use in indirect safelights.

Direct safelights are placed to provide illumination where a higher level of safelight is needed. One is required over the developing tray. The minimum distance is 4 feet (1.2 metres) and a 15-watt bulb is recommended with the type OC Filter.

Another location where direct illumination may be useful is over the paper cutter.

The KODAK Darkroom Lamp: This general-purpose safelight lamp can be screwed into standard light-bulb sockets. It provides illumination over sinks and benches. The filter size is a circle 5½ inches in diameter. As a rule, a 15-watt bulb is used in these lamps, but with some materials a 7½-watt bulb only is permitted.

KODAK Utility Safelight Lamp: This lamp hangs on chains attached to the ceiling. With the light directed towards the ceiling, it provides general, indirect illumination. This lamp can also be used with the light directed downwards. A bracket is available for bench or wall mounting.

KODAK Adjustable Safelight Lamp: Similar in design to the KODAK Darkroom Lamp, this safelight can be mounted on a wall or beneath a shelf, by means of a bracket and screws. This lamp also uses a 5½-inch circular filter.

KODAK 2-Way Safelamp: This is a small safelight lamp that can be screwed into a wall-mounted socket or other convenient lamp socket. Two 3¼ x 4¼-inch filters can be used, one to direct light upwards and the other downwards. The same wattage bulbs specified for the KODAK Darkroom Lamp are recommended for this safelamp.

BROWNIE Darkroom Lamp Kit: This simple safelight lamp is designed for the amateur who needs a lightweight lamp that can be screwed into any convenient lamp socket. Made from TENITE Plastic Material, it is supplied with two interchangeable safelight cups, yellow and green, and a 7-watt bulb.

It is best not to have a direct safelight near the enlarger. Not only does this raise the danger of safelight fog, it can also interfere with the vision of the enlarged image on the easel, and with any on-easel densitometry that may be done.

If there are several printing or processing darkrooms in a complex, it is important that the safelight conditions be close to the same in each room. The number and positions of the safelights, as well as the reflectivity of the walls and ceilings, are part of this condition. Printing operators can then go from one room to another with a minimum of adjusting to different levels of safelight intensity.

The KODAK Utility Safelight Lamp is equipped with chains to permit it to be hung from the ceiling to provide indirect safelight. The KODAK Darkroom Lamp is a hanging safelight for direct illumination, while the KODAK Adjustable Safelight Lamp is designed for wall mounting or mounting under a shelf.

Safety of Safelight Illumination

The purpose of safelight illumination is to provide just enough light of the right intensity to allow the operator to see to perform the enlarging and print-processing operations, without affecting the quality of the prints.

If the photographic paper receives little actinic (photographically effective) exposure from the safelights, the quality of the prints is not affected. If the paper receives slightly more exposure, the quality of the highlights may be degraded without actual safelight fog being present. If the safelight exposure occurs before the enlarger exposure, it is called "hypersensitization." When the safelight exposure occurs after the enlarger exposure, the exposure is called "latensification." Most papers are affected more by latensification exposure than by hypersensitization. Both these exposures first cause a loss in contrast in the highlights, resulting in tone compressions and an overall lowering of print contrast. If the safelight exposure is slightly more, it reaches a point where safelight fog occurs, and an overall low density is added to all the tones, being most apparent in the highlights.

Safelight exposure of the paper can occur because:

- The paper is exposed for too long a time to adequate safelight illumination.

- The safelights are too close to the paper, causing increased safelight exposure.

- The bulb is of too high a wattage, causing too great a level of safelight illumination.

- The safelight filters have faded, causing an increase in unsafe illumination.

Paper Sensitivity to Safelight Illumination

Both the inherent sensitivity of the paper, as evidenced by its paper speed, and its spectral sensitivity play a part in its potential for being fogged by safelight.

A paper with an ANSI speed of 500 is much more likely to receive safelight exposure that will affect the image than a paper with an ANSI speed of 50. Extra care must be taken with faster papers.

Graded enlarging papers are sensitive to UV radiation, blue light, and the shorter green wavelengths up to about 530 nanometres while selective-contrast papers are sensitive to UV radiation, blue light, green light, and yellow light up to about 630 nanometres. If a graded paper and a selective-contrast paper have the same speed, the selective-contrast paper will have a shorter safe-time exposure to safelight illumination than the graded-contrast paper.

Safelights for Panchromatic Papers

The KODAK Safelight Filter No. 13 (dark amber) transmits light in the 578 nm to 605 nm range—the yellow to yellow-orange region of the spectrum. (Because of the low transmittance, this filter looks dark amber.) The panchromatic papers are only slightly sensitive to these wavelengths. The paper is receiving a little exposure all the time it is under safelight conditions. The only reason it is "safe" is because the safelight intensity is so low and the spectral transmission is so narrow that the paper receives relatively little exposure. Even so, care must be taken to keep the time of exposure to the safelight at a minimum, and to keep the paper as far away from the safelight as practicable.

Testing Safelights

There are a number of tests for making sure safelights are safe. The main reason for testing is to check for fading. Safelights that get used 8 hours a day should be tested every 6 months to be sure fading of the filter has not occurred.

The simplest test is to place a piece of unexposed photographic paper on a flat surface, place a coin in the center of it, and expose it to the safelight for the maximum time the paper is likely to be exposed to the safelight in practice, usually about 4 minutes. After standard development, if a white circle in the center of a very light gray print can be seen, the safelight condition requires correction.

This tests for safelight fog, but not for the effects of latensification or hypersensitization. A fairly simple test for these two effects is to make a correct exposure of a negative on the paper with no safelights on. Then the paper is placed under the safelight, and a

series of test-strip exposures given to the print. One area should receive no exposure, and other areas 1, 2, and 4 minutes. The print should be given normal development in total darkness. After fixing, the print is examined.

If the paper is a fast, selective-contrast paper, slight safelight fog may show in the 4-minute segment. This serves as a reminder to keep the exposure of such paper to the safelight illuminator at a minimum. However, if the fog is severe, check the bulb wattage, the condition of the filter, and the distance to the lamp.

If the fog does not show on the white borders of the print, but does show in the highlights or light gray tones of the picture, latensification exposure has occurred. The fog only occurs where the paper has already received some exposure.

If there is no evidence of any of the safelight exposures, the conditions can be considered safe.

Another test that checks for fog, hypersensitization, and latensification effects is described in KODAK Publication No. K-4, *How Safe Is Your Safelight?*

Further Information: If further information on darkroom layout and materials is desired, see KODAK Publication No. K-13, *Photolab Design;* No. K-12, *Construction Materials for Photographic Processing Equipment;* and No. KW-14, *Building a Home Darkroom.*

Enlargers and Related Equipment

Enlargers and the related equipment used with them are the tools employed to make most photographic prints. Because of the variety of enlargers available, with many differences in design and construction, and because these differences have a definite effect on the use of enlargers, it is important to give this tool full consideration. The equipment normally used with enlargers includes constant-voltage transformers, easels, trimmers, dodging and burning-in tools, and photometers or enlarging exposure meters.

Enlargers

The basic differences among enlargers are:

- Size—This refers to the maximum negative size they will enlarge.

- Construction—Convenience and rigidity.

- Type of illumination—What kind of light source is used.

- Method of light distribution—How the light is made even over the negative area.

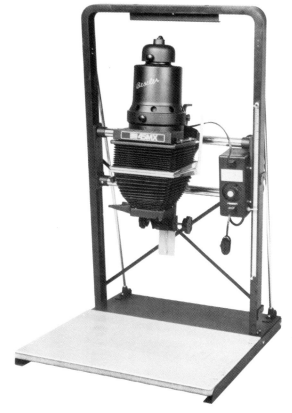

Beseler Photo Marketing Inc.

Several enlargers are shown in this and succeeding illustrations to demonstrate how the various enlarger features discussed in the text have been combined by various manufacturers to make successful enlargers.

Other differences include whether the enlarger is vertical or horizontal, how it is focused (bellows, screw mount, manual, auto-focus), and whether it has extra features that allow distortion correcting or the making of very large size enlargements. Very important factors are adequate rigidity of the enlarger so that it does not shake during the exposure, and ease of size changing and focusing.

Enlarger Sizes

The normal size range in enlargers is from the 35 mm format (24 x 36 mm) up to the 8 x 10-inch (20.3 x 25.4 cm) format. However, enlargers are available for smaller negatives, such as the 110 format (12.7 x 17 mm) and microfilms. Sizes for negatives larger than 8 x 10 inches are also obtainable.

Although it is possible to enlarge very small negatives on a big enlarger, it is usually inefficient and inconvenient, and the degree of enlargement is somewhat limited. It is better to limit the size of negatives to a small range. A convenient breakdown of sizes is given in the Table of Enlarger Sizes.

Table of Enlarger Sizes

Group	Enlarger Size	Negative Sizes
A	35 mm (1 x 1½ inches) (24 x 36 mm)	**110:** 12.7 x 17 cm **126:** 26.5 x 26.5 mm **Half-frame 35:** 17 x 24 mm **Full-frame 35:** 24 x 36 mm (1 x 1½ inches).
B	2¼ x 2¼ inches (6 x 6 cm)	**127 Square:** 1⅝ x 1⅝ inches (4 x 4 cm) **127:** 1⅝ x 2½ inches (4 x 6 cm) **4.5 x 6 cm:** 1¾ x 2¼ inches, **120 Square:** 2¼ x 2¼ inches (6 x 6 cm).
C	2¼ x 3¼ inches (6 x 8.3 cm)	All those in group B, 2¼ x 2¾ inches (6 x 7 cm), 2¼ x 3¼ inches (6 x 8.3 cm), and 2¼ x 3½ inches (6 x 9 cm).
D	4 x 5 inches (10 x 13 cm)	3¼ x 4¼ inches (8.3 x 10.8 cm), 9 x 12 cm (3½ x 4½ inches), and 4 x 5 inches (10 x 13 cm).
E	8 x 10 inches (20.3 x 25.4 cm)—many are actually 10 x 10 inches (25.4 x 25.4 cm)	5 x 7 inches (13 x 18 cm), 6½ x 8½ inches (16.5 x 21.6 cm), 9 x 9 inches (23 x 23 cm) aerial negatives, and 8 x 10 inches (20.3 x 25.4 cm).

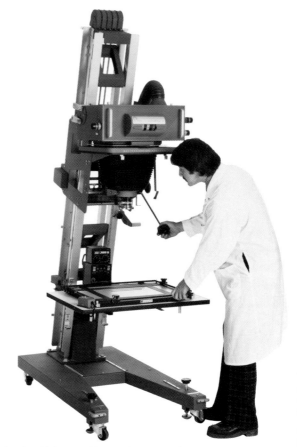

Professional labs are able to enlarge negatives up to 8 x 10 inches in size with equipment such as this.

Berkey Marketing Inc.

The physical size of an enlarger is usually not a factor. However, 8 x 10-inch enlargers must be physically large. If they are vertical, they require a high ceiling. A horizontal 8 x 10-inch enlarger requires a fairly long working distance. Set at normal bench height, even 4 x 5-inch vertical enlargers require a reasonable amount of head room. There is usually enough room in most darkrooms to accommodate the smaller format enlargers.

Mechanical Features

Enlargers consist of several basic parts. These parts vary from enlarger to enlarger in size, shape, material, etc, and in some cases, are omitted or combined with each other.

The *baseboard* is the flat base of the enlarger that holds the easel and provides stability to vertical enlargers. In horizontal enlargers, the base function is separated into the paper board, a vertical board in which the paper is placed, and the base, a horizontal table on which the enlarger rests. Most baseboards are made of thick plywood that retains its flatness. Some baseboards are made of metal, and may contain a lighttight drawer for paper, or a built-in photometer.

The *column* is the vertical support that holds the enlarger, and permits the enlarger to be moved up and down to change the projected image size. This is nearly always made of metal, but may consist of a round pipe, a square pipe, or a U-shaped or H-shaped girder. In most enlargers the column is set at 90 degrees to the base, but on some it is set at an angle. This feature permits larger pieces of paper to be put on the baseboard without striking the base of the column. For some bigger enlargers, the column consists of two girders spaced with metal connectors. Larger two-girder columns are often braced with diagonal rods for more rigidity. With slanted columns, extra struts are often used to provide additional stability. The column bar is made of metal and is used to attach the column to the baseboard.

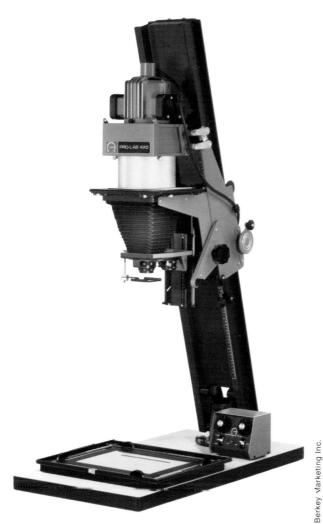

The various enlarger parts mentioned in the text and shown in this photograph are labeled in the drawing.

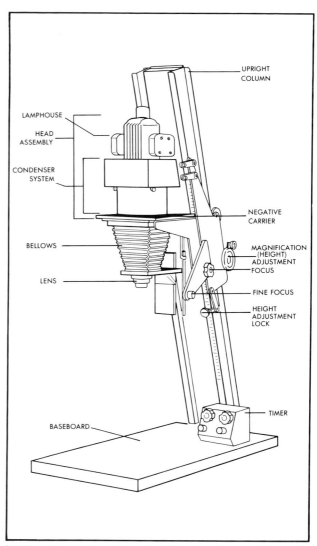

In other enlargers the parts may be different and may work in another way, but generally they serve the same purpose.

An important feature of an enlarger is rigidity so that the enlarger will not shake during print exposures. Vibration causes unsharp print images. It is largely the column and its base that contribute rigidity.

The *bracket* attaches the enlarger head to the column. At the column end, the bracket slides or rolls up and down the column, but there is almost always a locking screw that holds the bracket fixed on the column where the proper position has been determined. Also attached to the bracket at the column end is a counterweight or counterbalance device that almost balances the weight of the enlarger head so that it is easier to raise or lower.

The enlarger head is fastened to the other end of the bracket. On some enlargers, the fastening device permits rotating the enlarger head up to 90 degrees from the vertical position for projecting images for big-sized enlargements on a wall. In many enlargers, the bracket is an integral part of the enlarger head.

In a few cases, a parallelogram arm arrangement provides the up-and-down motion of the enlarger head. Such a device is counterbalanced with a spring. Some parallelogram brackets have autofocus arrangements. One disadvantage of this method is that the position of the image changes with every change in enlarger height, so that with even slight changes in image size, the easel must be repositioned; this is also true of enlargers with slanted columns.

Negative Carriers

Negative carriers are designed to hold the negatives reasonably flat and perpendicular to the axis of the enlarger.

Carriers for small negatives are usually glassless—they are held by the edges in the carrier aperture. Glassless carriers have the advantage that there are only the two negative surfaces to be kept dust-free. Some unsharpness in enlargements made from negatives held in this type of carrier can occur from two causes. Most negatives curl slightly toward the

Glassless negative carriers hold the negatives by the edges. Dust can be blown off after the negative is placed in the carrier.

emulsion side. Even when the four edges are held flat, there may still be a slight curve in the negative. If the lens is very flat field, and if the lens is used relatively wide open, it can lead to difficulty in getting the image on the easel sharp in the center and at the edges at the same time. Stopping the lens down adds enough depth of field to correct for this.

The other cause of unsharpness is called "negative popping." When the negative is focused, it is relatively cool. If some time is spent in composing, and if the exposure time is of some duration, the negative may heat up and "pop"—that is, change its curve so that it changes its position in relation to the carrier and lens, thus altering the focus of the image on the paper. The image may also shift laterally, giving a double image on the print.

In most modern enlargers for small-size negatives, the heat-absorbing glasses minimize this popping, and the glassless carriers work well for all but the most exacting uses.

The problem becomes more severe with large-size negatives such as 4 x 5 inches (10 x 13 cm) or 8 x 10 inches (20.3 x 25.4 cm). Glass carriers are often used with these sizes to provide image sharpness. Great care with cleanliness should be taken to avoid enlarging dust specks that cling to the glass.

It is convenient if negative carriers used for roll films have some device to open the carrier while it is in the enlarger so that the roll film can be moved

from negative to negative.

A final consideration concerning negative carriers is whether they effectively block any stray light from emerging. Some carriers do not have any light-blocking protection, and allow a narrow band of light to escape in nearly all directions. Such light can reflect off nearby objects and cause fog on the paper as it is being printed.

Distortion Correction

If a camera is aimed up or down at a subject with parallel vertical lines such as a building, the negative image of the lines will no longer be parallel but will converge. Sometimes it is desirable to make these lines parallel in the print.

The principle of correction is to move the film and paper closer together on the side where the lines are farthest apart, and farther apart on the side where the lines are closest together. In order to retain focus, two of the three factors must be tilted: negative, lens, and/or easel.

If both the lens and the negative can be tilted, the easel can stay flat on the baseboard. If just the lens or the negative can be tilted, then the easel must be tilted. To maintain focus, a line extended from the negative plane, the lens plane, and the easel plane must meet at a point. This is called the Schiempflug principle.

If it is likely that this type of correction will be needed at some time, it is desirable to have either the negative carrier or lens board, or both, capable of being tilted.

Some enlargers are equipped with tilting negative carriers and/or lens boards. With these features, converging lines can be made parallel and the relative size of foreground and background objects can be changed. See page 82.

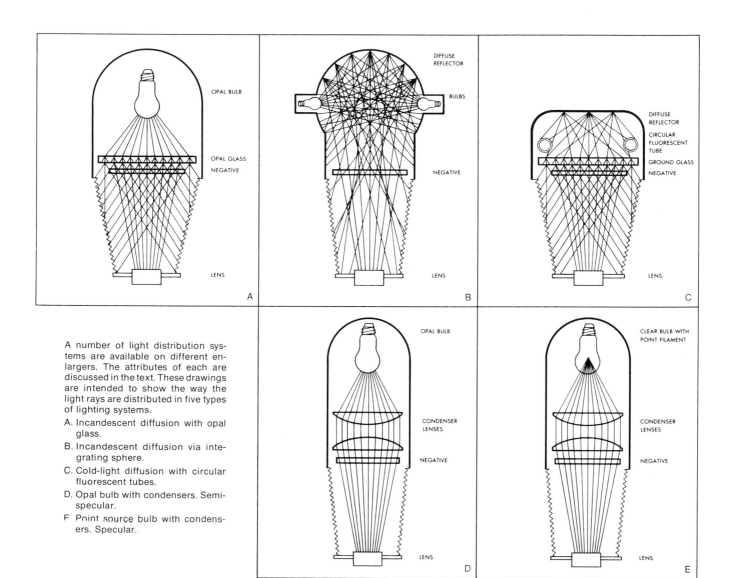

A number of light distribution systems are available on different enlargers. The attributes of each are discussed in the text. These drawings are intended to show the way the light rays are distributed in five types of lighting systems.

A. Incandescent diffusion with opal glass.
B. Incandescent diffusion via integrating sphere.
C. Cold-light diffusion with circular fluorescent tubes.
D. Opal bulb with condensers. Semi-specular.
E. Point source bulb with condensers. Specular.

Enlarger Illumination

There are four important characteristics of enlarger illumination.

1. Even spread of light across negative area.
2. Brightness.
3. Specular-diffusion characteristics.
4. Color characteristics of the light.

Light Distribution

There are several ways that light is distributed to make it even across the negative surface.

A translucent material, usually opal glass, is placed a short distance from the light source. If the light source is an incandescent bulb, there may likely be slight unevenness, with the central area brighter than the edges and corners. This results in prints being darker in the center than at the edges. If, however, the light source is a "cold light" (a bent fluorescent tube such as the Aristo* cold light), such diffusers make very even light.

Condensing lenses are also used to distribute the light. Condenser enlargers are generally faster than diffusion enlargers because they distribute the light more efficiently, but this depends also on the comparative light output of the light sources. Most condensing lenses are polished plano-convex lenses. Two are normally used with the convex sides toward each other. They are commonly used with opal enlarging bulbs. For most efficient use, the image of the enlarging bulb is focused on the rear element of the enlarging lens, and the image should just fill the lens aperture. If the image is too large, the light focused on the lens mounts is wasted. If the image is too small, the periphery of the lens is not used, and the lens is, in effect, stopped down. A few enlargers have some method of focusing the condensers. With most, a good compromise position is found by the manufacturer, and the condenser position is fixed.

*Aristo Grid Lamp Products, Inc., 65 Harbor Rd., Port Washington, NY 11050.

A condenser enlarger with an opal bulb offers a good compromise illumination for black-and-white printing. If the bulb has a small filament in a clear glass envelope, the light becomes very specular. Such enlargers are often called "point source" enlargers.

Enlargers made primarily for color printing can also be used for making black-and-white enlargements. The enlarger shown above has a diffusion system that uses a light integrating chamber. A different chamber is used for each negative format.

Although this lowers the printing efficiency of the light somewhat, it works in a practical way in most instances.

A few condenser enlargers use bulbs with transparent glass envelopes that have a small, compact filament. Such bulbs often use a lower voltage than the standard 110 V (USA) or 220 V (Europe). Transformers are required to achieve this voltage. The light for such enlargers is very specular (see following section on specular-diffusion characteristics).

If the bulb is centered with the optical axis of the condensers and enlarging lens, and if the focused image of the bulb on the enlarging lens is reasonable, most condenser systems give a very even distribution of light.

Some enlargers use diffuse reflection to distribute light. These are primarily color heads for printing color, but are often used to make black-and-white prints as well. One or two incandescent lights are used, which illuminate the inside of the enlarger lamphouse. This is usually domed and is finished in a very matte white. Some of the light is diffused downward through the negative. Such heads are relatively inefficient in their use of light, but are required for the mixing of the color-filtered light required for color printing. Circular fluorescent tubes are also used with diffuse reflection for enlarger light distribution, and are usually quite efficient.

Some color enlargers have a "light pipe" made of mirrors or a solid block of plastic to further diffuse the light and mix the colored light. These have diffused ends and reflecting sides. The light is reflected around a number of times inside the "pipe" before it is emitted toward the negative. Such light pipes do not have a noticeable effect on black-and-white enlarging.

Characteristics of Enlarger Light-Distribution Systems

Speed: Condenser systems are more efficient than diffuser systems. Given the same light output of the bulb, the images formed by condenser enlargers are brighter than those formed by diffusing systems, and so exposure times are shorter.

The drawing shows that light rays go in all directions with diffuse systems. Only those rays that reach the lens serve to form images. Those scattered inside the enlarger are not used. In the drawing of the point-source enlarger, it can be seen that the rays are efficiently focused by the condensers to the lens, so few of them are lost. Light whose rays travel in orderly paths is called specular light. Point-source enlargers create very specular light.

Condenser enlargers that use an opal bulb are called semi-specular. Some of the light rays travel in fairly orderly paths, while some rays are diffused. These enlargers are the most common, although they are somewhat less efficient than point-source enlargers.

Contrast: Specular light makes enlarger images of black-and-white negatives more contrasty than diffuse light does. This is caused by the "Callier" effect. The negative images are composed of tiny grains of silver that tend to diffuse light. If the light going

Cold-light sources provide even diffuse illumination. They are excellent for printing large portrait negatives. They tend to minimize the effect of dust, reducing the amount of spotting required.

A circular fluorescent tube with an integrating reflection surface is used in this type of cold-light source.

through the negative is already diffused, the darker areas do not add much to the diffusion. If the light is specular, it goes through light areas of the negative without being diffused. However, the darker areas of the negative diffuse the specular light, adding to its effective density, and thus increase the contrast of the image. This increase in contrast that results from various types of enlargers is in the following order:

Specular Type	*Increase in Contrast*
Point-Source Enlarger	Most Increase in Contrast
Opal-Bulb Condenser	Some Increase in Contrast
Incandescent Diffuse	No Increase in Contrast
Cold-Light Diffuse	Lowers Contrast in the Shadows

The illustration at right shows the characteristic curves of the prints from one negative printed on all four types of enlargers. The same paper emulsion and the same process were used for each print.

Sharpness: Given the same other factors, especially the enlarging lens, the sharpness of prints is affected by the type of light source. Prints made with point-source condenser enlargers (specular light) are sharpest, while prints made with diffuse-light enlargers are least sharp. If sharpness is the only criterion then the point-source condenser enlarger is best. This extra sharpness, combined with the greatest increase in contrast, has some disadvantages. Grain, scratches, dirt, and dust on the negatives show up more in such prints. If the degree of enlargement is great enough, even the "tooth" grit manufactured in many professional films to provide

a surface for retouching can show up as tiny white specks scattered all over. The time required to spot prints is increased.

In general, condenser enlargers with opal bulbs make a good compromise for small negatives, and

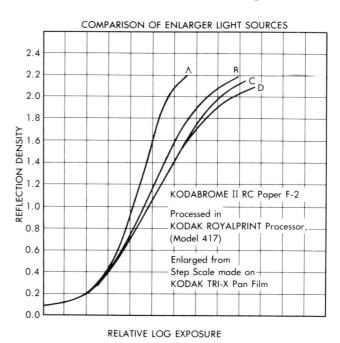

COMPARISON OF ENLARGER LIGHT SOURCES

KODABROME II RC Paper F-2

Processed in KODAK ROYALPRINT Processor, (Model 417)

Enlarged from Step Scale made on KODAK TRI-X Pan Film

RELATIVE LOG EXPOSURE

A. Specular-light enlarger (point source, polished condensers)
B. Semi-specular enlarger (opal bulb, polished condensers)
C. Incandescent diffusion enlarger (integrating-sphere color head)
D. Cold-light diffusion enlarger (integrating sphere, circular fluorescent light)

45

A variety of enlarging lenses is available. An enlarging lens differs from a camera lens in that it is designed to have a flat field at close working distances, while the camera lens has a flat field at long working distances. Field curvature changes as the working distance changes.

for larger ones when print sharpness is desired. Diffusion enlargers are considered best for large negatives when sharpness is not of prime importance, such as with portrait negatives. Some pictorial photographers who use large film formats also prefer diffusion enlargers. When extremely sharp detail is desired, point-source condenser enlargers are called for. Some enlargers have interchangeable heads that permit a degree of choice in the type of illumination.

Voltage Regulators

Many enlargers, mostly those with color heads, come equipped with a voltage regulator. A voltage regulator's purpose is to maintain a constant voltage output to the enlarger. Fluctuations in line voltage can ultimately cause inconsistencies in print densities, from print to print. These fluctuations can be caused by appliances, lights, or dryers being switched on or off. Large motors or elevators in industrial locations or large buildings are also likely to cause voltage fluctuations. In some areas, line voltage to buildings can fluctuate, also. As the voltage to the enlarger drops, the intensity and color of the enlarger light changes. A 10 percent decrease in line voltage can cause a 30 percent drop in enlarger-light output and a shift to the red or yellow (to which black-and-white paper is not sensitive). With a volt-

age regulator in place (available from professional photo dealers or electrical supply houses) the voltage to the enlarger is stabilized. This means that the voltage to the enlarger is constant despite fluctuations in line voltage over a fairly wide range.

Enlarger Lenses

Field Flatness: To obtain consistently good sharpness in enlargements, a good enlarging lens is a necessity.

Because both the negative and the paper are flat during the print exposure, a good enlarging lens has to have a flat field. The field curvature of lenses changes with distance—so a lens can have a really flat field at only one distance. Camera lenses are designed to have a flat field at long distances; an enlarger lens must have a flat field at its working distance. Most enlarger lenses are designed to have a flat field at a magnification of about 4×, and a range of acceptable flatness of field at about 2× to 6×. With lenses for small negatives, these figures are somewhat higher. If a lens does not have a flat field at a given magnification, it is difficult to get both the center and the edges of the image sharp at the same time. Stopping down helps by increasing the depth of field, but it also increases the exposure times.

Even Illumination: All lenses produce images that are somewhat brighter in the central area than at the edges due to the cosine fourth law. With the lens wide open, drop-off in illumination at the edges is worse due to vignetting. This is one of several reasons why the lens should be stopped down two or three stops for making prints.

Wide-angle enlarging lenses are becoming popular because they permit making bigger enlargements on the baseboard of the enlarger. Because the illumination fall-off is dependent on the field angle, wide angle lenses are likely to have greater fall-off than normal focal length enlarger lenses. However, if the wide-angle enlarging lens is designed as a reverse-telephoto lens (sometimes called a retrofocus lens) this increase in the degree of fall-off is minimal.

Definition: The purpose of an enlarging lens is to form an image. The better the lens is at forming the image, the better the definition of the print. Definition involves not only resolving power (the number of black and white alternate lines the lens will image), but also detail contrast, which has to do with the degree of contrast in the fine detail it can image. This is measured as the optical transfer function of the lens. Most enlarging lenses produce the best definition when stopped down one or two stops from the maximum aperture.

The extra sharpness available in a high quality enlarging lens shows up when the subject has many fine details to be reproduced.

Focus Shift: In poorly corrected lenses, the focal length of the lens at its outer edges is slightly shorter than the focal length in its central area. This gives an aberration called spherical aberration, and in addition to lowering the definition, it causes focus shift. When the lens is wide open, the image is formed by both the central and outer zones. When you focus, you get the best focus using both zones. However, when you stop the lens down to make the enlargement, only the inner zone is used. The focal length changes and the position of best focus shifts. Good enlarging lenses must be well corrected for spherical aberration. Even then, it is wise to recheck the focus after stopping down.

Focal Length of Enlarging Lenses: The focal length of a normal enlarging lens should be approximately equal to the diagonal measurement of the negative to be enlarged. Wide-angle lenses, of course, have shorter focal lengths by 20 to 25 percent. At the same enlarger height, this increases the size by about 30 percent.

The following table shows the focal lengths for standard negative sizes.

Enlarging Lens Focal Lengths

Format	Focal Length	
	Normal Lens	Wide-Angle Lens
110	25–30 mm	—
126	35–40 mm	—
35 mm	50 mm	40 mm
6 x 6 cm	75–80 mm	60 mm
6 x 7 cm	100–105 mm	80 mm
6 x 9 cm	100–105 mm	80 mm
4 x 5 inches	150–160 mm	135 mm
5 x 7 inches	8½ inches (210 mm)	—
8 x 10 inches	12–14 inches (300–360 mm)	—

The standard speed of enlarging lenses of 100 to 160 mm in focal length is f/4.5, while for the longer focal length lenses it is f/5.6. Shorter focal length lenses may have an f/4.0, f/3.5, or f/2.8 maximum aperture. Faster lenses reduce enlarging exposure times.

Other Factors: Moderately priced enlarging lenses usually have four elements. Better lenses usually

have six or more elements. If they are better corrected for chromatic aberration, they may be called color enlarging lenses, or APO lenses, which stands for apochromatic, meaning that they are better color corrected. While this correction does not directly affect black-and-white prints, it is likely to improve the lens definition. A well-corrected lens can also be used for color enlarging.

The aperture is changed on less costly lenses by simply rotating the aperture ring. In the dark, it is difficult to see the f-number markings. Better-made lenses may have click stops every half-stop, and the desired f-number is found in the dark by counting clicks as the aperture ring is rotated. For example, if the maximum aperture is f/2.8, and the lens is stopped down to f/5.6, there are four clicks. Some lenses have "light pipes" that go through the lens board and use some of the spare enlarger light to illuminate the f-number markings.

Lens Cleanliness: In printmaking, cleanliness is very important. Clean negatives make prints that

A tone-line derivation is made by printing a sandwich of positive and negative images made on KODALITH Film from the original negative. The quality of a print of this type is best when a pure white, a good black, and few middletones are achieved. More information on this technique is available in *Creative Darkroom Technique*, KODAK Publication No. AG-18.

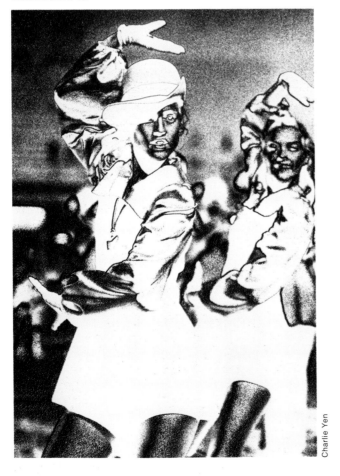

Charlie Yen

require little spotting. Clean lenses give prints with better tone quality and improved sharpness.

If lenses are kept in containers or are kept with lens caps on each end when not in use, and if the lens surfaces are not touched, the lenses stay clean. If, however, a lens stays out on a bench top, it collects dust (even chemical dust). The lens surfaces may get coated with a layer of grease film from the furnace, from cooking in the building, or from smoking. Dust, scum, and fingerprints all raise the flare level of the lens which reduces print contrast and sharpness.

A clean camel's-hair brush can be used to dust lens surfaces. One with a rubber bulb to blow while brushing makes it easier to remove the dust.

Scum and fingerprints are best removed with a slight amount of moisture, and by wiping with a *soft* cloth or lens tissue. If the soil is light, breathing on a lens surface usually provides enough moisture. For heavier soil, a lens cleaner made just for that purpose is recommended. A cloth or a piece of lens cleaning tissue is moistened with lens cleaner and gently rubbed over the soil. Dry cloth or tissue wipes the surface dry and clean. It is important to remove the soil from the outer edge of the lens next to the mount.

Well-laundered cotton cloth, such as old sheet material or handkerchiefs, makes a good lens cleaning cloth. Lens tissue should be torn and rolled up, and the frayed rolled edge used as the cleaning surface.

Inner surfaces usually never require cleaning. If cleaning the outer surfaces is not enough, it is best to take the lens to a professional camera repairman.

Autofocus Enlargers

Nearly all enlargers require that the user perform two steps to achieve image size and sharpness. The enlarger head is moved up and down (or sideways with a horizontal enlarger) to achieve the image size, and then the lens is moved in relation to the negative to achieve a sharp focus. For normal work this is a satisfactory arrangement.

For production work, however, time can be saved by having the lens automatically focus at the same time that the image size is changed. This feature, automatic focusing, is achieved using a cam and levers to move the lens into the right position for a sharp focus at any magnification.

Most autofocus enlargers are equipped with a single lens and cam system. This limits the range of magnifications that can be achieved. One, at least, is equipped with an autofocus mechanism that matches three focal length lenses.

PRINTMAKING PROCEDURES

Basic Steps

The basic steps in making a straight enlargement are:

1. Evaluating the negative
2. Selecting the paper
3. Cleaning the negative
4. Placing the negative in the enlarger
5. Setting the easel
6. Focusing the image
7. Sizing the image
8. Making a test strip
9. Making a test print
10. Dry-down
11. Exposing the good print
12. Processing the print

1. Evaluating the Negative: The negative size needs to be checked in order to choose the correct negative carrier. Ordinarily, the carrier for that particular size is used, but if the negative is to be cropped, a smaller size may be better. It is important that the area to be printed is masked. Clear areas tend to produce glare that reduces print contrast and sharpness.

An illuminator is useful in judging the negative quality. Exposure is gauged by the amount of shadow detail. Negative contrast is judged on the basis of density ranges and serves as the basis for selecting paper contrast. The following table suggests the categories of negative contrast.

Negative Contrast Table

| Negative Contrast | Density Range | | Paper Grade |
	Condenser Enlarger	Diffusion Enlarger	
Extremely low	0.48 and less	0.64 and less	5
Very low	0.49—0.59	0.65—0.79	4
Low	0.60—0.70	0.80—0.94	3
Medium	0.71—0.85	0.95—1.14	2
High	0.86—1.05	1.15—1.40	1
Very high	1.06 and more	1.40 and more	0*

*Not available in enlarging papers. Can be achieved with selective-contrast papers and two PC1 filters.

These figures are suggestions. The actual paper grade choice will be affected by individual enlargers, method of processing, the particular paper used, and individual taste. Experience in evaluating negatives with a particular set of conditions will improve the percentage of correct first judgments.

A magnifying glass is useful to check the negative for sharpness. Unsharpness is primarily caused by subject movement, camera movement, poor focus, and inadequate depth of field. Often the choice between two similar negatives can be made on the basis of sharpness. The power of the magnifier used should be from about 5× for large negatives to about 10× for small negatives. Viewing with a magnifier may also uncover some defect such as a dust speck or scratch.

2. Selecting the Paper: In previous sections the physical structure of photographic papers, image-tone characteristics, paper stock, and paper surface characteristics are covered. In the section entitled "Choosing a Paper" (page 24), the suitability of various papers for various applications is discussed. In the negative evaluation section just preceding, some information on the matching of paper contrast to negative contrast or density range and the effect of the enlarger illumination on contrast was presented. Paper size is usually dictated by the use for which the print is being made, or by the needs of the photographer or the customer.

The method of processing is also a factor in paper choice. If activation processing in a KODAK ROYALPRINT Processor, Model 417, is to be used, the paper has to be a resin-coated, developer-incorporated paper. If a stabilization processor, such as the KODAK EKTAMATIC Processor, Model 214-K, is being used, the paper chosen will be a fiber-base, developer-incorporated paper. If a continuous processor is to be used, the paper has to be one available in roll form. If tray processing is the method, the choice is

Evaluating negative quality.

49

wide. Any of the papers in sheet form can be tray-processed, although they may have been made to be processed in some other particular type of processor.

3. Cleaning the Negative:

If negatives are stored and handled properly, they rarely need cleaning beyond dusting off with a clean soft-bristled brush to remove the dust. A flat camel's-hair brush is recommended. Flipping the bristles several times across a plastic rod such as the barrel of a pen or mechanical pencil can build up a charge of static electricity that will charge the dust so that it is repelled from the film rather than just being moved around. An alternative method is to use oil-free compressed air. In some professional labs such air is available for burst agitation, and the air can be piped to the enlarger portion. Small cans of air are available for the occasional worker.

If there is greasy dirt or fingerprints on the negative, it can be cleaned with a liquid cleaner such as KODAK Film Cleaner. Care must be taken not to scratch the negative. If this is not sufficient, the negative can be soaked in a dilute solution of sodium carbonate for 10 or 15 minutes, and then washed and dried. The negative surface can be swabbed with a tuft of cotton while in the carbonate solution.

After placing the negative in the negative carrier the dust should be removed with a camel's-hair brush or compressed air. Some workers prefer to blow off the dust on the negative while it is in the enlarger and the enlarger lamp is on.

4. Placing the Negative in the Enlarger:

Enlargers have a variety of negative carriers. One purpose of the carrier is to get the negative flat and perpendicular to the lens axis, centered in the enlarger illumination. The other purpose is to mask off all light outside the area to be printed. This means that the negative should be placed in the carrier so that no clear edge is visible. If the negative is to be cropped considerably, a carrier with a smaller aperture can be used, or strips of thin black paper can be used to block out the negative around the area to be printed.

Some carriers, especially those for large-size negatives, have glass in them to hold the negatives flat. The glass adds four surfaces as possible dust collectors. They must be kept spotlessly cleaned, and dusted off with the camel's-hair brush each time a negative is to be placed in them. Glass negative carriers also have a tendency to form Newton's rings (especially with negatives that have a curl). Newton's rings are interference patterns similar to those seen in soap bubbles, and are caused by a thin layer of air trapped between the negative and the glass. Newton's rings may show up as wavy concentric circles or lines in the print.

The emulsion on a negative absorbs moisture from the air. When it is placed in a hot beam of light in an enlarger, the moisture is driven off. This changes the relative tensions on the two sides of the negative and can cause a physical change in position of the negative in the carrier. This is called negative popping, previously mentioned in the section on negative carriers. If a print is being made when a negative pops, two images are likely to show in the print. A negative is most likely to pop when the sizing and focusing time is short, and when exposure times are moderately long.

The negatives most likely to pop are 2¼-inch (6 cm) roll film negatives, all film pack negatives, and larger sheet films. This is a problem that occurs only with glassless negative carriers; it does not usually occur with cold light sources.

If popping becomes a problem, the preheating method can be used. Prior to exposing the paper, the negative should be exposed to the heat of the enlarger light for about 20 seconds. This will cause the negative to pop. The enlarger must then be refocused and the lens stopped down far enough so that all portions of the popped negative are in focus. The enlarger light is then turned off. The paper is quickly placed in the easel and exposed before the negative cools.

Using another technique, the negatives to be mounted are placed in a dehydrator to lower the moisture level of the film. A dehydrator can be made of a large jar with a tight lid into which dried silica gel has been placed. Another method is to place the negatives in a warming situation, where the temperature is about 110°F (43°C). Such a warmer can be made of wood, using a light bulb as a source of heat. The box should have vents both top and bottom to allow a flow of air. The better the separation between the negatives, the faster the negatives will be

preconditioned for the enlarger. If high humidity is a constant problem in the darkroom, a dehumidifier or an air-conditioner will reduce the humidity.

5. Setting the Easel: The easel serves three main purposes. It holds the paper flat on the enlarger base so that it is parallel to the negative. It also generally provides white borders to prints. It also provides a surface for sizing and focusing the image.

Some easels have fixed borders and standard-size openings for the standard-size papers such as 8 x 10 inches (20.3 x 25.4 cm), 14 x 17 inches (35.6 x 43 cm), and 16 x 20 inches (40.6 x 50.8 cm). The border size is usually fixed at ¼ inch.

Other easels have an adjustable border width and an adjustable opening size so that any size paper, from some minimum up to some maximum, can be accommodated.

Adjustable easels permit changing both paper size and the size of the print margins.

A few easels are borderless—they usually have a sticky substance for holding the paper. Vacuum can also be used.

The proper fixed-size easel is selected, or the border and opening sizes are set on the easel in the light. The easel is placed on the baseboard of the enlarger under the lens. Lights are turned off. The enlarger light is turned on for sizing and focusing.

6 and 7. Focusing and Sizing the Image: When the enlarger is on, the enlarging lens forms an image of the negative on the easel. At first, the image may be the wrong size and out of focus. Adjusting the height of the enlarger head changes the image size. Having the enlarger head farther away from the easel makes the image larger. Rotating the focusing

knob changes the lens-to-negative distance so that a sharp image can be obtained. Every time the image size is changed, the lens has to be refocused, unless the enlarger is the autofocus type.

The enlarger lens is usually opened to full aperture for focusing. This provides a brighter image and makes the focusing more critical by reducing the depth of field. When the sharpness is critical, a "grain magnifier" or "grain focuser" can be used to check the focus. This is a microscope with a mirror mounted on it so that the focus of the microscope is equivalent to the focus on the easel. To improve the accuracy, a piece of photo paper the same thickness as the paper being printed should be placed on the easel. Other mirror-type focusing aids can be used that provide simple magnification. Because of possible focus shift, the image sharpness should be checked after stopping down to the f-number to be used in making the enlargement.

A common error that is easy to make is to confuse the image of the edge of the negative carrier frame with the enlarger margin mask. It is wise to check to see that a slight amount of negative image falls on the top surface of the mask on all four sides. This does not apply to borderless easels, but with these it is important to be sure the projected image covers the entire easel area.

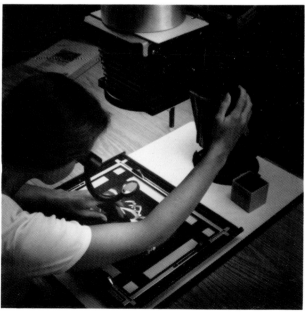

The image is usually sized and focused with the enlarging lens wide open. The lens is then stopped down one or two stops for the exposure to improve print sharpness.

If small enlargements are being made, such as with a magnification of 1.0 (same size as negative), the enlarger may focus to this position, but the enlarger head may not come close enough to the easel. In this case, the easel can be raised by placing spac-

Various types of enlarger focusing aids are available to aid in focusing the image on the easel.

The KODAK POLYCONTRAST Filter Kit contains a filter holder, seven POLYCONTRAST Filters, and a copy of the KODAK POLYCONTRAST Filter Computer.

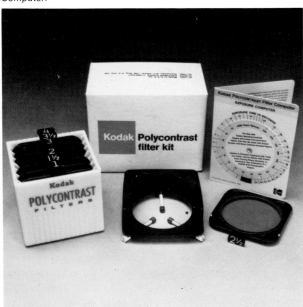

The KODAK Projection Print Scale provides a simple means of determining the proper exposure.

An opaque card can be used to give different sections of a test strip different exposure times.

ing blocks or boxes under it. If the lens will not focus close enough, a shorter focal length lens can be substituted. When the lens gets farther from the negative, it covers a larger negative area. If the enlarger is at the top, and the image is not big enough, a shorter focal length lens can be substituted if it will cover the required negative area. If a shorter lens is not available or will not cover the negative area required, a longer "throw" of the image is necessary. Some enlargers can be rotated 90° and the image projected on the easel placed horizontally, perhaps on a wall.

The Projection Print Scale contains ten pie-shaped sections each marked with an exposure time. Each section gives the paper a different exposure.

Jack Herman, Jr.

The best exposed section on the test print is selected, and the final print is given that exposure time.

Where long throws are a frequent occurrence, a special arrangement can be built. The enlarger is removed from its base and mounted solidly at the back of the bench. The bench top is cut out, and a series of guides built into the bench. A board is cut so that it can be slid into the guides at various levels, including level with the bench top. Thus, if a longer throw is needed, the board is placed in the appropriate sets and the easel placed on the board.

8. Making a Test Strip: There are a number of ways to determine the exposure to give a print. Experienced workers get so skilled that they can estimate the time very closely by judging the negative density and the degree of enlargement. A later section covers the use of enlarging meters (easel photometers) to measure the brightness of portions of the image on the easel and to calculate the exposure from the readings. Many workers rely on making test strips.

Some of the enlarging paper is cut into strips under safelight illumination. A strip is placed, emulsion up, on the easel in an area of the image that has a typical range of brightness resulting from negative densities. A black piece of cardboard is used to give a series of exposures to the strip of paper. A geometric series of exposure times covers a long exposure range time with relatively few steps on the test strip. One way is to have the strip uncovered to start. After 1 second, cover $1/5$ of the area. After 2 seconds total time, cover another $1/5$ of the

area. After 4 seconds total time, cover another $1/5$ of the area. After 8 seconds total time, cover another $1/5$ of the area. And after 16 seconds total time, turn off the enlarger light. This gives a strip with 1-, 2-, 4-, 8-, and 16-second exposures in the steps.

If the print is a big enlargement, and the paper is relatively slow, multiply each of the times in this series by 4, so that the series becomes 4, 8, 16, 32, and 64. If the paper is fast, and the degree of enlargement small, stop the lens down to a small aperture such as f/16; the 1, 2, 4, 8, and 16 record series is then appropriate. The test strip is then developed, stopped, and fixed for a couple of minutes and then looked at in white light.*

One step of the test strip should have about the right densities. The number of seconds of that step should be the exposure for the print. If one step appears a little too light and the next one a little too dark, give an exposure halfway between. If all of the steps are too light, open up the lens or give a series of longer times. If all of the steps are too dark, stop the lens down for the next test strip or give a series of shorter times.

The KODAK Projection Print Scale provides a convenient method of making test strips. The paper is cut into 4 x 5-inch pieces, and the print scale is placed emulsion side down on the paper and held flat. The entire area is given a 1-minute exposure. When processed, the test scale shows a series of

*Details of these steps are covered in the section "Print Processing."

pie-shaped steps of different densities, each marked with a number representing a number of seconds. The step that appears to have the correct density is selected; the number on that step is the number of seconds to use to make the test print.

9. Making a Test Print: The test strip provides a first approximation of the correct time for an enlargement. Since it is just a sample of the entire negative area, however, the time may not be exactly right because other negative areas may be too light or too dark when given that exposure time.

The first print of the entire negative, therefore, should be thought of as a test print. With luck, and experience, it can be the final print.

A sheet of paper is placed in the easel and exposed for the time determined by the test strip. This print is next processed and then examined in white light. If the densities appear correct overall, the print can be completely fixed, washed, and dried. If it is slightly too light overall, another print is made with a little more exposure. If too dark, another print is made with less exposure.

At the same time print density is evaluated, the print contrast should be checked. If the highlights are white and lacking in detail and the shadows are solid black, the paper may be too contrasty. A new test should probably be made with a lower contrast paper, or with a lower value PC filter. If, however, the midtone contrast is good, the same paper can be used, and the detail added to the highlights by burning in, and to the shadows by holding back (see the later section entitled "Exposure Controls").

If on the other hand, both the shadows and highlights are full of detail but there is no white or black in the print, a new print should be made with either a higher grade of paper or a higher numbered PC filter.

The paper with different contrast is more than likely to have a different paper speed, so a new test strip will probably be required.

10. Dry-down: In general, a print looks somewhat lighter when it is wet and the density is being evaluated while still in process, than it will when dry. Drying seems to darken the print a little. A darkroom worker will have to gain experience in judging the degree of change, and to compensate for it in making enlargements. If a wet print being judged for density looks just right, it will likely be a little too dark when dry.

The amount of dry-down is affected by the degree of gloss of the paper. Glossy prints appear to change less than do prints made on a lustre, semi-matt, or matte paper. Some workers feel that prints made on resin-coated papers dry-down less than do prints made on fiber-base papers.

Dry down. A print usually dries slightly darker (right) than it looks in the fixer or wash tray (left).

The choice of the final overall density of a dry print depends somewhat on its use. Prints to be viewed under high illumination levels should be slightly darker than average. An average-density print will look too light if viewed under very bright illumination.

On the other hand, if a print made for such high-level illumination is viewed under low-level conditions, such as exists in a home at night—illumination by the light from a few table lamps—it will appear too dark.

Such factors affect how light or dark the print should be, and this is determined primarily by the exposure in the enlarger, and evaluated in the wet-print stage. A further discussion of print quality is given in a later section entitled "Print Quality."

11. Exposing the Good Print: The test print may show a number of tonal deficiencies. Making a good print involves correcting these. Several later sections that cover print controls during enlarging provide helpful information in achieving quality enlargements. Also, in order to make the desired good print, special printing techniques may be used. These are covered in a later section by that name.

12. Processing the Print: A number of sections immediately following give the details of print processing, the solutions used, and special processing procedures.

Print Processing

The instructions given in the following section are of a general nature and apply to practically all photographic papers. Specific details for processing each type of paper are summarized on Data Sheet 20.

Selecting a Developer

There are basically two types of paper developers. One type produces colder image tones, the other warmer image tones.

KODAK DEKTOL Developer is the cold-tone developer recommended for most papers. It is generally used to develop papers whose image tone is listed as blue-black or neutral. It is available as a powder that is dissolved in water to make the stock solution, and is usually diluted 1:2* for use. KODAK Developer D-72 is made from a formula, and is similar in characteristics to KODAK DEKTOL Developer. D-72 has slightly less capacity than DEKTOL Developer.

KODAK EKTAFLO Developer, Type 1, is similar in characteristics to the other two cold-tone developers, but it comes in a very concentrated liquid form in a flexible container. It is usually placed on a shelf above the sink with flexible plastic tubing running down that has a crimping clamp on it. A graduate is placed under the tubing, the clamp released, and the concentrate flows into the graduate. EKTAFLO Developer is diluted 1:9 with water for use.

KODAK VERSATOL Developer is a cold-tone developer that can be used for both papers and films and

*A dilution of 1:2 means 1 part of developer and 2 parts of water.

Kodak darkroom chemicals are packaged in a variety of forms. Dry chemicals are packaged in a moisture-proof envelope. The layers of foil, plastic, and paper keep the chemicals fresh until use.

is available in small quantities for occasional darkroom work.

There are several developers designed to produce warm tones on papers with warm-black and brown-black image tones. KODAK SELECTOL Developer is a widely used one for such purposes. KODAK SELECTOL-SOFT Developer is similar, but develops prints to a lower contrast than does SELECTOL Developer. Both are supplied as powders that are dissolved in water to make stock solutions. The stock solution for both of these developers is usually diluted 1:1 with water to make a working solution.

KODAK EKTAFLO Developer, Type 2, is a warm image-tone developer that comes as a liquid concentrate in a flexible container, and is diluted 1:9 with water for use.

KODAK EKTONOL Developer is a warm image-tone developer especially recommended for prints that are to be toned, although prints developed in any of the developers can be toned with the right toner/paper combination. EKTONOL Developer is supplied in powder form.

Useful Capacities of KODAK Paper Developers

KODAK Developer	Dilution	Useful Capacity— No. of 8 x 10-inch Prints Per Gallon
DEKTOL	1:2	120
SELECTOL	1:1	80
EKTONOL	1:1	80
SELECTOL-SOFT	1:1	80
EKTAFLO, Type 1	1:9	120
EKTAFLO, Type 2	1:9	100
D-52*	1:1	80
D-72*	1:2	100

*Mixed from formulas.

Calculating Print Areas: If prints in sizes other than 8 x 10 inches* are being made, the number of prints that can be put through a solution with a known capacity has to be calculated. Some print sizes are easy to figure—the area of four 4 x 5-inch prints equals the area of one 8 x 10-inch print. Four times as many 4 x 5-inch prints can be put through a solution as 8 x 10-inch prints. A 16 x 20-inch print has four times the area of an 8 x 10-inch print—only one-fourth as many 16 x 20-inch prints can be put through a solution as 8 x 10-inch prints.

However, if the prints are odd-sized, the calculation is not as easy.

There are 80 square inches in an 8 x 10-inch print. The area of other size prints is found by multiplying

*The metric equivalents of the print sizes used in this section are:
2½ x 3½ inches (6.35 x 8.9 cm) 11 x 14 inches (28 x 35.6 cm)
4 x 5 inches (10.2 x 12.7 cm) 16 x 20 inches (40.6 x 50.8 cm)
8 x 10 inches (20.3 x 25.4 cm)

the length of the print by its width. For example, a 2½ x 3½-inch print has an area of 2½ × 3½ = 8¾ square inches. An 11 x 14-inch print has an area of 11 × 14 = 154 square inches.

To find how many prints of that size can be put through a solution, divide 80 square inches by the area of the different-size print and multiply by the capacity of the solution given in 8 x 10-inch-size prints. If the capacity of a gallon of solution is two hundred 8 x 10-inch prints, the capacity of the two print sizes given above is found in the following way.

Print Size	8x10-inch Area		New Print Size Area	Capacity in 8x10-inch Prints	Capacity in New Print Size
2½ x 3½	80	÷	8¾	= 9.14 x 200 =	1830 prints
11 x 14	80	÷	154	= .52 x 200 =	104 prints

If you know the capacity in quarts, multiply that figure by 1.057 to find the capacity in litres. If you know it in litres, multiply by 0.946 to find the capacity in quarts.

Other Processing Solutions for Tray Processing

Stop Baths: When print development is finished, the print is placed in a stop bath to stop development uniformly. The stop bath acidifies the print, preventing carry-over of alkaline developer into the fixer, thus increasing the life of the fixer.

A convenient stop bath to use is KODAK Indicator Stop Bath. It contains a yellow coloring agent that keeps the stop bath yellow in color as long as it is satisfactory for use. When it becomes exhausted, the coloring agent changes to a deep purple color. Under safelight illumination, the stop bath looks clear at the start, but changes to a very dark tone when it should be replaced. This product is furnished as a liquid and is diluted for use.

A simpler stop bath can be made using the KODAK Stop Bath SB-1 formula—48 mL of KODAK 28% Acetic Acid is added to 1 litre of water to make SB-1. Since there is no indicator to tell when this stop bath is exhausted, care should be taken to avoid overuse. Its capacity is seventy-five 8 x 10-inch (20.3 x 25.4 cm) sheets per gallon or twenty sheets per litre.

KODAK EKTAFLO Stop Bath is a concentrated indicator stop bath supplied in a flexible container. It is diluted with water for use. KODAK Universal Stop Bath with indicator is available in a small size for occasional use.

Fixers: There are a number of fixers available both in packaged form and of the formula type.

KODAK Rapid Fixer is an ammonium thiosulfate fixer with acid and hardener. Mixed as instructed for papers, it fixes in a shorter time than sodium thiosulfate fixers.

KODAFIX Solution is a liquid that is diluted to make small quantities of fixer for occasional users.

KODAK EKTAFLO Fixer is a liquid that is supplied in a flexible container and is diluted 1:7 with water for use. It is one of the series of paper processing solutions, two of which have been mentioned earlier.

KODAK Fixer is supplied in powder form in a number of sizes from the 1-quart size to a 25-gallon size. It is suitable for both film and paper fixing.

KODAK Photo-Fix is supplied in a packet to make 7 quarts of fixer.

The standard hardening fixer formula solution is mixed using KODAK Fixing Bath F-5. KODAK Rapid Fixing Bath F-7 is a formula-type ammonium thiosulfate* fixer. KODAK Fixing Bath F-24 is a non-hardening fixer. Some users prefer this bath for prints that are to be toned. Most fixers have a capacity of one hundred 8 x 10-inch (20.3 x 25.4 cm) prints per gallon of fixer (twenty-six per litre) when used as a single fixing bath. Capacity is increased when using a two-bath fixing procedure. (See page 60.)

Processing Technique

Tray Layout for Print Processing: Darkrooms are conventionally laid out with a dry section and a wet section. The dry section is where the enlarger is located and the prints are exposed. The wet section is where the print processing takes place.

A useful tray processing setup is to have all the required trays resting on duckboards in the bottom of a large sink. There should still be an area in the sink where water can be obtained and hands

A good method of putting the print into the developer is to place it face-down on the developer surface and submerge it immediately.

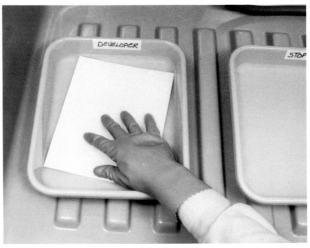

*F-7 is mixed with sodium thiosulfate, but the addition of ammonium chloride creates the ammonium thiosulfate in solution.

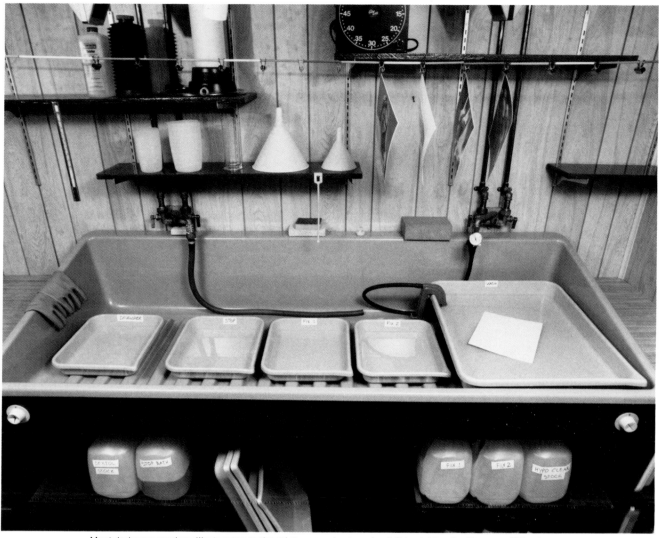

Most darkroom workers like to arrange the print processing trays in a left-to-right order. However, if the dry area is to the right, a right-to-left arrangement may be more convenient.

The print is turned over, and the print is agitated during development by rocking the tray.

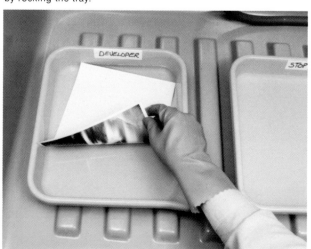

The developer is allowed to drain for 5 seconds or so (longer with larger prints) before placing it in the stop bath.

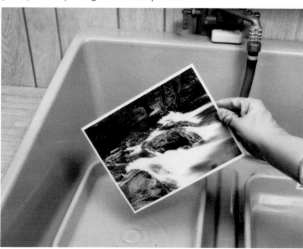

washed without splashing into any of the trays.

Most workers sequence the trays in the following way, starting either from the left or the right. The developer is usually at the end closer to the enlarger.

1. Developer

2. Stop bath

3. Fixer—2 trays (Some workers place the fixer trays next to the wash to avoid possible contamination of the developer.)

4. Water rinse

5. Hypo clearing agent solution

6. Wash or water-holding tray

This involves seven trays or six trays and a print washer. Even with 8 x 10-inch (20.3 x 25.4 cm) trays, this requires more space than is usually available in the darkroom sink. There are several alternative approaches.

If there is room for only three trays in the sink, the developer, stop bath and fixer should be placed there. If two fixers are used, the second fixer can be put in a tray placed on a "wet" bench near the sink. A holding tray of water should be placed next to the second fixer tray (for fiber-base papers). If single-tray fixing is being done, only the holding tray of water is placed on the "wet" bench. When a number of prints has accumulated in the holding tray, the three trays are removed from the sink, the holding tray is put in the sink and the prints are rinsed in running water for a couple of minutes, leafing the prints for good agitation. The KODAK Hypo Clearing Agent solution is placed in a tray in the sink, and the prints are placed in the solution. The prints are leafed for agitation, and are treated for 2 minutes if they are double-weight paper. (Not recommended

for RC papers.)

These trays are removed from the sink, and the prints are placed in a larger tray in the sink for washing.

When in the sink, trays must be far enough apart so that they can be rocked and so that splashes from one will not contaminate the solution in another.

The Technique of Tray Development: The developer chemically converts the invisible latent image in the paper emulsion that has been formed by the enlarger exposure into a visible image formed of black metallic silver. The time of development is important to achieve a consistent print quality.

The best quality prints are usually made when the exposure time is such that the print reaches the correct density in the recommended time. If the print is overexposed and the developing time is shortened (the print is "pulled"), the contrast is likely to be low, the highlights muddy, and the blacks will be dark gray. If the print is underexposed and the developing time is increased to try to get adequate density, stains may result. A correct balance between exposure and development is important for best quality.

When developing one print at a time, the print can be placed in the developer with the emulsion side up or down. If the emulsion is up, one edge is slid under the surface of the developer with the rest of the print following. To accomplish this, there must be a reasonable depth of developer in the tray, at least half an inch.

If placed in the tray emulsion down, the print is laid on the surface of the developer and immediately submerged with the flats of the hands. It is rocked in the developer for a few seconds, and then turned emulsion side up so that the developing image can be viewed.

The stop bath stops the action of the developer, and makes the fixer last longer.

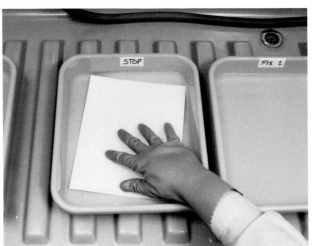

Proper fixing is important for print image stability. If there are several prints in the fixing bath, they must be agitated repeatedly by leafing.

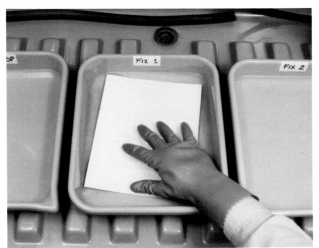

58

Continual rocking of the tray keeps the developer moving across the surface of the print, providing continuous agitation for even development.

The timer is watched so that the rate of development can be judged. If the image comes up to density too fast or too slow, the print should be raised and discarded and a new one made with a corrected exposure.

When the development has brought the density to the right level, allowing for dry-down, which should be in about the recommended time, the print should be slid into the stop bath for from 5 to 10 seconds, and placed in the fixer.

Developing Several Prints at Once: Many darkroom workers become more time-efficient by developing several prints at one time. When all the prints are in the developer, the bottom print is slid from the stack and placed on the top. This "leafing" of the prints is continued throughout development and provides the agitation.

Kodak resin-coated papers are coated on the back so that they can slide easily over each other during the leafing. However, the corners of the prints are sharp, and care must be taken not to scratch the surface of the prints as they are leafed. Leafing is also required in the stop bath and the fixer.

The uncoated paper surface of the base on fiber-base papers provides adequate slippage over the emulsion of an adjacent print for satisfactory leafing.

Solution Temperatures: The temperature is not as critical for developing prints as it is with films. "Room temperature" is usually acceptable, as long as the temperature stays between 65 and 80°F (18 and 27°C). The developing time can be lengthened a little when the developer is below 68°F (20°C) and shortened a little when the temperature is above 72°F (22°C). The relative activity of various ingredients changes at cold temperatures and can change the contrast of the developing images. The gelatin in the emulsions of fiber-base papers may become softened in developer that is too warm, and is then easily susceptible to damage. Emulsions of resin-coated papers can stand higher temperatures than those of fiber-base papers.

Stop Bath Technique: As development is finished, the prints should be held up above the developer with a corner down and allowed to drain for about 5 seconds to minimize carry-over of developer into the stop bath. They are placed in the stop bath, either emulsion up or down, and submerged. They should be constantly agitated for 5 to 10 seconds.

Most paper developers contain sodium carbonate as an activator. This often reacts with the acetic acid in the stop bath and causes carbon dioxide to bubble up through the stop bath. The bubble formation may cause a soft sizzling sound. If the action is violent, the stop bath may be too concentrated. Some "sizzling" is normal, especially when the stop bath is fresh.

The stop bath is drained from a corner of the print for about 5 seconds before the print is slid into the fixing bath.

Fixing Technique: Proper fixing is one of the three main factors leading to print longevity. The thiosulfate in the fixer changes the undeveloped silver-halide crystals in the paper emulsion into soluble silver salts that can be washed out of the emulsion. If left in the emulsion, the silver halide crystals soon turn dark because they are still light sensitive.

The fixing bath must not be allowed to become exhausted because silver complexes are formed that are impossible to wash out of the emulsion and paper fibers of the base. The useful capacity of a single fixing bath is about one hundred 8 x 10-inch (20.3 x 25.4 cm) prints per gallon (26 per litre).

The prints must be agitated or leafed while in the fixer to make sure of thorough fixing. This brings fresh solution to the emulsion surface and moves away the fixer that has become loaded with silver salts.

The prints must be fixed the proper length of time—2 minutes with resin-coated papers—6 to 10 minutes with fiber-base papers. Underfixing may leave some silver halide crystals in the emulsion. Overfixing will saturate the base of fiber-base papers with complexes and make them also impossible to wash out. Overfixing can also cause a slight bleaching of the image.

Using a two-bath fixing method provides two advantages: It increases the capacity of the fixer and

Prints should not be allowed to remain in the fixing bath for longer than the recommended time. After fixing is completed, prints on resin-coated papers should be washed immediately. Prints on fiber-base papers can be placed in a holding tray of clean water.

provides final fixing in a fixing bath low in silver salts.

Two fixing baths are prepared. Fiber-base prints are fixed for 3 to 5 minutes in each bath. After fifty prints per quart [two hundred 8 x 10-inch (20.3 x 25.4 cm) prints per gallon, fifty-two prints per litre] have been fixed, the first bath is discarded. The second bath is moved up to become the first bath. A new second bath is prepared. An additional fifty prints per quart are put through these baths. After three more such changes, both baths are discarded and the cycle is started again with two fresh baths of fixer. In the complete cycle of five changes, two hundred and fifty prints are processed in 6 quarts of fixer, for an average of forty-two 8 x 10-inch (20.3 x 25.4 cm) prints per quart, compared to twenty-five per quart if the single bath method is used. This increases the effective capacity by 68 percent.

The time for fixing prints made on resin-coated papers is 2 minutes in a single fixing bath, or 1 minute in each bath of a two-bath arrangement.

Silver Recovery: A system of silver recovery can be used in situations where there is a sufficient volume of photographic processing. Silver is recovered from the fixing bath in black-and-white processing after the fixer has been used to the recommended limit. Recovery probably does not pay for the occasional printer, but should be investigated by anyone doing regular processing. Silver can also be recovered from scrap photographic materials. One reason to recover silver from processing solutions is monetary; recovering silver can be profitable. Another reason is environmental. Some government agencies (local, state, or federal) limit the amount of silver that can be discharged in effluents. Additionally, silver is a finite resource. By recovering the silver from processing solutions and scrap photographic materials the silver can be reused. For more information on silver recovery see KODAK Publication No. J-10, *Recovering Silver from Photographic Materials.*

Washing Aid Technique: Use of a washing aid such as KODAK Hypo Clearing Agent reduces the wash time and permits better washing of the fixer out of the prints. It also permits washing in colder water. It is recommended only for fiber-base papers. **Its use is not recommended for resin-coated papers.** Use of KODAK Hypo Clearing Agent is unnecessary and lengthens the processing time, thus defeating the advantages of the RC base.

Fiber-base prints can be placed in the Hypo Clearing Agent bath directly from the fixer. However, this reduces the capacity of the bath. A 30-second rinse between the fixer and the clearing agent bath increases the capacity of the bath.

Single-weight prints should be treated for 2 minutes in the clearing agent bath, while double-weight prints should be treated for 3 minutes. Prints should be agitated in the clearing bath to be sure that the solution is kept working on both sides of each print.

When prints are rinsed before going into the Hypo Clearing Agent, its capacity is fifty 8 x 10-inch (20.3 x 25.4 cm) prints per quart (fifty-two prints per litre, two hundred prints per gallon) or equivalent area in prints of other sizes. However, if prints go into the clearing agent bath directly from the fixer without a rinse, the capacity is reduced to twenty 8 x 10-inch (20.3 x 25.4 cm) prints per quart (twenty-one prints per litre, eighty prints per gallon) or equivalent area.

Technique of Washing

As prints are taken from the fixer, they are saturated with sodium or ammonium thiosulfate and the silver complexes that have resulted from the action of the thiosulfate on the silver halide crystals. If the print is on a fiber-base paper, both the base and the emulsion are saturated with the chemicals. If the print is on a resin-coated paper, only the emulsion and the very edges of the paper base contain the chemicals.

If these chemicals are allowed to stay in the print, they will gradually fade the black metallic silver image. First a yellow-colored silver sulfide stain will form (most apparent in the light areas). In further time the silver sulfide is oxidized to become colorless silver sulfate,* making the image invisible. These reactions are more likely to occur in the presence of high temperature and high humidity. Thus, it is imperative to wash prints thoroughly to remove the thiosulfate and silver complexes.

Papers that contain fluorescent brighteners should not be subjected to excessive "wet" time. Brighteners may leach out of the paper while soaking in a solution or water over a long period of time. Most Kodak resin-coated papers have fluorescent brighteners incorporated in the paper base and should be washed and dried without a long delay. Fiber-base papers that contain brighteners can be treated in KODAK Hypo Clearing Agent to shorten washing times.

Print Washers: Most print washing is accomplished in running water. Properly done, the force of the running water or some other method is used to agitate the prints and keep them separate. The KODAK Automatic Tray Siphon converts a large-size tray into an effective print washer.

Some print washers tumble the prints in a rotating bin so that each print is agitated separately. Other washers agitate the prints with water flow; they are kept separate with perforated plastic sheets, with only one print in each compartment.

*A silver-sulfide image, as in a toned print, is more permanent than a silver image if the hypo and silver complexes have been removed.

Data Sheets for KODAK Black-and-White Papers

These Data Sheets contain technical information about Kodak black-and-white papers commonly used in both amateur and professional photography, as well as details of the surfaces, contrast grades, and base weights available in each kind of paper. A summary of these characteristics is given on page DS-2.

An outline of processing instructions is provided on page DS-20; these instructions apply to the papers listed on the following page with the exception of KODAK EKTAMATIC SC Paper. Processing instructions for this paper appear in the Data Sheet and in the instruction sheet that accompanies the paper.

The speeds and contrast shown on the following Data Sheets were obtained by using the ANSI procedures and the ANSI specified developer, which is very similar to KODAK DEKTOL Developer. It has been determined that DEKTOL Developer used in a tray process with continuous agitation gives the same speeds in practice as the ANSI formula. The use of other developers may cause slight differences in speeds and contrasts. When the paper speeds are determined for a process other than the tray process, as for KODAK EKTAMATIC SC Paper processed in a KODAK EKTAMATIC Processor, Model 214-K, the speeds are given simply as paper speeds—they are not ANSI speeds. Note that the ANSI paper speeds bear no direct relationship to ASA film speeds; they are derived by different methods.

The data provided in this section represent current product that has been stored, exposed, and processed according to the recommendations given in these Data Sheets and in the text. They are averages of a number of production ratings, and do not necessarily apply exactly to each package of product because of manufacturing variations, the effects of storage conditions, and different usage conditions. The data do not represent standards or specifications which must be met by Eastman Kodak Company. The Company reserves the right to change and improve product characteristics at any time.

Surfaces and Contrast Grades of KODAK Photographic Papers

Key:

Stock Tints		Weights	
WM-WH	Warm-White	SW	Single Weight
CR	Cream-White	DW	Double Weight
WH	White	LW	Lightweight
		MW	Medium Weight

Texture	Smooth	Smooth	Smooth	Smooth	Fine-Grained	Fine-Grained	Tweed	Tapestry
Brilliance	Glossy	Lustre	High Lustre	Semi-Matt	Lustre	High Lustre	Lustre	Lustre
KODAK Black-and-White Papers								
AD-TYPE		A WH LW 2,3						
AZO	F WH SW 1-5 DW 2				E WH SW 2-3 DW 2			
EKTALURE					G CR DW	K WM-WH DW	R CR DW	X CR DW
EKTAMATIC SC	F WH SW, DW	A WH LW		N WH SW				
KODABROME II RC	F WH MW S-UH			N WH MW S-UH	E WH MW LUSTRE-LUXE®			
KODABROMIDE	F WH SW 1-5 DW 1-5				E WH SW 2-4 DW 2-4			
MEDALIST	F WH SW 1-4 DW 2,3				G CR DW 2,3			
Mural							R, WRM CR SW 2,3	
PANALURE	F WH SW							
PANALURE PORTRAIT					E WH DW			
PANALURE II RC	F WH MW							
POLYCONTRAST	F WH SW, DW	A WH LW	J WH SW, DW	N WH SW, DW	G CR DW			
POLYCONTRAST Rapid	F WH SW, DW			N WH SW	G CR DW			
POLYCONTRAST Rapid II RC	F WH MW			N WH MW	E LUSTRE-LUXE			
Portrait Proof							R CR SW	
PREMIER II RC	F WH MW				E WH MW			
RESISTO				N WH, SW 2,3				
Studio Proof	F WH SW							
VELOX	F WH SW 1-4							
VELOX UNICONTRAST	F WH SW							

KODAK AZO Paper and AD-TYPE Paper

Applications
- Contact printing for commercial and professional photography
- AD-TYPE Paper is for use in booklets, inserts, or reports where folding is required

Characteristics
- Fiber base
- Neutral-black image tone
- AD-TYPE Paper is on a lightweight paper base that folds without cracking
- Surface and contrast characteristics are listed in the following table:

Symbol	Brilliance	Texture	Tint	Weight	Grades
F	Glossy	Smooth	White	SW, DW	SW 1-5 DW 2
E	Lustre	Fine-Grained	White	SW, DW	SW 2,3 DW 2
A*	Lustre	Smooth	White	LW	2,3

*AD-TYPE Paper is available in A surface only. AZO Paper is available in F and E surfaces only.

Safelight
- KODAK Safelight Filter OC (light amber)

Paper Speed

Contrast Number	1	2	3	4	5
ANSI Paper Speed	8	4	3	2.5	2

NOTE: Figures are for Azo Paper only.

Development
- Tray-processing recommendations for 68°F (20°C) are listed below:

KODAK Developer	Dilution	Development Time in Minutes		Capacity—8x10-in. (20.3 x 25.4 cm) prints		Purpose
		Recommended	Useful Range	Per U.S. Gal	Per L	
DEKTOL	1:2	1	¾ to 2	120	32	Cold Tones
EKTAFLO, Type 1	1:9	1	¾ to 2	120	32	Cold Tones
D-72	1:2	1	¾ to 2	100	26	Cold Tones
VERSATOL	1:3	1	¾ to 2	80	21	Cold Tones
EKTONOL	1:1	2	1½ to 4	80	21	Warmer Tones
SELECTOL	1:1	2	1½ to 4	80	21	Warmer Tones
EKTAFLO, Type 2	1:9	2	1½ to 4	100	26	Warmer Tones
D-52	1:1	2	1½ to 4	80	21	Warmer Tones
SELECTOL-SOFT	1:1	2	1½ to 4	80	21	Warmer Tones

Toning Recommendations: See page 99.

KODAK VELOX Paper

Applications ■ Contact printing

Characteristics ■ Fiber base
■ Contact speed
■ Blue-black image tone
■ Surface and contrast characteristics are listed below:

Symbol	Brilliance	Texture	Tint	Weight	Grades
F	Glossy	Smooth	White	Single	1-4

Safelight ■ KODAK Safelight Filter OC (light amber)

Paper Speed

Contrast Number	1	2	3	4
ANSI Paper Speed	10	5	4	3

Development ■ Tray-processing recommendations for 68°F (20°C) are listed below:

KODAK Developer	Dilution	Development Time in Minutes		Capacity—8x10-in. (20.3 x 25.4 cm) prints		Purpose
		Recommended	Useful Range	Per U.S. Gal	Per L	
DEKTOL	1:2	1	¾ to 2	120	32	Cold Tones
D-72	1:2	1	¾ to 2	100	26	Cold Tones
EKTAFLO, Type 1	1:9	1	¾ to 2	120	32	Cold Tones
VERSATOL	1:3	1	¾ to 2	80	21	Cold Tones

If you are using KODAK Tri-Chem Packs, dissolve a packet of DEKTOL Developer in 8 ounces of water and develop prints for 1 minute at 68°F (20°C). The developer capacity of a packet is approximately fifty 2½ x 3½-inch prints per 8 ounces of developer solution.

Toning Recommendations: See page 99.

KODAK VELOX UNICONTRAST Paper

Applications ■ Photofinishing

Characteristics ■ Enlarging speed paper, designed for moderate enlargement of small negatives
■ Fiber base
■ One grade for a variety of negative contrasts
■ Available in F surface, white tint, single weight
■ Blue-black image tone
■ ANSI Paper Speed 20

Safelight ■ KODAK Safelight Filter OC (light amber)

Development ■ VELOX UNICONTRAST Paper may be machine-processed or processed conventionally in a tray. Tray-processing recommendations are similar to those for KODAK VELOX Paper.

Toning Recommendations: See page 99.

KODAK PREMIER II RC Paper

Applications
- Primarily for photofinishing applications with machine processing

Characteristics
- Water-resistant paper base allows rapid processing and drying
- Developing agent incorporated in the emulsion
- Fluorescent brightener in paper base for crisp, clean whites
- Blue-black image tone
- Effective paper speed 125. (Tentative data; based on limited testing)
- Surface and weight characteristics are listed below:

Symbol	Brilliance	Texture	Tint	Weight
F*	Glossy	Smooth	White	Medium
E	Lustre	Fine-Grained	White	Medium

*Do not ferrotype. This paper dries to a natural surface gloss without a ferrotyping operation. Drying with warm air may enhance the gloss.

Safelight
- KODAK Safelight Filter OC (light amber), 15-watt bulb, no closer than 4 feet (1.2 metres) to the paper

Development
- For use in KODAK ROYALPRINT Processor, Model 417
- May also be tray-processed. Tray-processing recommendations are similar to those for KODAK VELOX Paper.

Toning Recommendations: See page 99.

KODAK EKTALURE Paper

Applications
- Portrait enlarging and contact printing with reduced illumination
- Makes excellent exhibition prints
- Suitable for continuous printing and machine processing

Characteristics
- Medium-speed projection paper (ANSI Paper Speed 100)
- Brown-black warm image tones
- Fiber base
- Surface and contrast characteristics are as follows:

Symbol	Brilliance	Texture	Tint	Weight	Grade
G	Lustre	Fine-Grained	Cream-White	Double	*
R	Lustre	Tweed	Cream-White	Double	*
X	Lustre	Tapestry	Cream-White	Double	*
K	High Lustre	Fine-Grained	Warm-White	Double	*

*Single contrast, similar to grade 3.

Safelight
- KODAK Safelight Filter OC (light amber)

Development

KODAK Developer	Dilution	Development Time in Minutes		Capacity—8x10-in. (20.3 x 25.4 cm) prints		Purpose
		Recommended	Useful Range	Per U.S. Gal	Per L	
EKTAFLO, Type 2	1:9	2	1½ to 3	100	26	Warm Tones
EKTONOL	1:1	2	1½ to 3	80	21	Warm Tones
SELECTOL	1:1	2	1½ to 3	80	21	Warm Tones
D-52	1:1	2	1½ to 3	80	21	Warm Tones
SELECTOL-SOFT	1:1	2	1½ to 3	80	21	Lower Contrast

Toning Recommendations: See page 99.

KODAK EKTAMATIC SC Paper

Applications
- Black-and-white enlarging for quality deadline work where a stable print is not essential
- Newspaper, medical, military, and proof printing

Characteristics
- A selective-contrast, high-speed enlarging paper
- Designed primarily for exposure with tungsten light
- Contrast can be varied by using KODAK POLYCONTRAST Filters
- For stabilization rapid processing in processors such as the KODAK EKTAMATIC Processor, Model 214-K
- May also be processed conventionally in a tray
- Keeping life of stabilized prints can be made more stable by fixing and washing
- Warm-black image tone with stabilization processing; neutral-black image with tray processing
- Fluorescent brightener incorporated for crisper, cleaner whites
- Surface and weight characteristics are as follows:

Symbol	Brilliance	Texture	Tint	Weight	Grades
F	Glossy	Smooth	White	Single	1-4
F	Glossy	Smooth	White	Double	by
N	Semi-Matt	Smooth	White	Single	filter
A	Lustre	Smooth	White	Light	

Safelight
- KODAK Safelight Filter OC (light amber). Safelight exposure should be kept to a minimum as this paper depends on both blue and yellow exposing light for contrast control

Paper Speed
- KODAK EKTAMATIC SC Paper speed is dependent on the filter and the type of developing. The following figures are based on tungsten exposure and the recommended development time and temperature:

POLYCONTRAST Filter	PC 1	PC 1½	PC 2	PC 2½	PC 3	PC 3½	PC 4	No Filter (white light)
Effective Paper Speed Stab. Process	200	250	320	200	200	125	80	320
ANSI Paper Speed Tray Process	250	320	320	250	250	125	80	400

Development*
- This paper is primarily for stabilization processing in processors such as the KODAK EKTAMATIC Processor, Model 214-K. If the prints are to be kept beyond the initial short-term use, fix them in a normal print fixing bath for 8-12 minutes, wash, and dry in the conventional manner. KODAK EKTAMATIC Paper can also be tray-processed. KODAK DEKTOL Developer or KODAK Developer D-72 is recommended. The useful range of developing times is 45-120 seconds. Rinse, fix, wash, and dry in the normal manner.

*Follow instructions on bottle concerning disposal of activator solution.

Toning Recommendations: See page 99.

KODABROME II RC Paper

Applications
- Black-and-white enlarging for general commercial, industrial, and press use
- Also used in aerial mapping, advertising display, and police and school photography
- Paper grade contrast No. 5 is particularly useful in reproducing line drawing and copy work where a minimum of midtones is desired

Characteristics
- Water-resistant resin-coated support allows rapid processing and drying
- Developer incorporated in the emulsion
- Warm-black image tone
- Fluorescent brightener incorporated for crisper, cleaner whites
- Particularly well suited for processing in the KODAK ROYALPRINT Processor
- May also be tray-processed
- Surface and weight characteristics are as follows:

Symbol	Brilliance	Texture	Tint	Weight	Grades
F*	Glossy	Smooth	White	Medium	1-5
N	Semi-Matt	Smooth	White	Medium	1-5
E	LUSTRE-LUXE®	Fine-Grained	White	Medium	1-5

*Do not ferrotype. This paper dries to a natural surface gloss without a ferrotyping operation. Drying with warm air may enhance the gloss.

Safelight
- KODAK Safelight Filter OC (light amber)
- Do not use KODAK Safelight Filter OA (greenish yellow)

Paper Speed

**KODABROME II RC Paper processed
in a KODAK ROYALPRINT Processor, Model 417**

Contrast Number	1*	2*	3*	4*	5*
Effective Speed	400	400	400	250	250

**KODABROME II RC Paper processed
in KODAK DEKTOL Developer
1:2 for 60 seconds at 68°F (20°C)**

Contrast Number	1*	2*	3*	4*	5*
Effective Speed	630	630	630	320	320

*Contrast grades for KODABROME II RC Paper have been changed from names to numbers.

OLD	NEW
S—Soft	1
M—Medium	2
H—Hard	3
EH—Extra-Hard	4
UH—Ultra-Hard	5

Unlike most Kodak black-and-white papers, this paper tends to increase slightly in image density with increased latent-image keeping time. See page 14.

Development
- Tray-processing recommendations for 68°F (20°C) are listed below:

KODAK Developer	Dilution	Development Time in Minutes		Capacity—8x10-in. (20.3 x 25.4 cm) prints		Purpose
		Recommended	Useful Range	Per U.S. Gal	Per L	
DEKTOL	1:2	1	¾ to 2	120	32	Warm-Black Tones
D-72	1:2	1	¾ to 2	100	26	Warm-Black Tones
EKTAFLO, Type 1	1:9	1	¾ to 2	120	32	Warm-Black Tones
EKTONOL	1:1	1½	¾ to 3	120	32	Warm-Black Tones

Toning Recommendations: See page 99.

KODABROMIDE Paper

Applications
- General-purpose enlarging
- Studio, commercial, press, photofinishing, and exhibition print production

Characteristics
- High speed for shorter exposures
- Neutral image tone
- Fiber base
- Surface and contrast characteristics are as follows:

Symbol	Brilliance	Texture	Tint	Weight	Grades
F	Glossy	Smooth	White	Single	1-5
				Double	1-5
E	Lustre	Fine-Grained	White	Single	2-4
				Double	2-4

Safelight
- KODAK Safelight Filter OC (light amber)

Paper Speed

Contrast Number	1	2	3	4	5
ANSI Paper Speed	500	320	200	160	125

Development

KODAK Developer	Dilution	Development Time in Minutes		Capacity—8x10-in. (20.3 x 25.4 cm) prints		Purpose
		Recom-mended	Useful Range	Per U.S. Gal	Per L	
DEKTOL	1:2	1½	1 to 3	120	32	Neutral Tones
D-72	1:2	1½	1 to 3	100	26	Neutral Tones
EKTAFLO, Type 1	1:9	1½	1 to 3	120	32	Neutral Tones

Toning Recommendations: See page 99.

KODAK MEDALIST Paper

Applications ■ General-purpose enlarging

Characteristics ■ Warm-black image tone
■ Fiber base
■ Wide exposure and development latitude
■ Surface and contrast characteristics are as follows:

Symbol	Brilliance	Texture	Tint	Weight	Grades
F	Glossy	Smooth	White	SW	1-4
				DW	2,3
G	Lustre	Fine-Grained	Cream-White	DW	2,3

Safelight ■ KODAK Safelight Filter OC (light amber)

Paper Speed

Contrast Number	1	2	3	4
ANSI Paper Speed	160	125	160	200

Development ■ Tray-processing recommendations for 68°F (20°C) are listed below:

KODAK Developer	Dilution	Development Time in Minutes		Capacity—8x10-in. (20.3 x 25.4 cm) prints		Purpose
		Recom-mended	Useful Range	Per U.S. Gal	Per L	
EKTONOL	1:1	2	1½ to 4	80	21	Warmer Tone
SELECTOL	1:1	2	1½ to 4	80	21	Warmer Tone
D-52	1:1	2	1½ to 4	80	21	Warmer Tone
SELECTOL-SOFT	1:1	2	1½ to 4	80	21	Lower Contrast
DEKTOL	1:2	1	¾ to 2	120	32	Warm Tone
D-72	1:2	1	¾ to 2	100	26	Warm Tone

Toning Recommendations: See page 99.

KODAK Mural Paper

Applications
- Enlarging paper for photomural and other large print work

Characteristics
- Warm-black image tone
- Fiber base
- Extra strength and abrasion resistance to withstand folding and handling
- ANSI Paper Speed 160
- Surface and contrast characteristics are as follows:

Symbol	Brilliance	Texture	Tint	Weight	Grades
R	Lustre	Tweed	Cream-White	Single Weight	2,3

Safelight
- KODAK Safelight Filter OC (light amber)

Development
- Tray-processing recommendations for 68°F (20°C) are listed below:

KODAK Developer	Dilution	Development Time in Minutes		Capacity—8x10-in. (20.3 x 25.4 cm) prints		Purpose
		Recommended	Useful Range	Per U.S. Gal	Per L	
EKTONOL	1:1	2	1½ to 4	80	21	Warm Tone
SELECTOL	1:1	2	1½ to 4	80	21	Warm Tone
D-52	1:1	2	1½ to 4	80	21	Warm Tone
EKTONOL	1:3	4	3 to 8	—	—	Large Prints*
SELECTOL	1:3	4	3 to 8	—	—	Large Prints*
D-52	1:3	4	3 to 8	—	—	Large Prints*
EKTAFLO, Type 2	1:9	2	1½ to 4	100	26	Warm Tone
SELECTOL-SOFT	1:1	2	1½ to 4	80	21	Lower Contrast
DEKTOL	1:2	1	¾ to 2	120	32	Colder Tone
D-72	1:2	1	¾ to 2	100	26	Colder Tone
DEKTOL	1:4	2	1½ to 4	—	—	Large Prints*
D-72	1:4	2	1½ to 4	—	—	Large Prints*
EKTAFLO, Type 1	1:9	1	¾ to 2	120	32	Colder Tone

*In processing large prints, prolonged development in a dilute solution helps to prevent the streaks and marks caused by uneven development.

NOTE: For more information regarding big enlargements and murals, see KODAK Publication No. G-12, *Making and Mounting Big Black-and-White Enlargements and Photomurals.*

Toning Recommendations: See page 99.

KODAK PANALURE Paper

Applications
- Making black-and-white enlargements from color negatives
- Making contact prints (with reduced illumination in the printer) from color negatives
- Commercial, portrait, and school photography

Characteristics
- Panchromatic emulsion sensitivity for proper tonal rendition from color negatives
- Fiber base
- Warm-black image tone
- ANSI Paper Speed—Color negatives 250
 —B/W negatives 400
- Surface and weight characteristics are as follows:

Symbol	Brilliance	Texture	Tint	Weight	Grade
F	Glossy	Smooth	White	Single	*

*Contrast of this paper is matched to typical color negatives. If used with a black-and-white negative, the contrast is similar to grade 4.

Safelight
- KODAK Safelight Filter No. 13

Development
- The following are recommendations for tray developing at 68°F (20°C):

KODAK Developer	Dilution	Development Time in Minutes		Capacity—8x10-in. (20.3 x 25.4 cm) prints		Purpose
		Recommended	Useful Range	Per U.S. Gal	Per L	
DEKTOL	1:2	1½	1 to 3	120	32	Warm Tones
D-72	1:2	1½	1 to 3	100	26	Warm Tones
VERSATOL	1:3	1½	1 to 3	80	21	Warm Tones
EKTONOL	1:1	2	1 to 3	80	21	Warm Tones
SELECTOL	1:1	2	1 to 3	80	21	Warmer Tones
D-52	1:1	2	1 to 3	80	21	Warmer Tones
SELECTOL-SOFT	1:1	2	1 to 3	80	21	Lower Contrast

Toning Recommendations: See page 99.

KODAK PANALURE Portrait Paper

Applications
- Making black-and-white enlargements from color negatives
- General photography, and portrait and school photography
- Exhibition and commercial work where a black-and-white print from a color negative is required

Characteristics
- Panchromatic emulsion sensitivity for proper tonal rendition from color negatives
- Image tone: brown-black
- Fiber base
- ANSI Paper Speed—Color negatives 50
 —B/W negatives 125
- Surface and weight characteristics are as follows:

Symbol	Brilliance	Texture	Tint	Weight	Grade
E	Lustre	Fine-Grained	White	Double Weight	*

*Contrast of this paper is matched to typical color negatives. If used with a black-and-white negative, the contrast is similar to grade 4.

Safelight
- KODAK Safelight Filter No. 13

Development
- Tray-processing recommendations for 68°F (20°C) are listed below:

KODAK Developer	Dilution	Development Time in Minutes		Capacity—8x10-in. (20.3 x 25.4 cm) prints		Purpose
		Recom-mended	Useful Range	Per U.S. Gal	Per L	
SELECTOL	1:1	2	1½ to 4	80	21	Brown-Black Tones
SELECTOL-SOFT	1:1	2	1½ to 4	80	21	Brown-Black Tones
DEKTOL	1:2	1½	1 to 3	120	32	Brown-Black Tones

Toning Recommendations: See page 99.

KODAK PANALURE II RC Paper

Applications
- Making black-and-white enlargements from color negatives
- Useful in commercial, portrait, and school photography

Characteristics
- Panchromatic emulsion sensitivity for proper tonal rendition from color negatives
- Resin-coated base allows rapid processing and drying
- Developer-incorporated emulsion
- Warm-black image tone
- Fluorescent brightener gives extra brightness to the prints—effect varies with the amount of ultraviolet radiation in the viewing light
- Surface and weight characteristics are as follows:

Symbol	Brilliance	Texture	Tint	Weight	Grade
F	Glossy	Smooth	White	Medium	*

*Contrast of this paper is matched to typical color negatives. If used with a black-and-white negative, the contrast is similar to grade 4.

Safelight
- KODAK Safelight Filter No. 13

Paper Speed

	KODAK ROYALPRINT Processor Model 417	KODAK DEKTOL Developer
Color Negatives	320	500
Black-and-White Negatives	320	800

Unlike most Kodak black-and-white papers, this paper tends to increase in density with latent-image keeping time. See page 14, *Latent Image Keeping.*

Development
- Tray-processing recommendations are as follows:

KODAK Developer	Dilution	Development Time in Minutes Recommended	Development Time in Minutes Useful Range	Capacity—8x10-in. (20.3 x 25.4 cm) prints Per U.S. Gal	Capacity—8x10-in. (20.3 x 25.4 cm) prints Per L	Purpose
DEKTOL	1:2	1	¾ to 2	120	32	Warm-Black Tones
D-72	1:2	1	¾ to 2	100	26	Warm-Black Tones
EKTONOL	1:1	1½	¾ to 3	120	32	Warm-Black Tones

NOTE: Do not ferrotype. This paper dries to a natural surface gloss without ferrotyping. Drying with warm air may enhance the gloss.

Toning Recommendations: See page 99.

KODAK POLYCONTRAST Paper

Applications
- Useful in commercial, industrial, photofinishing, and school photography
- May be used as a contact-printing paper with reduced printer illumination

Characteristics
- Moderate speed black-and-white enlarging paper for selective-contrast control by KODAK POLYCONTRAST Filters
- Warm-black image tone
- Fiber base
- Surface and contrast characteristics are as follows:

Symbol	Brilliance	Texture	Tint	Weight	Grades
A	Lustre	Smooth	White	Light	1-4*
G	Lustre	Fine-Grained	Cream-White	Double	1-4*
F	Glossy	Smooth	White	Single Double	1-4*
N	Semi-Matt	Smooth	White	Single Double	1-4*
J	High Lustre	Smooth	White	Single Double	1-4*

*With KODAK POLYCONTRAST Filters.

Safelight
- KODAK Safelight Filter OC (light amber)
- This paper depends on blue and green imaging light for contrast control; safelight exposure should be kept to a minimum to avoid fogging.

Paper Speed

POLYCONTRAST Filter	PC 1	PC 1½	PC 2	PC 2½	PC 3	PC 3½	PC 4	No Filter (white light)
ANSI Paper speed	100	125	125	100	100	80	50	160

Development
- Tray development at 68°F (20°C) as follows:

KODAK Developer	Dilution	Development Time in Minutes		Capacity—8x10-in. (20.3 x 25.4 cm) prints		Purpose
		Recom-mended	Useful Range	Per U.S. Gal	Per L	
DEKTOL	1:2	1½	1 to 3	120	32	Warm-Black Tones
D-72	1:2	1½	1 to 3	100	26	Warm-Black Tones

Toning Recommendations: See page 99.

KODAK POLYCONTRAST Rapid Paper

Applications
- Useful in making high-quality enlargements for commercial, industrial, photofinishing, and school photography

Characteristics
- High-speed black-and-white enlarging paper for selective-contrast control by KODAK POLYCONTRAST Filters
- Warm-black image tone
- Fiber base
- Surface and contrast characteristics are as follows:

Symbol	Brilliance	Texture	Tint	Weight	Grades
F	Glossy	Smooth	White	SW, DW	1-4*
G	Lustre	Fine-Grained	Cream	DW	1-4*
N	Semi-Matt	Smooth	White	SW	1-4*

*With KODAK POLYCONTRAST Filters

Safelight
- KODAK Safelight Filter OC (light amber)
- This paper depends on blue and green imaging light for contrast control; safelight exposure should be kept to a minimum to avoid fogging

Paper Speed

POLYCONTRAST Filter	PC 1	PC 1½	PC 2	PC 2½	PC 3	PC 3½	PC 4	White Light (no filter)
ANSI Paper Speed	250	320	250	200	160	125	64	320

Development
- Tray development at 68°F (20°C) is as follows:

KODAK Developer	Dilution	Development Time in Minutes		Capacity—8x10-in. (20.3 x 25.4 cm) prints		Purpose
		Recommended	Useful Range	Per U.S. Gal	Per L	
DEKTOL	1:2	1½	1 to 3	120	32	Warm-black Tones
D-72	1:2	1½	1 to 3	100	26	Warm-black Tones

Toning Recommendations: See page 99.

KODAK POLYCONTRAST Rapid II RC Paper

Applications
- Intended for use in commercial, aerial, industrial, and press photography
- Additional applications: advertising display, mapping, police, and school photography

Characteristics
- Fast black-and-white enlarging paper with selective-contrast control by filters
- Resin-coated paper base for water-resistant processing and excellent dimensional stability
- Fluorescent brightener incorporated for crisper, cleaner whites
- Developer-incorporated emulsion
- Particularly well suited for processing in the KODAK ROYALPRINT Processor
- May also be tray-processed
- Warm-black image tone
- Surface and weight characteristics are as follows:

Symbol	Brilliance	Texture	Tint	Weight	Grades
F	Glossy	Smooth	White	Medium	1-4*
N	Semi-Matt	Smooth	White	Medium	1-4*
E	LUSTRE-LUXE®	Fine-Grained	White	Medium	1-4*

*With KODAK POLYCONTRAST Filters.

Safelight
- KODAK Safelight Filter OC (light amber)

Paper Speed

POLYCONTRAST RAPID II RC Paper
Processed in a KODAK ROYALPRINT Processor, Model 417

F surface

POLYCONTRAST Filter	PC 1	PC 1½	PC 2	PC 2½	PC 3	PC 3½	PC 4	White Light (no filter)
Effective Speed	200	320	320	250	200	125	63	400

POLYCONTRAST RAPID II RC Paper Processed
in KODAK DEKTOL Developer 1:2 for 60 sec at 68°F (20°C)

F surface

POLYCONTRAST Filter	PC 1	PC 1½	PC 2	PC 2½	PC 3	PC 3½	PC 4	White Light (no filter)
ANSI Paper Speed	250	400	320	320	250	100	80	500

Unlike most other Kodak black-and-white papers, this paper tends to increase slightly in density with increased latent-image keeping time. For critical use and latent-image holding times of several minutes, a slight initial underexposure may result in a more acceptable print. Make test prints when changing conditions. See page 14, *Latent Image Keeping*.

Development
- Tray development at 68°F (20°C) is as follows:

KODAK Developer	Dilution	Development Time in Minutes		Capacity—8x10-in. (20.3 x 25.4 cm) prints		Purpose
		Recommended	Useful Range	Per U.S. Gal	Per L	
DEKTOL	1:2	1	¾ to 2	120	32	Warm-Black Tones
D-72	1:2	1	¾ to 2	100	26	Warm-Black Tones
EKTONOL*	1:3	1½	1 to 3	120	32	Warm-Black Tones

*Provides greater development latitude.

Toning Recommendations: See page 99.

Representative Characteristic Curves of
Kodak Black-and-White Papers

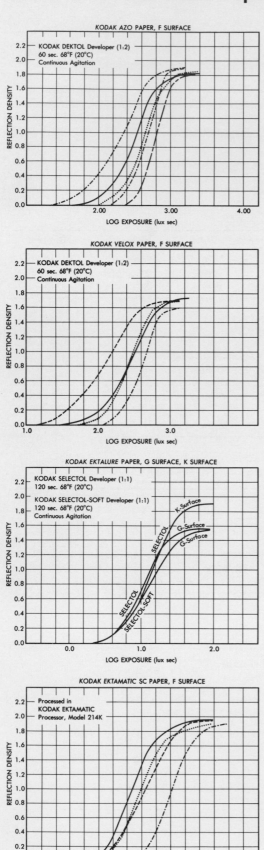

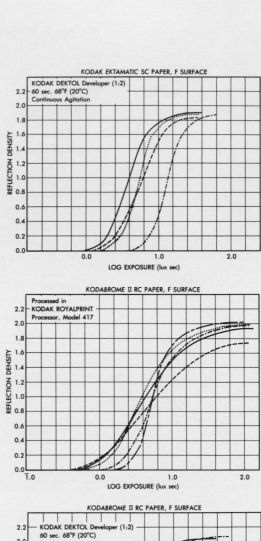

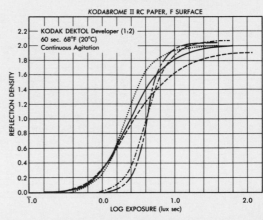

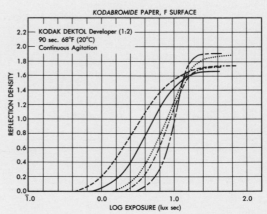

KEY	Contrast	No. 1 ---	No. 2 ——	No. 3 ⋯⋯	No. 4 ---	No. 5 —
	Filter	PC1 ---	PC2 ——	PC3 ⋯⋯	PC4 ---	—

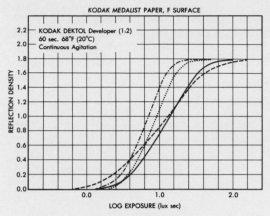

KODAK MEDALIST PAPER, F SURFACE

KODAK DEKTOL Developer (1:2)
60 sec. 68°F (20°C)
Continuous Agitation

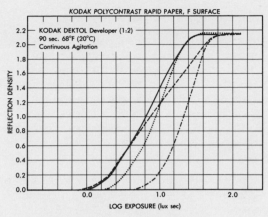

KODAK POLYCONTRAST RAPID PAPER, F SURFACE

KODAK DEKTOL Developer (1:2)
90 sec. 68°F (20°C)
Continuous Agitation

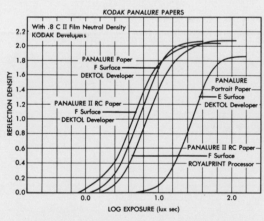

KODAK MURAL PAPER, R SURFACE

KODAK SELECTOL Developer (1:1)
120 sec. 68°C (20°F)
Continuous Agitation

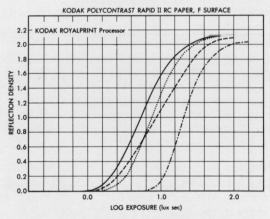

KODAK PORTRAIT PROOF PAPER, R SURFACE

KODAK SELECTOL Developer (1:1)
120 sec. 68°F (20°C)
Continuous Agitation

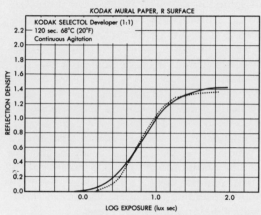

KODAK PANALURE PAPERS

With .8 C II Film Neutral Density
KODAK Developers

PANALURE Paper
F Surface
DEKTOL Developer

PANALURE II RC Paper
F Surface
DEKTOL Developer

PANALURE
Portrait Paper
E Surface
DEKTOL Developer

PANALURE II RC Paper
F Surface
ROYALPRINT Processor

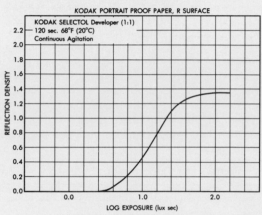

KODAK POLYCONTRAST RAPID II RC PAPER, F SURFACE

KODAK ROYALPRINT Processor

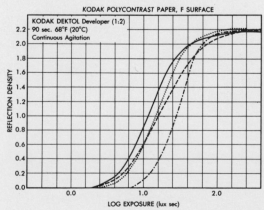

KODAK POLYCONTRAST PAPER, F SURFACE

KODAK DEKTOL Developer (1:2)
90 sec. 68°F (20°C)
Continuous Agitation

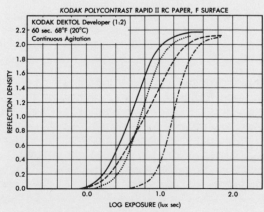

KODAK POLYCONTRAST RAPID II RC PAPER, F SURFACE

KODAK DEKTOL Developer (1:2)
60 sec. 68°F (20°C)
Continuous Agitation

Processing KODAK Black-and-White Papers

Conventional Papers

Development: Recommended developers and development times are given in the appropriate Data Sheets. The "Purpose" column in the table of development recommendations in the Data Sheets shows the effects of the developers on image tone and contrast, if any.

For best results, maintain the developer temperature at 68°F (20°C). To avoid uneven development, keep the prints completely immersed in the solution, and agitate them throughout the developing time.

Stop Bath: Rinse the prints for 5 to 10 seconds, with agitation, in one of the following stop baths: KODAK Indicator Stop Bath, KODAK EKTAFLO Stop Bath SB-1, or equivalent. Indicator Stop Bath and EKTAFLO Stop Bath are yellow liquids that turn purplish blue when exhausted, at which point they should be discarded.

Fixing: Fix the prints, with agitation, for 5 to 10 minutes at 65 to 70°F (18 to 21°C) in one of the recommended Kodak fixers. For the most efficient fixing and the greatest economy of chemicals, use the two-bath fixing system in which prints are fixed for 3 to 5 minutes in each of two successive baths. (See page 59, *Fixing Technique*.)

Washing: After fixing the prints, wash them for 1 hour either in a tray equipped with a KODAK Automatic Tray Siphon or in a commercially designed print washer. The rate of flow of the wash water should be adjusted to provide in 5 minutes a volume of water equal to the capacity of the wash vessel. For efficient washing, the water should be at 65 to 75°F (18 to 24°C).

To conserve water, to reduce washing time, and to obtain more complete washing, use KODAK Hypo Clearing Agent before washing. This preparation saves at least two-thirds of the time needed to wash single-, light-, and double-weight papers. Directions for use of KODAK Hypo Clearing Agent are printed on the package. (See pages 60 and 103.)

Drying: To promote even drying, squeegee or sponge the surface water from the backs and fronts of the prints, and then place them on drying racks, or between clean photo blotters, or on a dryer.

Ferrotyping: All Kodak F-surface papers except water-resistant papers can be ferrotyped by squeegeeing them in contact with chromium-plated sheets, or by use of a single-belt dryer with a ferrotyping drum.

Toning: The many possible combinations of Kodak papers and Kodak toners are indicated on the Toner Effectiveness chart in the section entitled "Toning." Some examples of the typical hues that are obtainable with Kodak toners are shown in the illustration on the back cover. A chart in the section entitled "Toning" indicates the paper/toner combinations that produce similar results. Formulas for KODAK Gold Toner T-21, KODAK Polysulfide Toner T-8, KODAK Sulfide Sepia Toner T-7a, and KODAK Hypo Alum Sepia Toner T-1a are given in KODAK Data Book No. J-1, *Processing Chemicals and Formulas,* available from photo dealers. The formula for KODAK Blue Toner T-26, is given in the text.

Developer-Incorporated Water-Resistant Papers

Machine Processing: Kodak developer-incorporated water-resistant papers are designed for activation processing in automatic processors such as the KODAK ROYALPRINT Processor, Model 417. They can also be processed in other types of automatic processors, as well as in trays.

Tray Processing: Developing recommendations are given in the appropriate data sheets. Stop bath recommendations are as above for fiber-base papers.

Fix, with agitation, for 2 minutes in one of the recommended fixers (1 minute in each bath if a two-bath method is used).

Wash as above for regular papers, but for 4 minutes only. There is no need to use Hypo Clearing Agent. Prolonged washing should be avoided in order to realize the advantages of the water-resistant base and to prevent physical damage. Sponge or squeegee the water from the prints and air-dry. Do not ferrotype water-resistant papers; the F surface dries to a high gloss without ferrotyping. Warm air circulation shortens the drying time and enhances gloss.

Processing KODAK EKTAMATIC SC Paper

This paper is designed to be processed in an activator-stabilizer processor such as the KODAK EKTAMATIC Processor, Model 214-K, which processes about 5.9 feet of paper per minute. It can also be processed as a conventional paper in the developers listed on the Data Sheet, and following the procedures for conventional papers shown above.

Others use the force of a directed flow of water to keep the prints swirling in the wash.

When prints made on resin-coated papers are washed in drum washers that provide a tumbling action, there is some hazard that sharp corners on one print may scratch the surface of another print.

The recommended washing times for prints are based on a given flow of water. The rate of flow is set so that a volume of water equal to the volume of the washer (or wash tray) flows in 5 minutes. This provides ample flow to provide removal of the fixer, and yet is not wasteful of water. With resin-coated papers the flow should be increased to provide a volume of water equal to the washer volume in 4 minutes.

Washing Times: When processing prints made on fiber-base paper, the recommended washing time is 1 hour for single-weight prints and 2 hours for double-weight prints. The washing time is decreased to 10 minutes for single-weight papers and 20 minutes for double-weight papers when KODAK Hypo Clearing Agent is used. The wash time for resin-coated papers is 4 minutes. Hypo Clearing Agent is *not* recommended for use with resin-coated papers. (See page 60.)

The timing starts when the last hypo-laden print is added to the washer. If the washer is loaded with prints, it is advisable to increase the water flow and/or the time of washing.

Still Water Washing: Where the supply of water is limited, prints can be washed by a series of successive soaks of the prints in still water. The prints are placed in a tray of water and left for 5 minutes, leafing the prints occasionally to allow water to bathe the surface of each print. They are then moved into a second tray of fresh water and leafed occa-

A rotary tank washer washes moderate quantities of large-sized prints at once.

Richard Mfg. Corp.

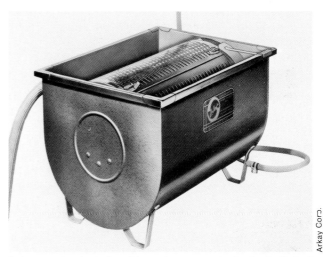

A drum washer is designed to wash many moderate- to small-sized prints at one time.

Arkay Corp.

The KODAK Automatic Tray Siphon converts a tray into a good print washer. The siphon action agitates the prints and is a convenient way of providing fresh wash water.

This type of washer is designed to keep prints separated during washing. It handles several prints at a time, and is designed for use with prints in which maximum image stability is desired.

Zone VI Studios

sionally. Six changes of 4 minutes each provide a good wash for single-weight prints, with twelve changes for double-weight prints If KODAK Hypo Clearing Agent has been used, three changes are sufficient for single-weight prints, or five changes for double-weight prints.

This method is not recommended for resin-coated papers, as the number of changes required takes more water than the running water wash, and the wet time is increased beyond that recommended for these papers.

Wash-Water Temperature: The temperature of the wash water has a definite effect on the rate of removal of the silver complexes and thiosulfate from photographic prints. A temperature of 60°F (16°C) will slow down the removal of chemicals from the prints. When practical considerations such as the cost of heating water as well as the physical characteristics of photographic papers are taken into account, the most suitable range of temperatures for print washing is 65 to 75°F (18 to 24°C). This applies to prints made on both fiber-base and resin-coated papers. When fiber-base prints have been treated in Hypo Clearing Agent, they wash just as fast in temperatures down to 40°F (4°C).

If the wash water is under 68°F (20°C), the wash time without the use of the clearing agent must be increased. At low temperatures, the hypo may never wash out of the prints. When the clearing agent is used, adequate washing is achieved in cold water.

Machine Processing

The three basic types of papers can be machine-processed when production quantities warrant it. KODAK EKTAMATIC SC Paper is a fiber-base paper that has incorporated developer and can be processed by a stabilization process as supplied by the KODAK EKTAMATIC Processor, Model 214-K. Kodak resin-coated papers with incorporated developer can be activation-processed in equipment such as the KODAK ROYALPRINT Processor, Model 417, in either sheet or roll form. More details on these processes are given in the section "Stabilization and Activation Processing."

Normal fiber-base papers in roll form can be processed in continuous paper processors such as the KODAK Continuous Paper Processor, Model 4DT-P. With this type of processor the paper is processed conventionally as it would be in a tray. The paper is transported by means of rollers through several tanks that contain the developer, stop bath, fixer, Hypo Clearing Agent, and washes. The agitation is provided by the movement of the paper through the solutions. The length of time the paper remains in each solution is controlled by the depth of the paper path through the tanks, by the number of passes the paper makes through the solution, as well as by the overall speed of the machine. Solutions are automatically replenished and the temperature is controlled by a thermostatic mixing valve. The processor can be used in conjunction with an automatic printer at one end. It can also be joined to a dryer and an automatic paper cutter at the other end.

Drying

When prints are finished in the final wash, they are dried. The drying procedure may be as simple as hanging the prints up to air-dry on a line with spring-type clothespins, or may utilize a large rotary print dryer that moves prints around a heated drum, using a canvas belt to hold them flat against the drum.

Drying prints requires removing the water from the prints, while keeping them as flat as possible.

This print washer is designed for washing prints made on resin-coated papers. The racks are for drying the prints after washing.

Automatic printers use paper in roll form. This KODAK Continuous Processor moves the "web" of paper through all the processing, washing and drying steps on rollers.

Paterson (Prime Marketing Inc.)

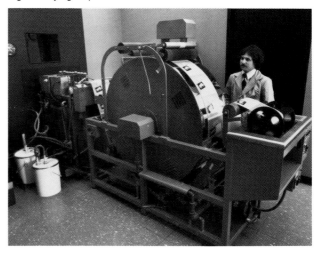

Prints made on F-surface fiber-base papers may also involve ferrotyping as well, to obtain a high gloss on the print surface. In production printing, the print drying operation should be able to keep up with print production. These factors must be considered in the various types of print drying.

Air Drying

The simplest method of drying prints is to let them air-dry. If quantities are small, the prints can have the water blotted or squeegeed off them, and they can be hung up on a line using spring-type clothespins. Small prints can be hung up by a corner; larger prints may require two or three clothespins. The bottoms of larger prints can be weighted with additional clothespins.

This procedure works well with stabilized prints (which of course, have not been washed) and with prints made on resin-coated papers. These prints dry with just a slight curl in them. Fiber-base prints, however, may dry with curl and a waviness. Single-weight prints may curl into a roll.

Another simple method of air drying that works well with RC prints is towel drying. Prints are first squeegeed and then laid face up on a clean cotton cloth towel on a flat surface. The prints will dry in a matter of hours, depending on the room temperature and relative humidity.

Drying Racks: An alternative method of air drying is to use drying racks. Frames covered with plastic or fiber-glass screening fit into the racks with adequate spacing for air circulation. Prints are blotted or squeegeed to remove excess water and placed face down on the screens. Prints on resin-coated papers should be dried emulsion side up on screens to avoid possible marking of the emulsion surface.

Prints dry somewhat flatter on drying racks than on a line, but single-weight prints (fiber-base) are likely to dry with considerable curl.

The screens should be washed at regular intervals to avoid possible contamination of prints with fixer from having underwashed prints dried on them.

Blotter Rolls: Using a blotter roll or blotter stack is another approach. These methods may leave the prints slightly curled, but there is generally much less curl than with air-dried prints, and practically no waviness.

The blotting paper used in the KODAK Photo Blotter Roll is chemically pure and faced with muslin. A roll of corrugated cardboard spaces the blotter and allows air circulation for faster drying. The prints are blotted or squeegeed and placed in the roll with the emulsion side facing the muslin. Allowed to dry normally, the drying rate is fairly slow but can be speeded up by using a fan to blow air through the roll.

Muslin-faced blotters are provided by Kodak for use in the KODAK Professional Print Dryer (no longer available). The blotters are alternated with corrugated cardboard in a stack and weighted down. Warm air circulated through the stack aids drying.

Effect of Relative Humidity on Air Drying: Relative humidity is a measure of the amount of moisture in the air. Low relative humidity speeds up the drying of prints because water evaporates more rapidly when the amount of moisture in the air is low. High relative humidity slows down the drying of prints because the air already has moisture in it. At 100 percent relative humidity, for example, the air contains all the moisture it will hold (at a given temperature) and the prints will not dry at all.

The drying drum has a ferrotype surface. F-surface papers come onto the drum with the emulsion surface against the polished surface. Prints being matte-dried come onto the drum with the base side against the drum surface.

The rollers are on hangers called racks. The time of passage in each solution is controlled by the speed of the paper, the number of tanks, the number of racks in each tank, and is fine-tuned by raising and lowering the racks.

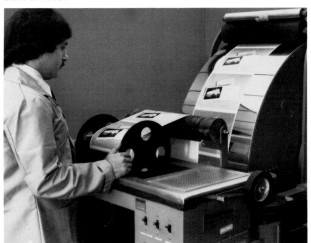

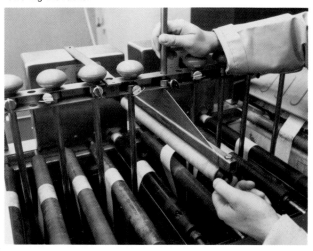

The surface water on prints being matte-dried on racks, or prints on RC paper, is often removed with a rubber squeegee.

If both surfaces are squeegeed, the prints dry faster, and dry free of "drying marks" caused by minerals dissolved in the water.

Prints are often placed face-down on drying racks made of framed plastic screen material.

The relative humidity also affects the amount of curl in dried prints. Prints curl more when air-dried in low relative humidity and curl less when the relative humidity is higher.

For occasional print drying, relative humidity in a small room can be raised by soaking a large towel with water and hanging it up over a sink or drip pan. For more regular work, small room humidifiers can be purchased.

Small dehumidifiers that work on the refrigeration principle can be used to lower the relative humidity. Electrical window-type air conditioners also lower the relative humidity.

Ferrotyping Prints on Plates: A ferrotyping plate (or tin) is also known as a glazing plate. It is usually a stainless steel or brass plate that has been buffed to a high degree of polish and chrome-plated. When wet prints made on a **fiber-base F-surface** paper are squeegeed or rolled onto the polished surface, the gelatin surface of the print conforms to the highly polished plate. When the print is allowed to dry against this surface, the print surface dries with a high degree of polish, known as a high gloss. Note: *Do not ferrotype prints made on resin-coated papers.*

If a print is allowed to air-dry on a ferrotyping plate, the edges dry faster than the center, so the print "pops off" the plate in irregular circular sections. When the center is finally dry, the entire print releases from the plate. The print is not flat, but shows irregular annular rings on its surface. This type of print is said to have an "oyster or cockle shell" finish.

If, however, the ferrotype tin is placed facedown on a taut screen in a drying rack and weighted down slightly, the prints will dry flat against the screen and the ferrotype surface will be smooth with no oyster-shell markings. For occasional ferrotyping, a clean cloth can be laid out smoothly on a rug, the tin placed facedown on the cloth, and weighted with a layer of books, perhaps 1 to 2 inches thick. The drying this way may take about 12 hours, depending on the relative humidity, but the prints will have a smooth, cockle-free ferrotyped surface.

A small, electrically heated dryer speeds up the drying. The ferrotype tin is placed on the curved dryer platen, print side up, and the canvas apron drawn tautly over the tin. If the heat is less than 180°F (82°C), the prints will dry fairly rapidly and with a smooth, glossy surface. If the apron is not tight or the heat is too high, the prints are likely to dry with an oyster-shell surface.

The platen surface on some small dryers has a ferrotyping surface. In using such dryers, the prints are rolled or squeegeed directly on the dryer platen, and no ferrotype plate is used.

Cleanliness: Cleanliness of two types affects print drying. Dust specks or tiny pieces of grit can scratch the surface of prints when squeegeeing. They can also damage the surface of ferrotype plates. If caught between the plate and the print surface when a print is placed on the plate, a small area is left without a gloss and the print surface may actually be damaged.

Inadequately washed prints contaminate blotters with fixer, and this contamination spreads to all prints which subsequently touch the blotter. It is highly important to wash all prints thoroughly so that blotters and blotter rolls can be reused a number of times. If a blotter is knowingly used on underwashed prints, as when a rush job is being done, the blotter should then be discarded.

Using Heated Dryers

Drying is speeded up with heat. Electrically heated dryers are made that are suitable for limited production quantities of fiber-base prints. The drying surfaces, or platens, are cylindrically curved, and prints are held flat against the drying surface with aprons of canvas or other fabric, using spring tension. Some have one drying surface; most have two. Some are made with polished platens upon which the prints are placed. Others are designed to be used with ferrotype plates.

For matte drying, prints are squeegeed, placed onto the platen faceup, and the canvas apron is tensioned over the prints, holding them tight against the drying surface. Most such dryers are equipped with thermostats so that the heat can be adjusted. For emergencies, a high setting such as 200°F (93°C) dries the prints rapidly. Such temperatures, because they lower the moisture content of the prints drastically, can cause curl and print brittleness. When set at about 175°F (79°C) the prints dry relatively fast, but with less curl and brittleness.

Such dryers should not be used to dry prints made on resin-coated papers. Moisture that is trapped between the print and hot metal cannot escape up through the print, and can cause drying bubbles in the print where drops of water are trapped between the print and the drying surface.

Drum Dryers: When print quantity gets large, automatic electrical dryers can be used to increase the productivity of print drying. There are several types available:

Single-belt drum dryer: This type of dryer consists of a ferrotype-surface drum that is heated with water or resistance wires. It has a continuous canvas belt that feeds the prints onto the drum surface and holds them in contact during one revolution of the drum, during which time the prints dry. These dryers are

An alternative method of ferrotyping prints that is especially useful with small prints is to roll them onto the plate under a clean photographic blotter, using a print roller.

When fiber-base, F-surface prints are to be dried with a high gloss, they are squeegeed onto the polished surface of a ferrotype tin.

A KODAK Blotter Roll provides another method of matte-drying prints. The prints are squeegeed to remove the excess water and placed against the linen side of the blotter and rolled up. Blowing warm air through the corrugations speeds up the drying.

A single-belt drum dryer that dries prints either matte or glossy, depending on whether the paper emulsion or base is against the drum.

Pako Corp.

generally used with fiber-base prints. F-surface prints are placed on a feeding belt with an orientation that places the print surface against the drum surface. For matte drying, the orientation is such that the paper base is against the drum.

Current Kodak resin-coated papers can be matte-dried (base against the drum) provided both surfaces of the print are squeegeed off before being placed in the dryer. If the dryer has a spray on the loading belt, it must be turned off. *All surfaces, including F, must be placed base side against the drum.* The drum surface temperature cannot exceed 190°F (88°C).

Double-belt dryer: This dryer does not ferrotype prints but dries all types of papers by matte drying. The drum does not have a polished surface. Two canvas belts are in contact as they go around the drum, but separate at the print feed station so that prints are fed between the belts. All prints are dried emulsion side away from the drum. Some double-belt dryers have two drums so that very long prints can be dried on them. F-surface fiber-base papers can be matte-dried on a double-belt dryer, as can all other surfaces of fiber-base paper prints.

Small drum dryer: The above dryers have a continuous operation. There is a small ferrotype single-belt drum dryer that comes somewhere between ferrotype plates and a drum dryer in operation. Prints are placed on a single belt and rolled up on the small drum, being held in contact by the belt.

When the surface of the drum is covered, the dryer is allowed to sit for a period of time until the prints dry. Then the belt is unrolled off the drum, and the dry prints are lifted up off the belt. The dryer is then ready for a new load of prints.

SPECIAL CAUTION: Never dry any underwashed prints on a drum dryer. The canvas belt(s) becomes contaminated with fixer, and then any prints dried afterwards become contaminated—thus shortening their useful life. If a contamination occurs, remove the belt immediately and launder it well.

Dryers for resin-coated papers: A special type of dryer is made to handle just resin-coated papers. This type of dryer works on the principle of the dryer section of the KODAK ROYALPRINT Processor, Model 417, a diagram of which is shown on page 106. The paper goes between rollers to remove surface water and is dried by moving warm air (air impingement). Since the paper base has not soaked up water, drying occurs quickly.

Care and Cleaning of Ferrotyping Plates and Drums

The surfaces of both ferrotyping plates and drums must be kept clean and free from scratches. Dirt and dried minerals from hard water can cause print sticking and drill spots on prints. Every scratch on the polished surface will reproduce itself on the glossy surface of every print dried in contact with it. This calls for great care in all aspects of handling the ferrotyping surfaces, especially in cleaning them.

For normal cleaning, flushing with water is sufficient. If the water flow pattern across the surface of the plate shows straight lines, it is probably gelatin from the edges of prints left on the metal as they dried. Rubbing with a clean photo chamois will usually clean the gelatin off. When this is insufficient, the use of **bar** Bon Ami cake soap (not the powdered) applied to the surface with a clean, soft cotton cloth may be the answer. Rub the wet bar of Bon Ami with a wet cloth and apply the cloth to the metal surface, rubbing gently. Rinse off, and buff with a soft dry cloth. GLASS WAX glass and metal cleaner, Nu Steel No. 1 cleaner and polish or other similar products may also work.*

When clean and covered with fresh water, the water should form a broken film on the plate surface, beading up from the surface in irregular puddles.

If cleaning with Bon Ami cake soap does not seem to achieve this result, the plates can occasionally be cleaned with a carborundum product called Aloxite grade A, No. 1 fine buffing powder. This product is available from Eastman Kodak Company, Parts Services, Bldg. 601, 800 Lee Road, Rochester, New

*Eastman Kodak Company cannot be responsible for changes made by manufacturers in the formulas of these and other products.

York 14650, as Part Number 545005. A thin, water paste is made from the Aloxite powder, which is applied to a small portion of the ferrotype drum or plate with a soft cloth. It is rubbed gently until no break in the water film is seen when water is applied to the surface.

Allow the spread-out paste to dry to a thin powdery film, and wipe it off. Be sure to get it all off. Then polish as above until the surface becomes water repellant—that is, until the drops of water bead up into puddles on the surface.

With proper use, cleaning, and storage, ferrotype tins and drums should give good service for a long time.

Enlarging Meters

In the section on making an enlargement, the method of finding exposure times by making test strips was presented. This method can be time-consuming when many prints are to be made. An enlarging meter or photometer can be used to find the exposure for the first print of each negative. Like exposure meters for cameras, enlarging meters work by measuring light intensity. In the case of the enlarging meters, this measurement is made on the easel.

There are a number of types of enlarging meters, and each one is used in a slightly different way. The specifics for each meter can be learned from the instruction sheet furnished with it; the general principles of meters are given here.

Integrating Meters

With integrating meters, the light from the projected negative is "integrated" by placing a special diffusing disk over the enlarger lens. This scrambles the light from all the negative areas and projects fairly even illumination to the easel. The meter probe is placed in the center of the easel, and the intensity or illuminance of the light falling on the easel from the enlarger is measured.

It is important with all meters that the easel, where the measurements are made, be shaded from direct safelight. When measuring dim images projected by the enlarger, direct safelight can affect the readings and give variable results.

The probe is the light-sensitive cell of the meter. In small meters, the probe is built into the meter body, so the whole meter is placed on the easel. In larger meters, the probe is in a small box at the end of a wire connected to the meter, which is a large box with dials and scales. Another type of probe is connected to the meter box with a glass-fiber cable.

There is a dial on the meter that sets it for the paper speed. Once the paper speed is dialed in, the exposure is found. In null-type meters, a dial is turned

A small, electrically heated platen dryer.

A small unit for drying resin-coated papers. The rollers remove the surface water and the rack holds the prints while they dry.

A dryer made for resin-coated papers only.

Enlarging meters can help reduce the time required to find the best exposure time for enlargements. They are especially useful when large quantities of negatives are printed, but are also an aid to the occasional photographic printer.

Hope Alexander

until the meter reads zero. The meter has been calibrated so that this zero means a standard exposure time.

In simpler meters, the nulling is accomplished by changing the aperture of the enlarging lens. The probe may be of the grease-spot type. A small light is placed behind a diffusing medium, which is a small spot in the center of a larger white circle. The white circle is illuminated by the enlarger light. The small spot is made brighter or dimmer by turning a dial. Balance of the null point is found when the brightness of the small spot matches the brightness of the white circle.

In another type of meter, a light under the small spot flashes on and off when the null point is reached. The light is on when the light from the enlarger is brighter than the null point, and off when it is dimmer than the null point. When it flashes, the null point has been reached.

In the electronic version of integrating enlarging meters, a needle dial may be used to find the null point. The needle scale is divided into minus and plus sides, with the null point being dead center.

A nulling meter is calibrated by testing. A print of correct density is made from a typical negative on the paper being calibrated. This negative can be called a "standard" negative. The enlarger is set with the negative, and the same enlarger height and f-number are used to make the enlargement. The integrating diffuser is placed over the lens, and the meter probe is located in the center of the easel.

The paper-speed adjustment is changed gradually until the null point is reached. The number on the dial becomes the paper-speed number for that paper.

When a new negative is placed in the enlarger, the light integrated, the meter set on the calibrated speed, and the aperture adjusted to the null point, the standard negative exposure time should give an acceptable print on that paper.

Other enlarging meters have scales that are calibrated in seconds of exposure. These are calibrated by placing the standard negative in the enlarger, which is at the calibration height, and the paper-speed dial is adjusted until the needle reads the time required to make the correct density print. The paper-speed reading is recorded.

When a new negative is to be printed with the same paper, the paper-speed dial is set at the recorded speed setting. The image is sized and focused on the easel. The diffusion device is placed on the lens, and the lens aperture is set to the desired f-number. The probe is placed in the center of the easel, and a measurement is made. The dial should then give the correct exposure time in seconds.

Some Disadvantages of Integrated Measurements

The integrated measurement method works well when two criteria are met:

1. The negatives used have a distribution of tones that come close to matching that of the standard negative used to calibrate the meter.

2. The same negative carrier mask is used for the readings. A large area mask lets more total light

Small, relatively inexpensive meters are available. The entire meter is placed on the easel.

Color analyzers that are made to find color balance and exposure time when making color prints can also be used to find exposure times for black-and-white prints. Electronic enlarging meters made specifically for black-and-white enlarging are also made. Only the probe of such meters is placed on the easel.

through to be integrated than a small mask, all other factors being equal. Although the exposure time will be the same, the larger area mask gives a higher reading. The meter must be calibrated separately for each carrier mask size.

If negatives vary considerably in the distribution of tones, as from a high-key negative to a low-key negative, the integrating method will give false readings that will cause underexposure of low-key negatives and overexposure of high-key negatives.

Spot Reading with Enlarging Meters

While the principle of integrated readings is to get an exposure based on the average density of each negative, spot readings are made of a small selected area of each projected negative image. No integrating disk is used over the lens.

Two types of areas are selected. The first is shadow area, which is a relatively thin area in the negative. The purpose is to print the shadows of each negative to the same degree of density blackness.

The second type of area for spot metering is diffuse highlights. As mentioned elsewhere, a diffuse highlight is generally a subject white that is printed to a very light gray with a density of about 0.04 above that of the paper base. The whitest part of sunlit clouds, white clothing, and a white painted house are examples. The same technique can be used for portrait negatives. The area selected is a lighted skin area, usually on the forehead, but not in a section containing specular highlights. In this case, the print receives enough exposure to make a medium to light gray, suitable for skin tones.

Because only a small area is selected for measurement, the negative mask area or overall tone distribution of the negative does not give misleading readings when using the spot method.

Calibration using either spot method is similar to the calibration described above for integrated readings. A print is made from a standard negative, and the exposure is recorded. The negative is left in the enlarger and the meter probe is placed in an appropriate shadow or diffuse highlight area in the projected image. If the null method is used, the paper-speed dial is adjusted until the meter nulls. This gives the paper speed for this paper at the exposure time and aperture used to make the standard print.

With a meter calibrated in exposure time, the paper speed dial is adjusted until the meter indicates the exposure time given the standard print. The reading in the paper-speed dial gives the paper speed for this paper when used with the type of spot reading being calibrated.

In general, shadow spot readings are simpler to use because the clear areas in the projected negative images are easier to find. Further, they are brightest on the easel and consequently result in higher readings. If a dense negative is chosen and the enlarger is set to make a big enlargement, this brightness may be necessary to get a reading with meters of relatively low sensitivity.

Shadow spot readings, however, tend to give slightly more variable results than do diffuse highlight readings. You do not know just how black the area should be made to have the other print tones of correct densities. On the other hand, diffuse highlight spot measurements, because they are almost always printed to the same light gray tone, are more consistent. However, they are more likely to be affected by stray safelight, and the correct areas are more difficult to find in the projected images. Further, they require quite sensitive meters when a big enlargement is being made from a dense negative.

Paper Speeds for Enlarging Meters

The method of calculating the *American National Standards Institute* paper speed from the characteristic curve of a paper is discussed and diagrammed in the earlier section entitled "Sensitometry."

The ANSI paper speeds for the various Kodak papers are given in the Data Sheets in the center of this publication.

The ANSI paper speeds are measured at a net reflection density of 0.60, which represents an average gray tone in prints. Hence, ANSI paper speeds are suitable to compare one paper with another when using the integrated enlarging meter methods. The dials on most meters are marked with arbitrary numbers, but after several papers have been calibrated, a graph can be made that correlates the dial markings with the ANSI paper speeds. Then, when a new paper is to be used, the dial can be set at a marking appropriate for that speed.

Paper Speeds for Spot Metering

The ANSI paper speed works well for integrated readings because the measurement is based on a reflection density of 0.60. However, spot readings are made in the shadow tones (low negative densities), which print nearly black, or in diffuse highlight tones (high negative densities), which print as very light grays. These speeds can be found by calibrating each paper, but it may be helpful to have a method of calculating a shadow speed and a diffuse highlight speed for each paper, based on its ANSI paper speed.

A series of five characteristic curves is shown in the illustrations on page 72. Note that the diffuse highlight speed is measured where the net reflection density is 0.04, and that the shadow speed is measured where the density is 0.95 x the paper D-max.

This gives a value appropriate for clear areas on the negative.

Note also that the shadow and diffuse highlight speeds are fairly close to the ANSI speed with the highest contrast paper, while they are spread quite far apart with the lowest contrast paper. In the following method of speed calculations, this difference is accommodated by a series of ratio numbers.

The ANSI paper speed for a particular paper is found in the Data Sheets in the center of this publication.

The shadow speed is found by multiplying the ANSI speed by the ratio number in the table for shadow speed and for the contrast of the paper selected. For example, a grade 3 paper has a speed listed as 100. The ratio number is found to be 0.25 x. The shadow speed is 0.25 x 100 = 25. The diffuse highlight ratio number is 2.75 x, so the diffuse highlight speed is 2.75 x 100 = 275. There is no 275 in the ANSI paper speed series, so the closest number is chosen, which is 250.

Robin Grier

In the photograph above, a diffuse highlight reading would be taken from the brightest section of the whitewall or the reflection of the sky in the hubcap, depending on which you want to print a gray tone just darker than white. A good shadow area to read is directly below the fender on the right side.

Ratio Numbers for Finding Spot Metering Paper Speeds

Paper Contrast	Diffuse Highlight Speed Ratio	Shadow Speed Ratio
1	4x	0.13x
2	3.2x	0.20x
3	2.75x	0.25x
4	2.3x	0.32x
5	2.0x	0.40x

Because of slight variations of contrast and speed due to manufacturing tolerances and changes in the emulsion as the result of storage, and because these are averaged figures for different papers, the speeds will be approximate. The calculated speeds can be fine-tuned quickly by running a short test. When using half-grade filters, choose a ratio number between the two grades.

Metering for Paper Contrast

By measurement of a diffuse highlight area and a shadow area of the negative image projected onto the easel, and finding the difference, the proper contrast of paper for the image can be found.

When the log-illuminance range of the image matches the log-exposure range of the paper, the paper will print the image with acceptable contrast.

The instructions packaged with most enlarging meters explain in detail how that particular meter is used to match the negative image to the paper. Since the calibration markings vary from meter to meter,

no specifics can be given.

Here is a method that can be used to check the meter. The diffuse highlight area is measured with the lens open to its widest full-stop opening. The meter probe is moved to a shadow area. The lens is stopped down until the reading is the same as it was in the highlight area. Since each stop is equivalent to a log-illuminance range of 0.30, the number of stops difference x 0.30 gives the log-illuminance range of the negative image. The following table shows the relationship.

When using an enlarging meter to find paper contrast, no distinction should be made between types of enlargers. The contrast of the negative has already been altered by the enlarger illumination system in forming the image on the easel, and by the time it is measured by the enlarging meter.

Stops difference	f-number when starting at f/5.6	f-number when starting at f/4.0	f-number when starting at f/2.8	Log-illuminance range	Average Paper Contrast
2	11	8	5.6	0.60	5
2⅓	12.7	9	6.3	0.70	
2½	13.5	9.5	6.7	0.75	4
2⅔	14.3	10	7	0.80	
3	16	11	8	0.90	3
3⅓	18	12.7	9	1.00	
3½	19	13.5	9.5	1.05	2
3⅔	20	14.3	10	1.10	
4	22	16	11	1.20	1

Calculation of Paper Speed Ratios

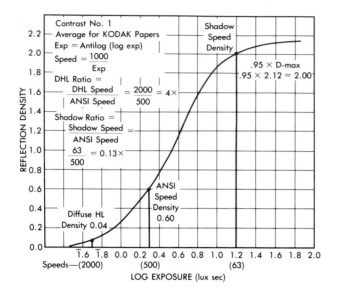

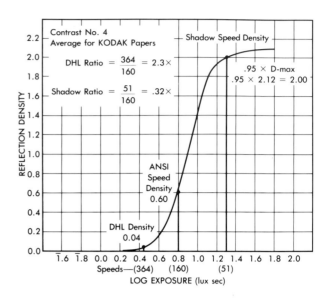

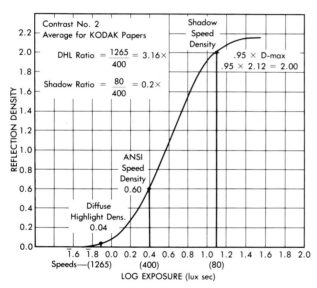

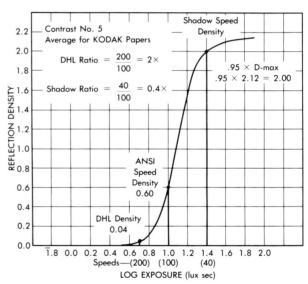

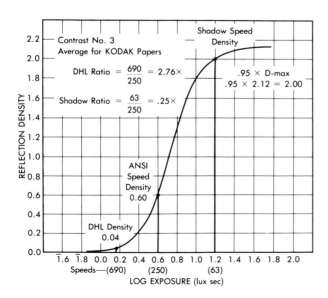

Special Printing Techniques

Exposure Controls

In the sequence of making an enlargement, 13 steps were given earlier. The first 11 steps were covered in detail. This section covers the special printing techniques that may be required to make the good print that was listed as step 12.

In the first 11 steps a negative has been chosen, cleaned, and placed in the enlarger. A photographic paper has been chosen. A test strip was exposed and processed to find an appropriate exposure time. A test print was exposed, processed, and reviewed for contrast and exposure, and remade if necessary.

In many cases, the test print is found to be satisfactory for the purpose intended for the print. However, in other cases the print can be improved by the use of special printing techniques. The improvement can be needed for either technical reasons or compositional reasons.

Cropping: When part of the negative area is not included in the print, the print (or the negative) is said to be cropped. One reason for cropping might be that the rectangular shape of the negative does not match the standard paper shape. A square negative is often cropped, for example, so that the image will fit an 8 x 10-inch (20.3 x 25.4 cm) sheet of paper.

Negatives are often cropped to improve the composition of the picture. The negative may contain subject area that does not contribute to the visual story to be told by the print, so it is excluded in making the print.

The test print can be used to determine how the cropping will be done. Wax negative pencils can be used to mark the print to show what area is to be used in a final print. The enlarger is set to give an increased magnification so that the area wanted fits within the easel marks. Because of the increased magnification, increased exposure time is needed for the cropped print.

Cropping is also used to place the center of interest in a location that improves the composition. In portraits, for example, the head may be centered in the negative, but can be moved slightly to one side or the other, or moved up closer to the top border, by cropping. Portrait photographers usually allow extra negative space around the subject for just this purpose.

Local Control of Print Exposure: While the test print may show most areas to have received correct exposure, there are often local areas that have printed too light or too dark. One way to help in this situation is to choose a paper with a lower contrast. This can, however, lead to a print that is flat looking; it does

Two L-shaped pieces of cardboard are useful in finding the best cropping of a print.

not have enough tone separation in the middletones.

The other solution is to give more exposure to those areas that are too light and less exposure to those areas that are too dark. This is done during the enlarging of the print and is accomplished by "burning in," which means to give areas more exposure, and by "dodging," or "holding back," which means that print areas are given less exposure. Local exposure control is used.

Care must be used so that the effects of local control do not become obvious in the final print. This means that the amount of control must not be too great and that the area covered must be controlled carefully.

Various shaped tools can be used to burn in print areas. Shown is a burning tool with a hole that can be changed in shape and size.

Burning-in gives more exposure to an area that would otherwise be too light in tone.

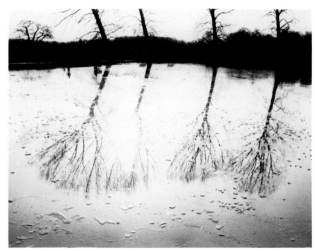

A straight print of this picture has little tone in the sky and water. A finished print is shown at right.

Burning In: This operation is usually performed with a piece of cardboard larger than the print area. A hole is cut in the cardboard to allow a small part of the image light to pass through. The cardboard should be dark (black is best) on the side towards the paper so that reflected light will not give a foggy exposure to other areas of the paper. It is convenient to have the side of the cardboard toward the enlarger lens white colored to aid in viewing the projected image during the burning-in operation.

A small hole is required for burning in small areas. It also can be used for burning in larger areas by holding it up near the enlarger lens. In this case, the edges of the burning-in area are graduated in intensity. If the area to be burned in is fairly large and has a definite shape, the hole can be cut to approximate the shape of the area, and the card held close to the paper during the burning-in operation.

Skilled workers learn to make different sized and shaped holes by using their two hands. The shape of the hole can be changed during the burning in to give different degrees of exposure addition.

With both hands or a card, the burning hole should be kept moving in a circular or oval motion so that a sharp exposure difference line does not form in the print.

Often one or more edges of a print are darkened by burning in with a card with no hole in it. A light sky can be given tone by burning in the top of the print. A print with a light foreground can be given a deeper toned base by burning in the bottom edge of the print. Darkening both edges of a print often helps to "hold the subject together."

It takes experience to learn to control the area being burned in. Covering too small an area leaves the edges of the area still light in tone. Covering too large an area darkens the tones around the area being burned in and gives a false look to the print. It

also takes experience to learn just how much extra time to give the burned-in area.

Dodging or Holding Back: Burning in is used to darken print areas; dodging or holding back is used to lighten print areas. Burning in requires extra exposure time after the main print exposure has been given. Holding back is done during the main exposure so that the areas that need lightening receive less than the regular print exposure.

Many areas to be held back are in the central area of the picture, so a dodging tool needs a narrow handle to hold the circular or shaped shadowing card in that area without shadowing other areas. Usually a black wire is used as the handle.

Circular and elliptically shaped cards, white on one side and black on the other, are very useful. Several sizes of each shape provide a useful range of dodging tools. Black wire coat hangers can be cut and bent to provide the handles. The wire is bent in a loop at the handle end to provide a device for hanging up the tool. The card can be attached to the working end of the wire with black masking tape.

Several extra handles can be made, and specially shaped cards can be cut for holding back odd-shaped areas.

As with burning in, the dodging tool should be kept moving during the holding-back operation. Raising the tool covers a larger area; lowering it reduces the shadow size.

As with burning in, the holding back must be done so that its effect is not obvious. If the tool is allowed to cover too large an area, the lightening effect will be seen in the surrounding area. If the dodging is done for too long a time, the area dodged will be obviously too light, and any black tones will have been changed to grays. If the entire area to be dodged is not held back, the outer edges of the area will show up as a dark rim around the dodged area.

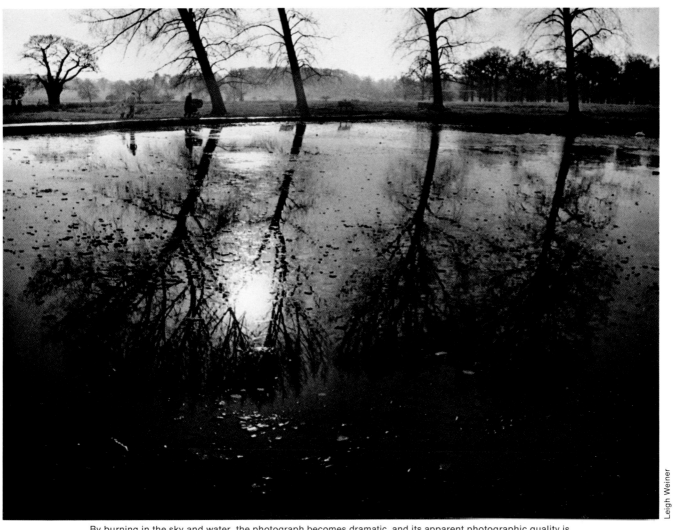

By burning in the sky and water, the photograph becomes dramatic, and its apparent photographic quality is considerably enhanced.

Usually holding back tools are mounted on wire handles so that areas within the picture area can be held back without affecting the exposure of other areas.

An area is held back for only part of the total exposure. The length of time is usually found by making test prints.

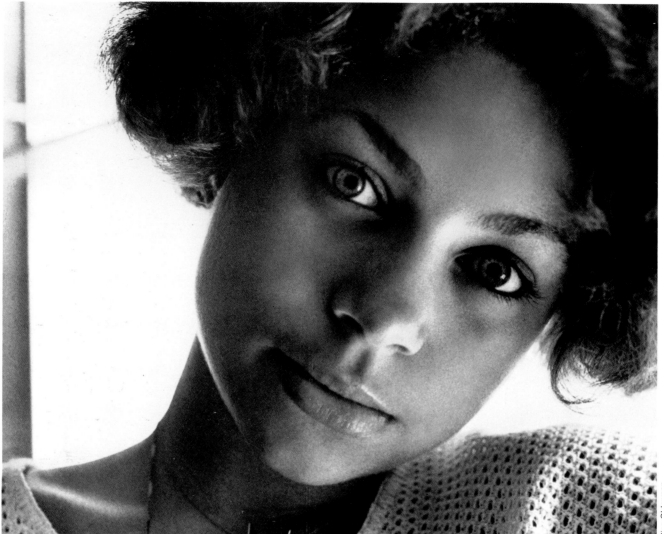

<div style="text-align:right">Elisa Olderman</div>

Holding back is useful for lightening shadow areas so that shadow detail can be seen. It cannot be overdone or the shadow area will look unnaturally light.

This is a straight print of the held-back photograph shown above. Note how the shadow detail has been improved by holding back.

With experience, a worker can learn to estimate how much total exposure is required for holding back. Even then, a first-dodged print may often have to be remade. Dodging or burning in should never show. It is better to underdo than overdo.

Increasing Local Contrast: One of the important factors of print quality is good local contrast. Sometimes when the entire negative scale prints suitably on a certain contrast grade so that both highlight and shadow detail are visible, the local contrast is too low, and the print appears to lack contrast.

The local contrast can be increased by using a higher contrast paper, but then either the highlights print too light or the shadows print too dark, or both. By burning in the highlight areas or holding back the shadow areas (or both) a print can be made that has increased local contrast and improved detail in both the highlights and shadows.

This is fairly easy to do when the areas to be dodged or burned in are few and reasonably large. However, it becomes difficult when there are many scattered areas to be burned in or dodged. Whether

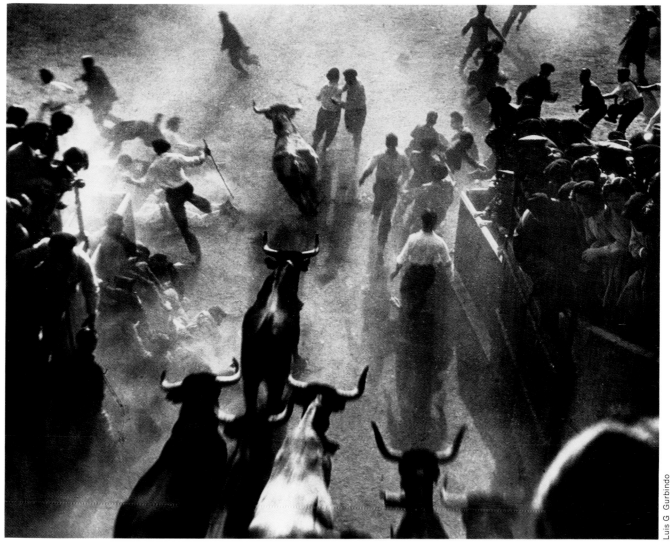

it is worth the effort depends on the value of the photograph. A second method can be tried that does not require dodging.

This approach to increasing local contrast is to use a selective-contrast paper and a "two-PC-filter" exposure. The main enlarging exposure is given through a somewhat contrasty POLYCONTRAST Filter. The exposure is such that the shadows and midtones are printed a little light, and the highlights do not receive enough exposure to record. The PC filter is removed, and a lower contrast PC filter is placed in the enlarger without moving the enlarger, negative, or paper. A second exposure is given that is just enough to print in highlight detail, and just enough to give a total correct exposure to the midtone and shadow areas.

This type of exposure gives improved local contrast in the midtones and shadows, and adequate highlight contrast. Some trial and error, combined with experience, is required for this method.

High-Key and Low-Key Printing: A high-key picture is one that has a preponderance of light tones.

When a low-contrast paper is used to match the long density range of a negative made of a high-contrast subject, the local contrast can appear soft. By increasing the local contrast, the print quality is improved. This print was made by the two-filter method with a selective-contrast paper.

A straight print of the negative used to make the above illustration shows the relatively low local contrast that results when the paper contrast is matched to the negative density range.

77

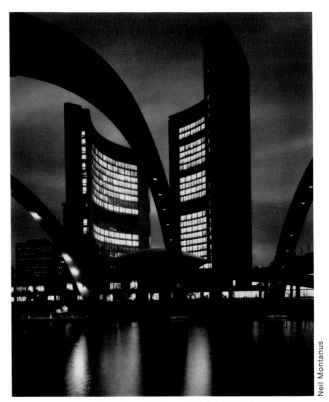

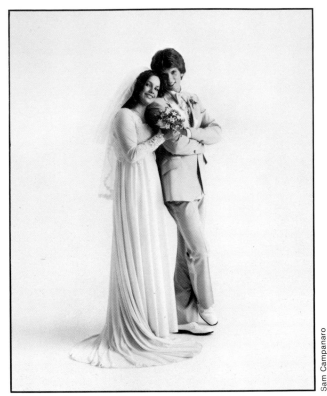

A low-key picture that still has small light-toned areas.

Neil Montanus

A high-key picture that still retains enough density in the faces to retain good facial tones.

Sam Campanaro

Pictures taken for high-key prints are usually softly lighted so that there are no deep shadows. True high key is achieved when the print is exposed on a very low contrast paper. However, this eliminates all deep tones, and such prints have a "weak" appearance. A good approach is to make the basic exposure with a PC1 filter on a selective-contrast paper, and then make a second, very short exposure with a PC4 filter. The second exposure should be just enough to darken the darkest print tones somewhat. In a portrait, this would be the eyelashes and the pupils of the eyes. These dark tones add strength to the print and make the light, high-key tones look lighter.

A low-key picture is one that has a preponderance of dark tones. Depending on the subject, the dark tones may contain detail, or may be printed to have large areas of solid black. It is important in low-key pictures to have at least small areas of middle, light tones and white to keep the low-key print from looking "muddy." Usually, a low-key print is printed normally, with printing in and holding back being used to achieve this kind of tonal distribution. Another method is to print for correct dark tone rendition, and to lightly bleach the entire print, which lightens the light tones without affecting the darker tones.

Flashing: Burning in darkens tonal areas while retaining tonal differences in the detail. There are times when an area is to be darkened where it is

desirable to reduce the tonal differences. The usual purpose is to subordinate background areas that have full contrast and hence compete visually with the main subject. The tone is darkened and contrast is reduced by a technique known as "flashing." Basically, flashing is exposing the parts of the paper to be darkened with an even exposure of light.

One method is to make the basic exposure, burning in and holding back as desired. Then, without moving the paper, the negative is removed from the enlarger and the enlarger lens is stopped down. Finally, using burning-in cards to control the areas to be flashed, the paper is exposed to the light from the enlarger. By moving the card over quite an area, the flashed tone can be graded from light to dark. This is especially useful to darken the edges of a plain background in a formal portrait.

A card with a hole in it can be used to flash small areas.

An alternative method for flashing small areas is to equip a flashlight with a diffuser and black, cone-shaped hood. A circle of matte acetate, ground glass, or opal plastic cut to the size of the flashlight lens serves as a diffuser. The cone can be cut from black paper and taped on the front of the flashlight. A hole about a half-inch in diameter is left at the apex of the cone.

The light from this flashing tool can be used to flash areas of the print while it is being exposed. A red filter can be placed under the enlarging lens and

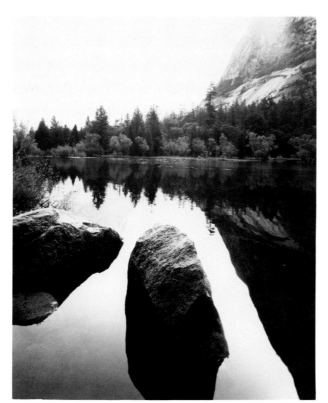

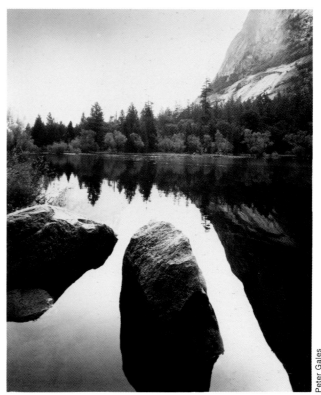

Peter Gales

Flashing is useful for adding tone to an area of a print that otherwise would print pure white.

The effects of flashing can be seen in the before (above left) and after (above right) example illustrations.

the enlarger turned on so that the image can be seen on the paper to locate the flashing if it is done after the main exposure.

Flashing can cause a false look if it is overdone. Burning in or holding back still prints fine photographic texture or grain in the controlled areas. Flashing does not; it creates a perfectly even tone on the paper. If the negative is fairly large and is enlarged only a few diameters, the grain texture is invisible, and the difference between the image made by the negative and flashing is not usually noticeable. When a small negative is enlarged many diameters, however, the print may show a slight grain texture, and the areas flashed will not have the texture and so will look different.

Flashing can also be used to reduce the overall contrast of a paper if the negative contrast range exceeds the limit of a certain paper. This is useful when a negative with exceptionally high contrast must be printed on a paper that is available in a limited number of contrast grades, such as KODAK PANALURE Paper or KODAK EKTALURE Paper. A carefully controlled overall pre- or post-flash can reduce contrast by about one grade. Beyond that, unacceptable image fogging can result.

Vignetting: A vignette is a photograph, usually a portrait, where the subject is made to stand out against a white background by having the background shade gradually into imprinted paper. The most suitable subject is a head and shoulders por-

trait, but other subjects are occasionally vignetted. A picture in which the background is naturally light yields the most pleasing result. Pictures with dark backgrounds are very difficult to vignette so that the area of the background right around the subject does not show up as a dark ring.

A vignette is made by burning in the subject during the enlarging exposure so that the background gets no exposure at all. A hole is cut in a card. The hole is elliptical in shape, although odd shapes that follow the subject shape are often needed. A sharp-edged hole cut only slightly smaller than the enlarged subject image will exclude as much of an unwanted background as possible. If a softer gradation is desired, the edges of the hole can be serrated, or a smaller hole used, held closer to the enlarger lens, and kept moving during the enlarging exposure.

Some pictorial subjects are suitable for vignetting, especially those with water or snow in the foreground and with a light sky behind the subject. The subject can be made to appear floating in space.

To make the most of the white background, the subject is usually printed relatively smaller than it would be in a picture with a background. While spacing the image in the frame is up to the judgment of the printer, it is common practice to have even space at each side, a little more space at the top than at a side, and a little more yet at the bottom.

It is usually a help to print a vignette on a soft grade of paper; harder grades tend to give hard edges to the vignette.

Vignetting is similar to holding back, but it is done for the entire exposure time. Busy backgrounds can be removed by vignetting.

The diffuser is held near the lens and moved slightly during the exposure. If less diffusion is desired, the diffuser is used for just part of the exposure time.

One use of diffusion in printing is to smooth out skin tones. Below is the before picture. The print on the next page was printed with diffusion.

Two layers of black tulle stretched on a frame make a good diffusion tool.

Bob Clemens

Some enlargers are built with tilting lens brackets or negative carrier brackets, or both, so that distortion can be corrected.

Image Diffusion: Most photographic images are printed as sharply as possible. However, there are some pictures in which the sharp lines and details are softened or blurred slightly by diffusion of the image during enlarging.

Diffusion is best accomplished in the camera by use of a soft-focus lens or a diffusing screen with a regular lens. Some diffusing screens are called fog filters. This is because, in the camera, the light areas are diffused over the dark areas, creating a pleasing, brilliant appearance. Diffusing during enlarging, on the other hand, diffuses the dark areas over the light, often reducing the brilliance of the print.

The need often arises, however, to diffuse a print from a sharp negative already made. This is the type of diffusion discussed here.

A diffused print image is not the same as an out-of-focus image. In the out-of-focus image, nothing is sharp. In a diffused image a soft image overlays a sharp image; hence, the diffused image is more acceptable visually.

A diffusion screen is a sheet of clear glass with concave lines or dimples polished into its surface. The flat areas of the screen allow image light from the enlarger to form a sharp image on the paper. The pattern lines in the screen throw the image light out of focus, forming a soft image. Hence the sharp-soft final diffused image.

Such screens are advertised in the photographic magazines. An alternative method is to use one or

This picture was taken with the camera angled upward to include the top of the building. As a result, the vertical lines are converging.

more layers of black or dark-colored net nylon or similar fabric stretched on a frame, such as an embroidery hoop. Black tulle* has a hexagonal net pattern that works very well. The diffusing material is held near the lens and moved during the exposure of the print. Yet another alternative is to use a piece of thin transparent plastic sheeting such as that found on a cigarette package. The material is crumpled into a tight ball, flattened out again, and cemented over a hole cut in a piece of cardboard.

The diffusion can be done for part of the exposure time or all of it, depending on the effect desired. With glass diffusing screens there is a possibility of causing a double image with partial diffusing exposures if the glass surfaces are not exactly parallel.

Diffusing tends to lower the contrast of prints. This can be compensated for by using a higher contrast paper.

Diffusing is often used to lessen the appearance of wrinkles in portraits without eliminating them. It is also used to reduce the visibility of retouching on negatives that are being enlarged. Another use is to give an old-time look to landscape photographs.

Making Lines Parallel: Humans are used to seeing vertical lines, such as the edges of buildings, as parallel. However, when a camera is aimed up or aimed down at an angle, the vertical lines in the negatives cease to be parallel, and converge or diverge. Within limits, the lines can be made parallel in the print. Correcting the lines requires space around the subject and results in an elongation of the subject image.

The negative is placed in the enlarger so that the lines to be corrected are approximately parallel to the

*Wedding veil material, blackened with a felt-tip pen, can be substituted for black tulle.

82

The wedging has been minimized in this print using the Scheimpflug principle.

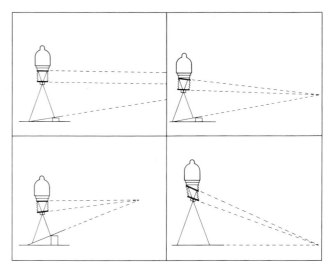

In the upper left drawing, neither the negative nor the lens brackets are tilted. The easel is tilted slightly for minor wedging correction. The lens is stopped down to give enough depth of field to maintain sharpness. In the other three drawings, the Scheimpflug principle is met in three different ways, using tilting negative and lens brackets, and tilting easel.

front of the enlarger. The enlarger is tilted or, if it has a tilting negative plane, the plane is tilted. If the convergence of the lines gets worse, tilt the other way. Then the easel is tilted by propping up one edge with blocks, books, or other spacing objects. The edge to be tilted up is the edge where the negative is closest to the easel. If the lens can be tilted also, it is tilted slightly so that the image comes in focus over all the easel surface. As shown in the drawing, if extensions of the negative plane, lens plane, and easel plane meet in a single line (shown as a point in the drawing), the image will be in focus overall. The various tilts are adjusted until the image lines are parallel.

It will be seen that the entire image has become a trapezoid in shape. The easel cuts off the wide parts of the trapezoid and makes a rectangular print. This is why the extra image area around the subject is required.

The lines are made parallel because one end of the negative where the lines are closest together is being enlarged more than the end where the lines are farthest apart. Because of the tilt, the length of the image increases. This means that the building will look taller than it really is in relation to its width.

If the available enlarger does not have tilting features, some degree of correction can be obtained by simply tilting the easel. The enlarging lens has to be stopped down to its smallest aperture to get enough depth of field to make the print sharp.

The same technique can be used to change the relative size of objects at different locations in the image. The illustration of the cat shows how the relative size of the paw has been reduced compared to the size of the head, resulting in a better proportioned cat.

When the camera is close to the subject, the closest parts of the subject are enlarged compared to the rest of the subject. In this picture, the size of the cat's paw is exaggerated.

Using the Scheimpflug principle, the size of the cat's paw relative to the cat's face has been reduced. Note that the cat's face has been lengthened.

This print is the result of two negatives being sandwiched together. The lettering across the top came from an overlay negative made on KODALITH Film placed in contact with the paper during the print exposure.

A print from the inset negative used to make the above sandwich print. The bottle was photographed against a black background to provide a clear negative area around the bottle.

The print from the background negative used to make the sandwich print. Negatives used for this purpose must have a relatively clear area where the inset is to be placed.

Multiple Image Techniques

Combination Printing: Combination printing is the successive printing of images from two or more negatives to make a print that generally looks as though it had been printed from one negative. In some uses, however, the images are allowed to overlap on the print, so that a double- or multiple-exposure effect is obtained. When made from just two negatives, such a print is said to have been double-printed.

Combination printing is commonly used to add clouds to a clear sky, to join together two or more sections of a panorama, or to change the background behind a figure.

Sandwich Combination Printing: When two or more negatives are "sandwiched" together, placed in the negative carrier, and printed at one time, the process is known as sandwich or simultaneous combination printing.

This process can be done only when at least one of the negatives has been exposed with a black background so that the negative has a large clear area. One common example of sandwich printing is the adding of a moon to a twilight scene. The moon is exposed when it is dark so that the image of the moon is a small dark area in an otherwise transparent negative. When it is sandwiched with the negative of the twilight scene, the moon prints as though

A contact texture screen is placed in close contact with the paper, and the negative image is projected through the screen.

Charles Miller

An etching pattern texture screen was used to make this print. The pattern is not obvious in the reduced halftone.

it were in the sky in the original scene. It is important to match the size of the moon with that of the scene so that it looks natural.

A less common usage of sandwich printing is the placement of light figures in dark areas of another picture. As with moon pictures, the scale of the inserted figures must be suitable for the overall picture. If there is other detail in the figure negative, it is often removed from the figure negative with KODAK Farmer's Reducer.

Using Texture Screens: A special type of combination printing is the use of a texture screen as one of the negatives. A texture screen is a fairly weak negative of a textured surface. Texture screens are available commercially or can be made by photographing a textured surface, usually with grazing light to emphasize the texture.

Texture screens can be negative size and sandwiched with the negative in the carrier. The contact between the two negatives should be close, so glass carriers are usually recommended.

Other texture screens are print size and are placed on top of the paper and held flat with a sheet of glass. The negative is enlarged through the screen.

Tissue paper, various types of fabric, drymounting tissue, and other materials can also be used as texture screens. Use of canvas or etching pattern screens can give a feeling of age to a picture. When the texture is of a rock or weathered-wood

surface, a certain mood is added to the photograph.

There is also a practical reason to use a texture screen. If a negative is slightly unsharp, or if the image section is quite small and being enlarged many diameters, the use of a screen will add a feeling of sharpness to the pictures and can make graininess less obvious.

The exposure time with a texture screen is somewhat longer than without it.

Successive Combination Printing: As the name implies, successive combination printing consists of exposing various areas of the paper to images from two or more negatives one after the other. The process may be simple, as when clouds are added to a sky in a picture with a straight horizon line. If the foreground subject extends into sky area, or if the horizon line is moderately complex, as with mountains, the blending of the two negatives requires a shaped dodging edge. This can be cut from cardboard. If the main subject has a very complex shape, the combination printing may require the use of masks made on an extremely high contrast film to separate the images from each negative into their carefully defined print areas.

It is quite important in this type of printing that the lighting of the subject in each negative match that of the other negatives in quality and direction. Combining a negative of a softly lighted subject with another in which the subject exhibits strong

A simple and effective use of combination printing is taking the sky from one negative and the foreground from another negative.

W. Arthur Young/Jerry Billings—Lab

The clouds in this picture are more dramatic than those in the original photograph at lower left.

The overcast sky in this picture is relatively uninteresting.

W. Arthur Young

highlights and shadows results in a combination print that looks false. Just as serious is combining negatives of back- or sidelit subjects with another where subjects are frontlit. It is also important that the light in each of the combined subjects comes from the same direction.

Adding Clouds to a Sky: Very often outdoor pictures are taken when the sky is cloudless or when the clouds are not exactly suitable for the subjects. A major use of combination printing is to put suitable clouds from another negative in the sky of such a picture.

Once the two negatives are selected, the procedure is straightforward. The subject negative is exposed on a sheet of paper. The sky portion is held back so that it does not print. This is simple if the horizon is a straight line or of a fairly simple shape. If it is of a moderately complex shape, a dodger is cut to this shape and moved slightly during the exposure. The paper is marked so that it can be replaced in the easel with the same orientation, and replaced in the paper box or lighttight drawer.

The cloud negative is placed in the enlarger, and the image is sized and focused. The paper is placed in the easel in the same orientation and exposed to the cloud image, while the area covered by the subject is held back. The paper is processed normally.

Jerry Uelsmann

Jerry Uelsmann is an outstanding multiple-image craftsman. His prints portray an unreal world by the careful selection of images that would not coexist in reality, but which combine in an artistic visual manner.

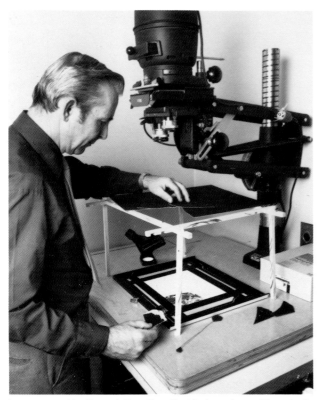

In some combination printing, the effect is to end up with a single picture from two or more negatives. A montage is a type of combination print where the picture images are intended to be viewed as separate images, yet the edge detail of one image blends into the edge detail of those images around it. In the picture to the left, the enlarger is set up to print a single image. The framework supports cardboard masks about halfway between the lens and the paper that vignette each image as it is enlarged. The masks are changed for each negative.

A full-sized guide is drawn on a piece of paper to be sure that each negative will cover the correct area. It is placed in the easel while the masks are arranged. A test print provides proper density, size, and location. The guide drawing shown above is for the montage on the next page.

Although the procedure is straightforward, there are several factors that must be considered. To know the correct exposure for each negative, test strips have to be run at the magnification at which each is to be printed. Also, when dodging the sky, the shape of the subject is not visible, and the dodging must be done by remembering where the subject was on the paper and its size. It is helpful to place white-tape guide marks on the easel masks to follow in locating the position of the dodging card.

A good plan to follow is to expose several sheets of paper to the first negative and to store them in the dark. Then expose one sheet to the second negative and process it. If errors in dodging have been made, corrections can be introduced in printing the second sheet. By making several prints in this way, the chances of getting a good combination print are enhanced.

It is helpful to have two enlargers for combination printing. In this way, one negative can be put in each enlarger, and the image sized and focused. Then the paper can be exposed successively in each enlarger.

While graded papers can be used for combination printing, it is often useful to use a selective-contrast paper. Each negative can be printed with a different PC filter to match the contrast of the negatives in the print.

Double-Exposed Combination Prints: In this type of combination print, the detail in the images of various negatives is allowed to overlap intentionally to create a special effect. The main subject of one negative is printed in an area of another negative that has minimal detail. Those edges of the areas are dodged so that overlapping detail is seen. In this type of printing, the exposure time given each image that overlaps is usually less than that required to produce a normal print density because the exposure from each negative is additive.

Making Montages: A montage is a print made from several negatives in which the edges of one image are blended into the edges of another image.

A layout is made of paper the size of the first print, and the positions and edges of the various images are marked on the layout. This layout is placed in the easel, and one of the negatives is put in the enlarger and the image sized and focused in the space allotted to the image. The layout is located so that the image is located in the proper space.

The edges of the image must overlap the adjacent spaces. Tests are run to determine the proper exposure. Then a sheet of paper is marked so that it can always be placed in the easel with the same orientation. The paper is exposed to the image, dodging all the edges of the image so that they vignette into the adjacent image areas.

Each negative is printed in turn in the same manner until all the spaces are exposed. Then the print is processed. It is important with both the tests and the final print that the development times be consistent to make the images have the same relative densities.

Because of the extended period of time that the paper will be exposed to safelight, it is wise to in-

A group of informal portraits or snapshots can be grouped into a family montage using the techniques shown on the opposite page. Other uses for montages are to combine various views of a single city or a state or national park, various outdoor views of a manufacturing facility, various buildings of a school or college, a number of interior views of a building or a factory, or even some scenes of a play. Any group of pictures that have a common theme and which are better tied together visually than being presented individually are suitable for montaging.

crease the distance of the safelight, or to reduce the safelight filter area by masking to avoid the chances of fogging.

It is also wise to run several sheets through the exposure procedure because it is fairly easy to make a mistake with so much handling. If an error is made on one sheet, there are still others that have been properly exposed up to that point.

Double Printing Using Photographic Masks: When the image of the figure on one negative is to be printed with a detailed background from another negative, and the line between the two must be sharp, a registered masking method can be used.

Registration punches and pin strips are used to mask prints made by the dye transfer process and are also used in the graphic arts industry to make color separations. They can be purchased through a dealer handling Kodak products or from a graphic

arts supply dealer. Pin registration is the key to having an accurate outline between the figure and the background in a masked print made from two negatives.

The negative with the figure is placed in the enlarger, and the image sized and focused on the easel that has been equipped with a pin strip. This is a thin strip of metal on plastic with two pins located on the strip. A sheet of an extremely high contrast film, such as KODALITH Ortho Film, Type 3, is punched with a precision punch that makes two holes along one edge of the film that are of a size and spacing to fit the pins on the pin strip. The film is exposed to the enlarged image and processed in a high-contrast developer such as KODALITH Developer. An extremely high contrast positive image of the figure results.

If the figure is a light figure on a dark background, the film image will have a dark figure on a light

The pin-register setup for the drop-out masking method of combination printing and one mask is shown above.

The mask for printing the drop-in area is shown above.

background. However, there are also likely to be light areas in the dark figure and dark areas in the light background. The light areas in the figure are opaqued with a retouching paint such as KODAK Opaque; either the black or red (really brownish red) colored opaque is satisfactory.

Some workers remove the dark areas in the light background with KODAK Farmer's Reducer. Others remove it by making a contact print of the first mask, which reverses the tones, and opaque the light areas on the now black background. A third mask is made by contact-printing the second mask on the KODALITH Film. This is similar to the first mask, but it now has a perfectly clear background. The registration has been maintained by using the pins each time contact printing is done.

The second mask is used to print the figure. The enlarger and easel with the pin strip has been left unchanged. A sheet of paper is punched and placed on the pins. The appropriate mask is placed over the paper and weighted down with a clean sheet of glass to give good contact. The exposure is made of the figure in the clear area of the mask. The dark area of the mask completely holds back any exposure of the background. Several sheets are exposed this way, but not processed.

The background negative is placed in the enlarger and the image sized and focused. One of the exposed sheets is placed on the easel, using the pins. The third mask is placed over the paper and weighted down with the glass. The background is exposed, and the print is developed.

If the choice of negatives was good and the work was done carefully, the print should show the figure against the background of the other negative with no lines showing around the edges of the figure.

These techniques are covered in more detail in KODAK Publication No. AG-18, *Creative Darkroom Techniques.*

Proof Prints

Proof prints are usually contact prints made to evaluate the images on negatives. They need not be permanent, so they may be processed by stabilization or on a printing-out paper, such as KODAK Studio Proof Paper. They may be produced for one's own use to select the best images, or they may be provided for a client's use. When a selection has been made, the approved proofs can be marked to indicate what special treatment should be given the print when it is enlarged.

Roll Film Proofs (Contact Sheets): It is fortunate that all the negatives on a 36-exposure roll of 35 mm film, or on a roll of 120 film will fit on an 8 x 10-inch (20.3 x 25.4 cm) sheet of paper. To proof a roll, the 35 mm roll is cut into six sections of six negatives each. They are laid out on a sheet of a soft-grade paper, and a sheet of glass is placed over them to provide contact. They are then exposed to enlarger light and processed.

Low-contrast paper provides more latitude for exposure variations between negatives; therefore,

This is the mask for printing the background area.

The final combined print. The printing was added with a high-contrast contact overlay negative placed on the paper during the exposure.

When the background is printed through the appropriate mask, a white area is left for printing the drop-in subject.

When the drop-in subject is printed with the appropriate mask, all the rest of the print area is left blank.

A whole sheet of small-camera negatives can be contact-proofed using the enlarger as a light source.

When the photographer does not do his own printing, he can mark a proof with symbols to show the lab technician how to crop, flash, burn in, and hold back when making a print. The symbols recommended by Berry Homer, Inc. of Philadelphia are shown here.

most of the detail in each negative will be visible, even though the contrast may be low. This type of proof is usually called a contact sheet. Some difficulty is usually encountered in getting the negatives to lie flat and not move when the glass is placed on them. If proofing is to be done on a regular basis, it might be wise to invest in a proofing print frame that is provided with slots to hold the film sections in place.

A roll of 120 film is cut into three sections. If the images are 2¼ x 2¼ inches (6 x 6 cm), there will be four negatives in each section. If the image size is smaller, 2¼ x 1⅞ inches (6 x 4.5 cm), or larger, 2¼ x 2¾ inches (6 x 7 cm), there will be correspondingly more or less images in a section.

If one of the sections is underexposed or overexposed, it can be placed along one edge and given less or more exposure using a dodging card.

Marking Proofs for Special Treatment: Photographers may mark a print for special treatment if they want to remind themselves what they want to do to the print when enlarging it themselves, or to indicate to someone else who will be doing the enlarging what is to be done.

The illustration shows some markings often used to indicate areas that are to be held back, burnt in, flashed, etc.

A contact sheet is also shown with one proof marked for special treatment.

The markings shown are commonly used, but there is no standard for proof marking, and other markings are sometimes employed.

Portrait Proofs: Proofs are made from portrait negatives to allow customers to choose the pose or poses that they wish to have printed. They are usually made from negatives that have not been retouched. Two approaches are used.

If a proof paper with a highly textured surface, such as KODAK Portrait Proof Paper, is used, wrinkles and blemishes tend to be minimized. If the prints are made somewhat soft and light, the effect is maximized. Since this paper is processed normally, such prints have relatively stable images.

The other approach is to use a paper with a short-life image. KODAK Studio Proof Paper is a printing-out paper that darkens on exposure to light. It is contact-printed by exposure to a strong light source with high ultraviolet content. On further exposure to light, the paper gradually darkens until the image becomes so dark it cannot be discerned.

A proof print is shown with markings indicating how the print should be made.

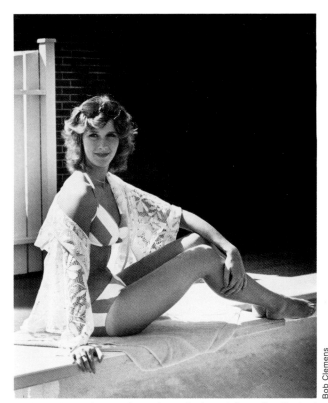

Bob Clemens

The final print made according to the marked proof shows the effects of the enlarging controls.

Making B/W Prints from Color Negatives

Sometimes it is necessary or desirable to make a black-and-white print from a color negative. Ordinary black-and-white paper is not designed for this purpose. If you were to make a print from a color negative on ordinary black-and-white enlarging paper, it would be similar to using a cyan filter over the lens of your camera when using panchromatic black-and-white film. Black-and-white paper is sensitive mainly to blue and green light. Consequently, when printing a color negative on ordinary black-and-white paper a gray-tone rendition of colors approximating their visual brightness is not achieved. Object surfaces that were red in the original scene appear too dark, and objects that were blue appear unnaturally light. This effect is particularly noticeable in flesh-tone renderings, where skin tones take on a darker appearance, blemishes are accented, and red lipstick prints almost black.

KODAK PANALURE Papers are panchromatic papers designed to produce black-and-white prints from color negatives. With KODAK PANALURE Papers a more normal gray-tone rendition of colors is achieved for objects of all colors. The result is similar to a subject photographed on panchromatic black-and-white film. Printing with KODAK PANALURE Papers is the same as with conventional black-and-white papers except that a different safelight must be used. KODAK Safelight Filter No. 13 (amber) with a 15-watt bulb no closer than 4 feet away is recommended. Some workers print these papers with no safelight.

An additional advantage of KODAK PANALURE Papers is that you can use color filters when printing to get effects that are similar to using filters over the camera lens with panchromatic film. To lighten the gray-tone rendering of an object, use a filter over the enlarger lens similar to the color of the object. This affects all tones in the print. For example, if you use a red filter to lighten the red tones in a print, the blue tones darken.

Kodak supplies three PANALURE Papers. KODAK PANALURE Paper is a single-weight fiber-base paper available in F surface. KODAK PANALURE Portrait Paper is a double-weight fiber-base paper on a white stock, available in E surface. KODAK PANALURE II RC Paper is a resin-coated paper with a developer-incorporated emulsion, suitable for processing with a KODAK ROYALPRINT Processor or for rapid tray processing. KODAK PANALURE II RC Paper is available in F surface.

KODAK PANALURE Paper is especially useful to wedding, portrait, and school photographers in situations where all shooting is done on color negative film in order to supply color-print packages to the subjects, but where a black-and-white print of each subject is needed for school newspaper or yearbook publications. Many commercial photog-

M. Richie

94

Printing a color negative on regular B/W paper (orthochromatic) gives a tone reproduction similar to taking the picture on an orthochromatic film or on a panchromatic film through a cyan filter.

Printing the same negative on a panchromatic paper such as one of the KODAK PANALURE Papers gives a more normal tonal rendition of the various colors. The background was dark blue.

raphers also find it helpful to have a PANALURE Paper on hand for the occasional black-and-white print required from a color negative.

There are some color negatives that print well on a selective-contrast paper which has an orthochromatic emulsion. The facial tones in some color portrait negatives, for example, may appear to lack form or texture when printed on a panchromatic paper. An improvement may result when the negative is printed on one of the KODAK POLYCONTRAST Papers, or if a cyan color-compensating filter is used with the panchromatic paper (try CC50C).

The cover picture is an example. The cover illustration was printed on KODAK PANALURE II RC Paper. Inside the front cover, a color reproduction of the subject and the color negative are shown. In addition, a print made on KODAK POLYCONTRAST Rapid II RC Paper is reproduced. A careful comparison of the two black-and-white reproductions will show the differences in tone reproduction.

Chemical Treatments

Local Control in Development: When developing prints made on regular black-and-white papers, local control of densities is sometimes used. If a print image density is forming slower than usual because of slight underexposure, it is likely that the highlight areas in the final print will lack tonal separation and be too light. One answer is to keep a beaker of warm concentrated developer near the developing tray, and swab the highlight areas with this developer using a ball of cotton while the rest of the print is developed normally. Such a procedure speeds up the development of the light areas, and may make a usable print out of one that would have to be reprinted without this special treatment.

Some workers rinse the print in water (not stop bath) and place it on the bottom of an overturned tray for the swabbing operation, and then return it to the developer until the overall density is satisfactory.

If this treatment is overdone, the "pushed" areas may develop a stain. Also, if a warm image-tone paper is being processed, the treated areas may have a colder tone than other areas.

Another special treatment is sometimes used with prints that are slightly overexposed. The image "comes up" fast in the developer, so the print is placed in a tray of room-temperature water. If the

When a color negative is printed on an ortho-sensitive paper (regular B/W paper), the tonal rendition of colors is similar to that of a picture taken on a panchromatic film through a cyan filter.

When a color negative is printed on a KODAK PANALURE Paper without a filter, the tonal rendition of colors is similar to that of a picture taken on a panchromatic film without a filter.

This print was enlarged on KODAK PANALURE II RC Paper through a deep blue filter. Note the similarity of the tonal rendition with the above print.

This print was enlarged on KODAK PANALURE II RC Paper through a deep red filter. The sky is darkened, the clouds stand out, and the red barn is made lighter in tone.

96

KODAK Farmer's Reducer has several practical uses in printmaking. When taking pictures of objects against a white background, the background usually reproduces as a light gray.

If the original print is made a little dark, and the print is reduced in Farmer's reducer, the background can be made paper-base white.

Leif Skoogfors

print needs more development, it is placed back in the developer for a short time and placed in the water again. This treatment slows down the development, and allows more time to judge print density while retarding the developing rate. One effect of this treatment may be the lowering of print contrast.

The best quality prints, of course, result from correct exposure, proper holding back or burning in (or both), and developing the print the correct length of time without having to resort to special treatment.

Chemical After-Treatments: While chemical after-treatments are not strictly printing techniques, they often play a part in improving prints.

The use of KODAK Farmer's reducer can solve several print problems. This is a solution of potassium ferricyanide and hypo, available in packaged form or mixed from a formula. It reacts with the

silver in the image, changing it to a soluble salt that is washed out of the print, thus reducing the density. It is used both locally and overall.

When a print is slightly dark, it can be lightened by treatment in a tray of dilute Farmer's reducer. This will reduce the silver, lightening the print densities. The action is stopped by placing the print in a tray of fixer.

If the overall density is about right, but the highlights are slightly dark, giving a muddy appearance to the print, the highlights can be reduced locally by swabbing the highlight areas in the wet print with dilute Farmer's reducer, using cotton balls, cotton swabs, or if the areas are very small, a spotting brush. This can be especially useful in prints made from copy negatives.

If shadow areas need lightening up, local reduction can be used to reduce their density.

Care must be taken not to overdo bleaching. Too much reduction can give a false look to a print. If the bleaching is carried too far, a yellow-brown stain can be formed that is nearly impossible to remove.

When the hypo and the ferricyanide solutions are mixed together, the solution life is limited. If the color changes to a greenish color, discard the solution and replace it with fresh.

If prints are too light, it is simpler and more satisfactory to remake them rather than to try to intensify them.

Toning

Toning is a treatment of a finished print in a chemical solution, usually to change the color of the print image. It has also been found that most Kodak toners add to the life of a print by protecting the silver image against the effects of oxidizing gases in the air. (See the section entitled ''Processing for Image Stability'' on page 103.)

The toners usually used provide either a brown or a blue tone to the image. KODAK Brown Toner and KODAK Sepia Toner change the silver image into silver sulfide, a brown-colored chemical salt. KODAK Rapid Selenium Toner changes the image into a silver selenide salt (also brown colored). KODAK POLY-TONER changes the image to part sulfide and part selenide. KODAK Nelson Gold Toner T-21 creates a brown image by ''plating'' the silver in the image with gold, while KODAK Blue Toner T-26 creates a blue image with gold.

The directions for use of Kodak proprietary toners are given on the bottles or packages. The toners with a T in the name are formula toners, and the formulas are given in KODAK Publications No. J-1, *Processing Chemicals and Formulas*, and No. G-23, *The ABC's of Toning*. The formula for KODAK Blue Toner T-26 is just now being made available, so it is included here:

KODAK Blue Toner T-26

Part A—Solution

Water	31.0 mL
Gold Chloride*	0.4 gram

*Gold chloride crystals readily absorb moisture from the air. The crystals should be stored in a tightly sealed moistureproof container.

Part B—Powder

Thiourea	1.0 gram
Tartaric Acid	1.0 gram
Sodium Sulfate, Anhydrous	15.0 grams

Dissolve the gold chloride in the water with stirring to make the Part A solution. Add Part A to one U.S. quart (946 mL) of water at about 125°F (52°C). While stirring, add Part B and continue stirring until the chemicals are dissolved completely.

Note: A fine, white precipitate may appear in the solution when kept overnight. This does not impair the properties of the toner.

The price of gold chloride has risen to keep pace with the price of gold, so that this is a fairly costly toner. A 1 percent gold chloride solution can be obtained from Light Impressions, 131 Gould Street, Rochester, New York 14610. Use 40 mL of this solution as Part A, and add to 937 mL of water to make a total of 977 mL of solution.

For best results, the solution should be made fresh prior to toning. Prints to be toned must be washed free of fixer. Tone for 8 to 45 minutes at 68°F (20°C) or from 100°F to 105°F (38°C to 40.5°C) for 2 to 15 minutes. From five to fifteen 8 x 10-inch (20.3 x 25.4 cm) prints or equivalent can be toned per quart of solution, depending on the degree of toning.

The exact color achieved varies with the paper and the developer (see color plate on back cover), but in general is a soft, gray-blue and not a vivid, saturated blue.

Color and Density Changes in Toning: The degree and color of toning varies from paper to paper with a particular toner. In some instances, an increase in density and contrast results from toning. For example, the use of KODAK Rapid Selenium Toner usually increases the D-max and contrast, whether there is a change in color or not. Some workers use this toner with neutral or warm-black image-tone papers to increase the tonal scale.

The Toning Effectiveness Table: As indicated above, the paper, paper developer, and toner all affect the color of the final print. Some paper-toner combinations do not produce any color change at all. The degree of tone change is indicated in the table on page 99 by a letter.

These letters denote the degree of color change under most conditions. Toning processes are not, however, as predictable as most other photographic processes, and there may be times when prints will tone more or less than the table indicates. For example, if a print is dried and then soaked and toned, the results may not be the same as if the print were toned while still wet from the wash.

Toners also can provide effective protection of the silver image of a print from harmful oxidizing gases present in the atmosphere or released by wood, wood by-products, or varnishes that are commonly found in frames or furniture used to store photographs. Toners that are recommended for protection of the image are KODAK Rapid Selenium Toner, KODAK POLY-TONER, KODAK Sepia Toner, KODAK Brown Toner, KODAK Sulfide Sepia Toner T-7a (similar to KODAK Sepia Toner), KODAK Polysulfide

Toner Effectiveness with KODAK B/W Papers

KODAK Toners

KODAK Papers	KODAK Developer	POLY-TONER 1:4	POLY-TONER 1:24	POLY-TONER 1:50	Brown	Poly Sulfide T-8	Sepia	Sulfide Sepia T-7a	Hypo Alum	Rapid Selenium 1:3	Rapid Selenium 1:9	Gold T-21	Blue T-26
AD-TYPE A2*	DEKTOL	M	M	M	F	F	F	F	F	M	S	M	M
AZO F2*	DEKTOL	M	M	M	F	F	F	F	F	M	S	F	M
VELOX F2*	DEKTOL	S	S	S	M	M	F	F	F	S	N	M	S
EKTALURE	SELECTOL	F	F	F	F	F	F	F	F	F	F	M	M
EKTAMATIC SC 2309	DEKTOL	N	S	S	M	M	F	F	S	N	N	N	S
	‡	S	S	S	S	S	F	F	N	N	N	S	S
KODABROME II RC F2*	DEKTOL	S	M	M	F	F	F	F	S	N	N	M	S
		N	S	S	M	M	F	F	S	N	N	M	S
KODABROMIDE F2*	DEKTOL	N	S	S	S	S	F	F	S	N	N	N	S
MEDALIST F2*	DEKTOL	N	S	M	M	S	F	F	M	N	N	N	S
Mural R2*†	SELECTOL	M	M	F	F	F	F	F	F	M	M	N	M
PANALURE II RC	DEKTOL	S	M	M	M	M	F	F	M	S	S	S	S
	§	S	S	S	M	M	F	F	M	N	N	S	S
PANALURE	DEKTOL	N	S	S	F	F	F	F	M	N	N	N	S
PANALURE Portrait	SELECTOL	M	F	F	M	M	F	F	F	F	F	M	F
POLYCONTRAST	DEKTOL	N	S	S	M	M	F	F	F	S	S	M	S
POLYCONTRAST Rapid	DEKTOL	S	M	M	F	F	F	F	M	S	N	S	S
POLYCONTRAST Rapid II RC	DEKTOL	N	S	S	F	F	F	F	M	S	S	S	S
	§	N	S	S	M	M	F	F	S	S	N	S	S
Portrait Proof	SELECTOL	F	F	F	M	M	F	F	F	F	M	F	F
PREMIER II RC	DEKTOL	N	N	N	N	N	F	F	S	S	N	N	N
	§	N	N	N	N	N	F	F	S	N	N	N	N
VELOX UNICONTRAST	DEKTOL	S	M	M	M	M	F	F	M	M	S	M	N

*Other contrasts may produce slightly different tone changes.

†WRM surface shows less tone change than R surface.

‡Processed in the KODAK EKTAMATIC Processor, Model 214-K, then fixed and washed.

§Processed in the KODAK ROYALPRINT Processor, Model 417.

The toning effectiveness symbols have the following meanings:

N — **No change in tone**
S — **Slight change in tone**
M — **Moderate change in tone**
F — **Full change in tone**

Note: Where the Kodak developer name is given, the prints were tray-processed prior to toning in the developer named, diluted as recommended, for the recommended time as given in the Data Sheets. Toning was done as recommended on the toning instructions supplied with the Kodak toners. Toning with the Kodak formula toners was done as recommended in KODAK Publication No. J-1, *Processing Chemicals and Formulas*.

Paper/Toner Combinations

The following chart lists combinations of KODAK Papers and KODAK Toners that produce tones similar to those shown in the illustration on the back cover. Unless otherwise specified, the KODAK Developer is DEKTOL, diluted 1:2, used at 68°F (20°C).

A. Neutral Tones

POLYCONTRAST—No Toner
MEDALIST—No Toner
KODABROMIDE—No Toner
KODABROME II RC—No Toner
POLYCONTRAST Rapid II RC—No Toner
PANALURE—No Toner
EKTALURE—SELECTOL 1:1, Blue Toner T-26
POLYCONTRAST G—Blue Toner T-26*

B. Reddish Brown Tones

POLYCONTRAST—Brown Toner
KODABROME II RC—Brown Toner
KODABROME II RC—Brown Toner†
POLYCONTRAST Rapid II RC—Brown Toner
POLYCONTRAST Rapid II RC—Brown Toner†
PANALURE II RC—Brown Toner
PANALURE II RC—Brown Toner†
KODABROME II RC—Sepia Toner†
POLYCONTRAST Rapid II RC—Sepia Toner
POLYCONTRAST Rapid II RC—Sepia Toner†
KODABROME II RC—Hypo Alum Sepia Toner T-1a
POLYCONTRAST—Hypo Alum Sepia Toner T-1a
MEDALIST—Hypo Alum Sepia Toner T-1a
Mural—SELECTOL 1:1, Hypo Alum
 Sepia Toner T-1a

C. Purplish Brown Tones

POLYCONTRAST—POLY-TONER 1:50
KODABROME II RC—POLY-TONER 1:50
KODABROME II RC—POLY-TONER 1:50†
POLYCONTRAST Rapid II RC—POLY-TONER 1:50
POLYCONTRAST Rapid II RC—POLY-TONER 1:50†
PANALURE II RC—POLY-TONER 1:50
PANALURE F—POLY-TONER 1:50
POLYCONTRAST G*—POLY-TONER 1:50
MEDALIST—POLY-TONER 1:50
EKTAMATIC SC—POLY-TONER 1:50
Mural—SELECTOL 1:1, POLY-TONER 1:24
POLYCONTRAST Rapid II RC—Hypo Alum
 Sepia Toner T-1a
POLYCONTRAST Rapid II RC—Brown Toner†
POLYCONTRAST G*—Rapid Selenium Toner 1:3

D. Cool-Brown Tones

POLYCONTRAST—Sepia Toner
KODABROME II RC—Sepia Toner

KODABROMIDE—Sepia Toner
MEDALIST—Sepia Toner
EKTAMATIC SC—Sepia Toner
PANALURE II RC—Sepia Toner
PANALURE II RC—Sepia Toner†
POLYCONTRAST G*—Brown Toner
POLYCONTRAST G*—Hypo Alum Sepia Toner T-1a

E. Blue-Gray Tones

Portrait Proof—SELECTOL 1:1, Blue Toner T-26
Mural—SELECTOL 1:1, Blue Toner T-26
PANALURE Portrait—SELECTOL 1:2, Blue Toner T-26

F. Warm-Black Tones

EKTALURE—SELECTOL 1:1, No Toner
PANALURE Portrait—SELECTOL 1:2, No Toner

G. Warm-Brown Tones

EKTALURE—SELECTOL 1:1, Brown Toner
POLYCONTRAST G*—Sepia Toner
PANALURE Portrait—SELECTOL 1:2, Brown Toner

H. Chocolate-Brown Tones

EKTALURE—SELECTOL 1:1, POLY-TONER 1:50
PANALURE Portrait—SELECTOL 1:2,
 POLY-TONER 1:50
PANALURE Portrait—SELECTOL 1:2,
 Hypo Alum Sepia Toner T-1a
Mural—SELECTOL 1:1, Sepia Toner

I. Yellow Sepia Tones

EKTALURE—SELECTOL 1:1, Sepia Toner
PANALURE Portrait—SELECTOL 1:2, Sepia Toner

J. Cool-Chocolate-Brown Tones

EKTALURE—SELECTOL 1:1, Rapid Selenium Toner 1:3
EKTALURE—SELECTOL 1:1, POLY-TONER 1:4
PANALURE Portrait—SELECTOL 1:2,
 POLY-TONER 1:24
PANALURE Portrait—SELECTOL 1:2,
 Rapid Selenium Toner 1:3

Note: Dilution of single solution toners can be varied to achieve alternate tonal changes.

Some Kodak formula toners give results similar to the Kodak packaged toners listed above.

KODAK Sepia Toner—
 KODAK Sulfide Sepia Toner T-7a.

KODAK Brown Toner—
 KODAK Polysulfide Toner T-8.

*KODAK POLYCONTRAST Paper, G surface is manufactured on a cream-white base. This tint tends to neutralize blue tones and enhance warm tones. That is the reason for the separate listing.

†With the KODAK ROYALPRINT Processor, Model 417

Toner T-8 (similar to KODAK Brown Toner).

These toners, used as directed by the packaged instructions or the instructions supplied with the formulas, will provide additional protection to the properly processed photographic print. KODAK Rapid Selenium Toner is most effective for this purpose when diluted 1:3 and toned for 2 to 8 minutes at 70°F (21°C) or diluted 1:9 and toned at least 8 minutes at 70°F (21°C). KODAK Hypo Clearing Agent used as directed after toning will shorten washing times with fiber-base papers and is recommended for maximum stability. KODAK POLY-TONER is most effective for protection when diluted 1:24. Prints should be toned for 3 minutes at 70°F (21°C). KODAK Hypo Clearing Agent used after toning as directed in the instructions with the toner is recommended for maximum stability with fiber-base prints. KODAK Brown Toner and KODAK Polysulfide Toner T-8 are effective for protective toning when they are used as recommended. KODAK Brown Toner is diluted 1 ounce (30 mL) to 1 quart (946 mL) of water. KODAK Polysulfide Toner T-8 is used without dilution. KODAK Hypo Clearing Agent is also recommended for use after toning with KODAK Brown Toner and KODAK Polysulfide Toner T-8. KODAK Sulfide Sepia Toner T-7a and KODAK Polysulfide Toner T-8 are formula toners and are published in KODAK Publication No. J-1, *Processing Chemicals and Formulas.*

If a minimum tone change is desired, but protective toning is required, a paper/toner combination that has an N or S symbol can be selected from the Toner Effectiveness chart.

Making Big Enlargements and Murals

Large prints are made in much the same way as small prints. Some of the equipment required, however, is on a larger scale and the technique of handling large sheets of wet paper is usually more difficult. In an operation where large prints and murals are made on a daily basis, a horizontal enlarger is used that accepts negatives up to 8 x 10 inches. A small enlarger can be used if it can be made to project horizontally by turning the head sideways. Another method is to swing the enlarger head so that the image can be projected on the floor. Poor lens quality, misalignment of enlarger parts, uneven enlarger illumination, and negative defects are accentuated in a large print. These problems should be corrected before attempting a mural-size print. When the original negative is small, 8 x 10-inch enlarged duplicate negatives are often made.

Large processing machines capable of processing wide sheets and rolls of paper are used in a full-scale production of large prints. Large sinks and trays are also used to process prints of this size. For the maker of occasional large prints, trays can be fabricated out of marine plywood and painted with epoxy paint. Long, narrow trays can be used instead of the conventional wide, flat trays if the prints are processed by rolling them through the solutions. A temporary tray can be made out of a wide cardboard box if it is lined with plastic sheeting.

Twin-belt matte drying machines are available for drying prints up to 54 inches (1.37 metres) wide, the widest paper size available. Large drying racks can be made by stretching muslin or plastic screening over wooden frames. Prints dried by this method are laid facedown on the racks after being sponged off with a clean, damp sponge on both sides. As a last resort, prints can be hung from a line to dry if they are weighted at the bottom to prevent curling.

Large prints can be dry-mounted on heavy illustration board or on foam-core mounting stock. The size of the mounting press or the maximum width of the paper limits the size of prints that can be dry-mounted. Many large prints are wet-mounted instead, particularly if they are murals. Murals are large prints where several prints are spliced together to form one picture. Prints can be wet-mounted on many different materials such as hardboard, cardboard-like construction board, or others. Often murals are wet-mounted directly on walls for decoration. Wet mounting is done by pasting a wet print on a board with a water-soluble adhesive. Ordinary wallpaper paste is often used. For more details about wet mounting and about making large prints and murals see KODAK Publication No. G-12, *Making and Mounting Big Black-and-White Enlargements and Photomurals.*

KODAK Mural Paper is specially made to withstand the repeated folding and rolling that is often necessary in making big enlargements. The rough surface is easy to spot and it tends to break up any objectionable grain that is visible. The slight texture and single weight also aid in minimizing the visibility of splices in photomurals. Other photographic papers can also be used. Those with a fast emulsion, however, are most suitable due to the relatively long exposure times encountered.

Corrections for the Reciprocity Characteristics of Papers: Exposure times are usually long when making very large prints. The reciprocity characteristics must be considered in making exposures. See the section entitled "Reciprocity Characteristics" on page 12.

Scenic pictures with reasonable amounts of subject detail are often suitable for photographic murals.

Processing for Image Stability

Photographic prints, if properly processed, can be expected to have a long life, barring fire, flood, gross mishandling, and other catastrophies. The paper base is very stable, and will not yellow or become brittle as do some papers. The gelatin in the emulsion, if kept at a reasonable relative humidity and temperature, can be expected to last for generations.

The silver that forms the photographic image requires some special care. If the print is not entirely free of fixer and silver complexes, the silver image, in time, will first turn yellowish in color, and then fade completely away. For image stability, complete and thorough washing is a stringent requirement. The use of washing aids such as KODAK Hypo Clearing Agent makes it easier to achieve complete washing. Making sure that the fixing bath is not overused avoids the silver complex problem. KODAK Hypo Eliminator HE-1 can be used to make sure of complete removal of the hypo.

KODAK Hypo Eliminator HE-1

Water	500 mL
Hydrogen Peroxide (3% solution)	125.0 mL
Ammonia Solution*	100.0 mL
Water to make	1.0 litre

*Prepared by adding 1 part of concentrated ammonia (28%) to 9 parts of water.

Caution: Prepare the solution immediately before use and keep in an open container during use. Do not store the mixed solution in a stoppered bottle, or the gas evolved may break the bottle.

Note: Do not use this solution on film negatives. The gas formed can cause blistering of the film emulsion, which is likely to be softer than that of a print.

Directions for use: Treat the prints with KODAK Hypo Clearing Agent or wash them for about 30 minutes at 65 to 70°F (18 to 21°C) in running water which flows rapidly enough to replace the water in the vessel (tray or tank) completely once every 5 minutes. Then immerse each print about 6 minutes at 68°F (20°C) in the Hypo Eliminator HE-1 solution, and finally wash about 10 minutes before drying. At lower temperatures, increase the washing times.

Capacity of HE-1 Solution: Fifty 8 x 10-inch prints per gallon (thirteen 20.3 x 25.4 cm prints per litre).

Protection Against Gases: The black metallic silver that forms the images in prints that are completely free from silver complexes and hypo will last almost forever in this form unless it is subjected to oxidizing gases or to intense illumination for a long period of time. Such gases include hydrogen peroxide, nitrous oxide, and the sulfur gases of hydrogen sulfide and sulfur dioxide. These may be in the air or may come from storage materials. A list of materials that can give off harmful gases is given on pages 105 and 106. Prints that are framed under glass or plastic are particularly subject to attack if the frame seals in contaminant gases. **Excellent protection against the action of these gases is provided by Kodak toners.**

As indicated in the earlier section on toning, use of toners that change the metallic silver to sulfides and selenides significantly increases the life of the images in the prints. The use of toners that contain gold chloride and KODAK Gold Protective Solution GP-1 is slightly less effective than use of the other Kodak toners. Their use does, however, extend the life of untoned prints considerably.

The protection is given to the images by the toners whether there is a color change or not. If a neutral image is desired, for example, a paper-toner combination can be chosen that shows an N, a no-tone change, classification in the toning table.

The Effect of Radiation on Image Stability: Apparently light and ultraviolet radiation have no effect on the longevity of black-and-white print images that have been properly toned as above. The prints can be displayed or kept in the dark with no difference in image stability. Untoned prints exposed to high levels of radiation for long periods of time may show image changes.

Such radiation seems to have little effect on the base of prints made on fiber-base papers. Processed and toned as indicated in the previous section, prints made on fiber-base papers can be expected to last for generations, whether they are displayed or not.

Photographs that are likely to have historic value in the future are usually worth processing to gain maximum image stability.

103

Don Buck

The illustrations in this Data Book were selected to represent a variety of photographic fields: commercial, advertising, portraiture, wedding, travel, fine arts, etc. This photograph is to show that enlargements are made of aerial photographs as well. F-surface papers are generally used to reproduce the maximum amount of detail.

Prints made for fine arts or other exhibition purposes should generally be treated for maximum image stability.

The resin coating on early RC papers had a tendency to form a series of fine, interconnected cracks, similar to the mosaic cracking of oil paintings, when subjected to alternate periods of light and dark.

Recently, another method of manufacture developed by Kodak, which involves the use of certain stabilizers and pigments, has improved the resistance of the resin coating to cracking. Current product, even when displayed, can be expected to last without cracking for many years. The keeping of prints made on RC papers is excellent when stored in the dark.

Customer needs for photographic papers are widely diversified. Many customer needs are efficiently met with RC papers, while others may be more appropriately met with fiber-base papers.

As long as there is customer demand for both fiber-base and resin-coated papers, Kodak will continue to supply papers on both bases.

Tests for Residual Chemicals: For those involved in large quantity print production or those who make fine-arts prints where maximum image stability is required, a number of tests are available.

KODAK Fixer Test Solution FT-1 utilizes a potassium iodide solution to test the exhaustion (build-up of silver) of the fixing bath.

KODAK Residual Silver Test Solution ST-1 is used to test prints to be sure that there are no residual silver complex salts in the print.

KODAK Hypo Test Solution HT-2 is used to test prints to make sure that they have been completely washed. This is a precise empirical test. A more analytical test is the ANSI *Methylene Blue Method for Measuring Thiosulfate and Silver Densitometry Method for Measuring Residual Chemicals in Films, Plates and Papers*, PH 4.8-1971.

These tests are useful in establishing a standard to which prints can be processed to make sure of consistent results in processing for stability. Formulas for the above solutions, directions for their use, and a more thorough discussion of this subject are given in KODAK Publication No. J-19, *B/W Processing for Permanence*.

Storing Photographs: Materials used in storing photographs can have a very important effect on long-term keeping quality. Many materials commonly used to store photographs are damaging to the emulsion or paper base of photographic prints. Some of the materials release harmful chemicals as they age. Materials to avoid in storing photographs are:

Wood
Wood products
 (chipboard, plywood, hardboard, strawboard)
Low-grade paper (glassine)
Nitrated and formaldehyde-based plastics
 (polyvinyl chloride, acrylic lacquer,
 acrylic enamel, acrylic plastics)
Rubber
Rubber cement

All hygroscopic adhesives
Adhesives containing iron, copper, sulfur
Some pressure-sensitive tapes or mounting
 materials
Acid inks, water-base marking pens

Materials that are safe when used to store photographs:

Baked enamel steel shelving,
 anodized aluminum, stainless steel,
 (for cabinets and shelves)
Polyester or polyethylene
 without surface coatings
Cellulose acetate (also without coatings)
Acid-free high alpha-cellulose
 mounting board and paper
(All paper products should be free of
 ground wood, alum, or rosin size)

Several dealers sell products manufactured from materials that are suitable for storing photographs, such as print storage boxes made from acid-free cardboard. Two dealers are Light Impressions, 131 Gould St., Rochester, New York 14610, and Talas Division of the Technical Library Service, 130 5th Ave., New York, New York 10011. Many dealers in art supplies also handle acid-free mounting and storage materials.

It is recommended that the prints be stored at a temperature of 70°F (21°C) or cooler. Refrigeration is not necessary. A relative humidity of 30 to 50 percent is also recommended for storage. Higher relative humidity encourages the growth of fungus, while lower relative humidities can lead to brittleness of the prints.

Stabilization and Activation Processing

Stabilization Processing: In commercial situations such as news photography labs, processing times must be short so that deadlines can be met. The stability of prints is of secondary importance, as long as the images remain stable long enough for halftones to be made. For such purposes, stabilization processes are useful.

In the regular photographic process, prints are fixed to remove the undeveloped silver halide, and washed to remove the fixer and dissolved silver salts. In the stabilization process the silver halide is treated with a chemical that converts it to a relatively stable compound. The stabilizer remains in the print and must not be washed out. Stabilization takes place in seconds, and with no wash being required, the print can be handled in light very quickly. The life of such a stabilized print depends primarily on ambient light, temperature, and relative humidity, but is often as long as months.

Actually, the process commonly employed is an activation-stabilization process. The papers used, such as KODAK EKTAMATIC SC Paper, have developing agents incorporated in the emulsion. The activation solution is strongly alkaline, which dissolves the developing agents, creating a developer within the emulsion. Development is accomplished in a few seconds. In the KODAK EKTAMATIC Processor, Model 214-K, activation and stabilization of an 8 x 10-inch (20.3 x 25.4 cm) print takes about 15 seconds. The print is damp dry as it leaves the processor, and air-dries in a few minutes.

The presence of residual stabilizing chemicals in the paper base is a requirement for the moderate

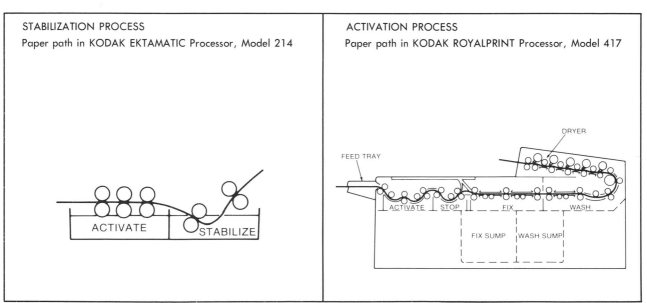

STABILIZATION PROCESS
Paper path in KODAK EKTAMATIC Processor, Model 214

ACTIVATE STABILIZE

ACTIVATION PROCESS
Paper path in KODAK ROYALPRINT Processor, Model 417

DRYER
FEED TRAY
ACTIVATE STOP FIX WASH
FIX SUMP WASH SUMP

stability of the stabilized print, hence the requirement for not washing the prints. Further, resin-coated papers are not suited for stabilization processing because the stabilizer cannot soak into the water-resistant base. The life of the image of a stabilized print on resin-coated paper can be measured in minutes.

Another application for the activation-stabilization process is in situations where water is costly or difficult to obtain. This makes the process useful in exploratory or military operations where photographic work is being done in portable darkrooms.

Stabilized prints can be used for their immediate purpose, such as making halftones, and then made permanent by fixing the print and washing in the normal manner.

Fix prints for 8 to 12 minutes in a print fixing bath, treat in KODAK Hypo Clearing Agent solution, and wash for 10 to 20 minutes. Prints can be dried in any of the normal manners. Prints made on F-surface EKTAMATIC SC Paper can be ferrotyped or can be matte-dried.

Note: Fixing and washing stabilized prints can alter the tonal characteristics of the prints slightly.

The diagram shows the paper path through the KODAK EKTAMATIC Processor, Model 214-K.

The KODAK EKTAMATIC Processor, Model 214-B, processes prints using the stabilization process.

8 x 10-inch stabilized prints come out of the EKTAMATIC Processor damp dry in about 15 seconds.

The KODAK ROYALPRINT Roll Feed Adapter is made so that rolls of exposed developer-incorporated resin-coated paper can be processed by the activation process.

The KODAK ROYALPRINT Processor, Model 417, utilizing the activation process.

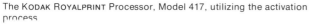

The original prints from which these reproductions were made were enlarged on either KODABROME II RC Paper or KODAK POLYCONTRAST Rapid II RC Paper and processed in a ROYALPRINT Processor, as were most of the prints used to illustrate this publication.

Activation Processing: Several Kodak papers are made for activation processing in processors such as the KODAK ROYALPRINT Processor, Model 417. These are medium-weight, resin-coated, developer-incorporated papers. A brief description of each is given below:

KODAK Paper	Description
POLYCONTRAST Rapid II RC	Selective contrast, fast speed
KODABROME II RC	Graded contrast, fast speed
PANALURE II RC	Panchromatic, fast speed
PREMIER II RC	Single contrast, machine printed

The activation process might be called an activation-conventional process. While the development occurs with an activator because the papers have developing agents incorporated in their emulsions, the rest of the process is the conventional stop-fix-wash-dry process. However, because of the way the fixer and wash are applied, and because of the water-resistant base, the time required for the activation process is very short. It takes about 55 seconds for the ROYALPRINT Processor to process two 8 x 10-inch (20.3 x 25.4 cm) prints, dry to dry. The diagram shows the paper path through the ROYALPRINT Processor.

KODAK PREMIER II RC Paper is available only in rolls and is designed for making low magnification, standard-size enlargements using automatic printers such as the Kodak color printers and Kodak enlarging color printers that handle paper from 3½-inch to 8-inch roll widths.

The KODAK ROYALPRINT Roll Feed Adapter is made to attach to the feed of the ROYALPRINT Processor so that the rolls of PREMIER II RC Paper can be processed continuously, up to three strands of paper simultaneously.

Prints processed in the ROYALPRINT Processor are washed free of fixer up to the optimum level of stability (ANSI Standard 4.32-1980).

An advantage of the activation process compared to the stabilization process is that the prints are fixed, washed, and dried as they come out of the processor, and so additional fixing and washing are not required to increase the life of the prints.

FINISHING AND MOUNTING

Finishing

When prints have been dried there may be several operations to perform on them before they are finished, professional-quality prints.

Print Flattening: Most prints made on resin-coated papers generally dry flat enough to use as is, although there may be just a slight curl in them. The amount and direction of curl depends on several factors, including the ambient relative humidity. Prints made on fiber-base papers may or may not require flattening. Prints dried on rotary dryers, whether ferrotyped or not, are generally fairly flat. Fiber-base prints dried in blotter rolls or between blotters spaced with corrugated cardboard are also likely to be fairly flat. However, unferrotyped prints made on fiber-base papers that have been air-dried on screens or by hanging up are likely to be quite curled, and may require special treatment to flatten them.

When the curl is not too great, both resin-coated and fiber-base prints can be flattened under pressure. If the prints are small, and there are not too many of them, they can be put between the pages of a book, and more books piled on top to provide weight. They must be dry so that they will not stick. A day or more under pressure leaves the prints flat.

Some workers flatten fiber-base prints by drawing them over the edge of the table, or by pulling them under the edge of a ruler on a flat surface (see illustration). The print should not be curved on too tight a radius or flattened in this way if conditions are too dry.

A print press can be used to flatten stacks of prints if the quantity is not too great. If the prints are dry, they can be stacked directly. Some workers prefer to dampen the backs of the prints and to use a photographic blotter alternated between the prints. Other workers dampen the backs of the prints and alternate the orientation of the prints so that they are dry emulsion to emulsion, and damp back to back. Dampening prints reduces the wavy edges that sometimes occur when dry prints are pressed, but care must be taken so that the prints do not stick together.

A homemade press can be made using two pieces of ¾-inch plywood cut slightly larger than the size of the prints to be flattened, and two to four large C-clamps. The prints are assembled as for a print press, and the boards placed on the outside. The clamps are tightened on the "sandwich" to press the prints. Two clamps are adequate for small-size prints, while four are needed for larger prints.

The curl in a print made on fiber-base paper can be minimized by pulling it over the edge of a table. Cracking can occur, so it is wise to practice this technique on a worthless print before trying it with a good print.

The KODAK Print Straightener, Model G, utilizes steam, belts, and roller action to minimize print curl.

These methods are for small to moderate production levels of prints. When larger quantities are involved, a print flattener such as the KODAK Print Straightener, Model G, which accepts prints up to 14 inches (35.5 cm) wide, is useful. The Print Straightener moves the prints over a steam bath and sends them over a bar in a manner similar to the table edge method discussed earlier. The bar height is adjustable, allowing control over the degree of straightening.

Spotting: Cleanliness of the camera interiors and cleanliness in the darkroom can minimize the number of spots on an enlargement, but does not seem to eliminate them completely. A piece of dust on the film when a picture is taken casts its shadow on the

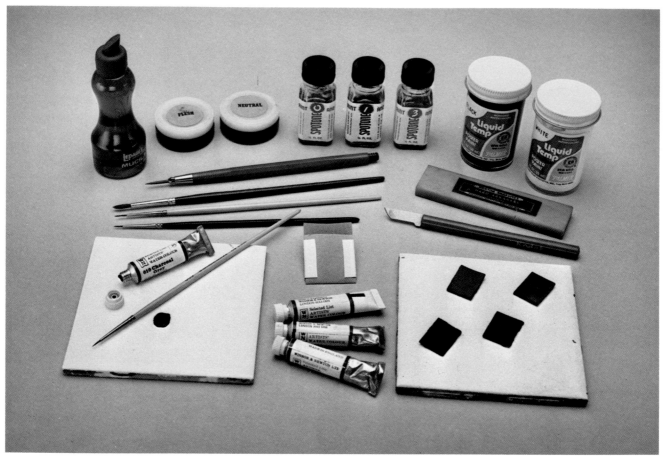

Some of the tools and materials used by print retouchers. Dyes, tube and cake watercolors, tile palettes, brushes, and etching knives all play a part in print finishing.

image, resulting in a clear area on the negative and a black area on the print. A similar piece of dust on the negative when the enlargement is made results in a white area on the print.

The purpose of spotting is to blend the tone of the spot area with the surrounding tones so that the spot is not seen in the print.

Black spots on the print are difficult to remove and can be treated on the negative. Some workers use a red dye such as KODAK Crocein Scarlet as a retouching dye and spot the clear area on the negative using a very fine spotting brush. A spotting brush is a watercolor brush that has red sable bristles that make a fine point when moistened. No. 00 and No. 0 brushes are very small brushes suitable for spotting dust areas on negatives. The negative is put on an illuminator and, under magnification, is spotted in on the emulsion with a dye solution. Some workers spot tiny round clear areas using a pointed etching knife on the base side. The point is placed on the negative base just above the clear area and twirled. The knife point creates a small opaque circle that will print white.

Skilled workers etch black spots on semi-matt prints using an extremely sharp etching knife. The surface of the print is scraped lightly, shaving off the silver image of the spot until its density matches that of the surrounding area. The spot blends in with the tone and "disappears" from view. The etching knife is made of surgical steel, and is kept sharp using an Arkansas sharpening stone. This type of stone has an extremely fine texture, and leaves a very keen, smooth edge on the knife.

Etching usually lowers the sheen of the print surface so that the etched spot shows up in reflected specular light. The sheen can be restored by carefully covering the spot with a solution of mucilage,* a type of glue designed for gluing paper. A very dilute solution is used for semi-matt surfaces, while a slightly more concentrated solution dries with a higher sheen to match the sheen of high-lustre paper surfaces.

It is useful to have a color-corrected light source so that the color of the spotting materials will match the color of the print under various lighting conditions. The drawing lamp that has a magnifying lens, circular fluorescent tube, and an incandescent bulb is a good source of spotting illumination.

Spots that are white, or lighter in tone than the surrounding tonal areas, are spotted with neutral dyes, watercolors, or pencils. Neutrality varies,

*Kodak has no official recommendation for this procedure and has run no tests on the long-term effect of mucilage on photographic paper.

A good light and magnifier make print spotting easier.

however, from warm grays to cool grays, so the actual neutral used must be matched by eye to the actual print color. It is better to keep the color a little more neutral than the print color.

Spotting brushes are used for watercolors and dyes. A variety of brush sizes may be used, from a No. 0 for tiny spots to a No. 3 for larger spots. The larger brushes have almost as fine a point as the smaller ones and hold more dye or watercolor, so they do not have to be recharged with color as often.

Spotting dyes soak into the gelatin on the print surface and are less visible when the spotting is finished. Dyes are more difficult to lighten in tone, however, if the spotting is overdone than are watercolors. Further, dyes have a tendency to change color as they dry on a print, so color matching must be done by applying the dye to an actual print surface (a margin or a discarded print) and the color matched after the dye dries. However, dyes are the only type of spotting medium to use on F-surface prints.

Spotting dyes usually come in three colors, a brownish gray color, a bluish color, and a fairly neutral gray color. The last is a good match for some papers, but must be made slightly browner for warm-image-tone prints or slightly bluer for cold-image-tone prints.

Some workers work with wet dyes. Several drops of dye are put in a small container and diluted with water. Sometimes a drop of KODAK PHOTO-FLO Solution is added to make the dye absorb into the paper more easily. The dye is picked up on a spotting brush, the brush point is twirled against a piece of absorbent paper or a piece of photo blotter to set the point and make the bristles damp-dry, and then the dye is applied to the spot.

Other workers place several drops of each color dye on a white ceramic palette (a glazed tile works well) and allow them to dry. In use, a damp spotting brush is employed to pick up a small amount of the

Spotting out little white areas caused by dirt is usually at least 90 percent of the retouching job.

dry dye, and a small area of thin dye is made on the palette and tinted with another dye if necessary. The dampened brush picks up the dye from this area. The brush is "pointed" on a piece of paper or blotting paper as when using wet dye.

When the brush is first charged with dye, it is used to work on spots in darker areas. As the dye is depleted, spots in lighter areas are worked on.

In applying the color, a stippling or dabbing procedure usually works better than merely painting it on with strokes. It is important to cover just the spot, with no overlap into the surrounding tones, or the finished spot will have a dark ring around it, and the work will be obvious. The tone is built up gradually, allowing the dye to dry between applications. It is better to stop with the tone just lighter than the surrounding tone than to have it go darker.

Watercolors can be used to spot prints made on matte, semi-matt, and lustre surfaces, but they are not generally satisfactory for glossy paper surfaces. Watercolors tend to sit on the gelatin rather than to soak into it. Both pan-type and tube watercolors are used. Payne's gray is a bluish gray color; ivory black and bone black are warm grays. Watercolors are applied to a white ceramic palette and used in much the same way as dyes.

Pencils can be used on very small spots on matte, semi-matt, and lustre paper surfaces. Charcoal pencils leave matte marks, while lead pencils leave marks with more sheen. Pencils are graded for

Airbrushing is often used to remove backgrounds for catalog illustrations. The prop holding the electronic flash unit and a shadow show on the background.

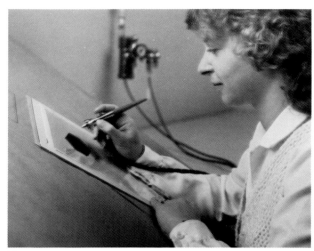

The artist sprays a white opaque watercolor to cover the background.

The subject is covered with protective material, and the excess carefully cut away with an artist's knife.

When the protective material is removed, only the subject can be seen against a white background.

An airbrush is a small paint sprayer. Two separate controls allow adjustment of the width of the spray and the amount of color being sprayed.

hardness. B stands for soft and H for hard. HB is the middle hardness, and H, 2H, 3H, 4H increase in hardness, while B, 2B, 3B, and 4B increase in softness. The softer the lead is, the darker the mark.

Pencils are sharpened to leave a long lead—about an inch—extending from the wood. The pencil lead is sharpened using a sandpaper pocket made by folding a small piece of very fine grit paper into a pocket with the grit inside. A very sharp, long tapered point can be put on the lead by twirling the pencil while moving it in and out of the pocket, keeping a slight pressure on the lead by squeezing the outside of the pocket with a thumb and index finger.

Retouchers use a variety of strokes to pencil in spots. Some use a stippling stroke, while others make swirls or rows of tiny figure eights in the spots.

On matte and semi-matt papers, fairly large areas can be darkened somewhat by using a mix of

112

pencil-lead dust (from the sandpaper pocket) with powdered pumice. The area is rubbed with pumice using a cotton ball, a cotton swab, or artist's stump. Then some of the pumice-pencil dust mix is picked up on the cotton or stump, applied evenly to the print area, and wiped smooth with a clean cotton ball. If the darkening overlaps into other areas, it is removed with art gum or kneaded rubber eraser. When the proper effect has been achieved, the pencil dust is set into the print surface by steaming, which is as simple as passing the area back and forth in front of the spout of a steaming teakettle.

If the spotting shows up on a print surface as areas of a different sheen, the print can be sprayed with artist's fixative, which is a type of lacquer. Fixative is available in both matte and glossy finishes. Using a spray lacquer may shorten the life of a print somewhat—Eastman Kodak Company does not test the various lacquer products made by other manufacturers for their effects on Kodak papers.

Air Brushing: An airbrush is a small, very refined paint sprayer that works with compressed air. Most artist's airbrushes have a double control, which determines the amount of spray being sprayed and controls the angular distribution of the spray. Used carefully, an airbrush can spray lines almost as fine as a pen line, or cover a large area with a fine mist of paint.

An airbrush can be used in two ways. The first is to darken areas. Dyes or transparent watercolors are used in this application. The technique is especially useful for darkening edges or corners of portraits, or the top area of a fairly light-toned sky. The results achieved by this technique are similar to those achieved by flashing during enlarging. It is applicable to any paper surface.

The other technique is used to prepare catalog pictures for reproduction, and tempera paints or opaque watercolors are commonly used. Only matte, semi-matt or unferrotyped F-surface fiber-base papers can be used.

Backgrounds can be made plain, rough surfaces can be made smooth, subject outlines can be made to stand out against backgrounds, and other beautifying techniques can be employed. Various graphic arts materials such as ruby lith, frisket, or photo maskoid are applied to the print surface, and the area to be airbrushed is cut out with a sharp artist's knife. The paint is mixed by mixing white with black to obtain the tone desired. The ruby lith acts as a stencil while the color is applied to the print area. When the one area is finished and the paint is dry, that area is covered with the ruby lith, and another area is cut out and airbrushed.

A print finished in this way generally loses some of its photographic look, but this technique does improve the appearance of products, many of which may have been photographed in a rough condition. It can also be used to remove the background in exploded views so that the parts of an assembly appear to be floating in white space.

Mounting

Photographic prints can be mounted for display or for protection, if they are to be handled, as when they go to a printer for reproduction, or prints can be mounted in an album for ordering and occasional viewing.

Album Mounting: In regular albums, where the pages are paper, snapshots can be mounted using four photo corners for each print. Prints can also be mounted in this type of album using KODAK Rapid Mounting Cement. Rubber cement is *not* recommended because most such cements contain chemicals that will damage the prints in time. Dry-mounting, as described below, can be used to mount album prints, but is a relatively inconvenient way to do it. Either a hand iron must be used, or the album disassembled so that the individual papers can be put in a dry-mounting press.

Mounting prints in a KODAK Photo Album consists of lifting the transparent plastic sheet, positioning the prints on the adhesive-coated paper, and replacing the transparent sheet, rubbing it flat by hand or with a soft cloth.

Commercially made slip-in window mats make mounting prints a simple operation.

The attached overmat is lifted and the print is gently inserted into the sandwich.

Many albums now are the instant-mounting type. Each page is covered with thin transparent plastic, held in place by a waxy coating. The plastic is carefully detached from the page, the prints arranged on the page and pressed by hand to adhere to the wax. When all the prints are arranged, the plastic sheet is placed over the page, prints and all, and rubbed by hand so that it adheres to the wax between the prints.

Slip-In Mounts: Many portrait photographers deliver prints to customers in attractive slip-in mounts. Such mounts are made of two layers. The top layer has a cutout where one print will be viewed. The bottom layer is a backup for the "frame" layer. The back may be extended to form a "book cover" for the picture, or to fold to provide a support so that the mount will stand up on a flat surface.

Such mounts are available in standard sizes, with the cutout usually about one-half inch smaller each way than the standard paper sizes such as 4 x 5 inches, 5 x 7 inches, or 8 x 10 inches. Smaller and larger mounts are also available.

Prints must be quite flat for use in such frames. Mounting them involves lining up the print behind the cutout opening, and taping the upper two corners to the back.

Some slip-in mounts, especially those in the larger sizes, do not have a folding cover or stand, but

Window mats with multiple openings are readily available. Groups of prints with a single theme (like pictures of a family) are simply positioned behind the openings.

consist of just the cutout frame and backing board. These are designed primarily for wall hanging.

Dry-Mounting: Plain mounts are less costly than slip-in mounts and are widely used for mounting prints for display. The most common method of mounting prints on this type of mount is called "dry-mounting," because the adhesive is in sheet form and is not a liquid adhesive.

One type of dry-mounting tissue consists of tiny beads of adhesive coated on both sides of a sheet of tissue. The print is trimmed, aligned on the mount

The first step in dry mounting is tacking dry-mounting tissue to the center of the print back with a tacking iron.

The print is lifted away from the tissue, and the tissue corners are tacked to the board with the tacking iron.

The print with dry-mounting tissue is then trimmed to size as a unit.

The mount (with the print tacked in place) is placed under a clean sheet of brown kraft paper in the dry-mounting press.

The print is located on the mount. Left and right margins are usually equal in width, while the bottom margin is somewhat greater in width than the top margin.

The heated platen of the press is lowered, pressing the print-mount sandwich flat together. The heat melts the adhesive in the tissue, causing the print to stick to the mount.

The first step in making a window mat is measuring the image area of the photograph.

An outline of the opening to be cut is made on the back of the mat board.

A professional mat cutter is helpful when a large number of window mats are to be cut. This type of cutter has a guide that keeps the mat at right angles to the rail on which the blade slides.

with the sheet of tissue between the print and mount. The print is rubbed, which breaks the beads and allows the adhesive to attach to the print and mount. This is sometimes called cold-mount tissue.

The more commonly used tissue consists of a heat-melting adhesive coated on both sides of a sheet of tissue. The tissue is tacked to the back of the print, using a heated tacking iron. The print and tissue are then trimmed to the final size together. They are aligned on the mount, two opposite corners of the tissue are tacked to the mount, and the assemblage of print, tissue, and mount are pressed together in a dry-mounting press. The heat melts the adhesive, and the print is thus bonded to the mount. The temperature of the press and the length of time the print is pressed to the mount differs with the type of tissue.

A piece of clean kraft paper is usually placed on top of the print when it is in the press so that the platen does not contact the print emulsion directly. Moisture in this cover sheet can cause the paper to stick to the print, so it is advisable, at least on start-up, to dry the paper out by pressing it with the hot platen several times (depending on the relative humidity, three or four times of 15 seconds each time, then lifting the platen for about 10 seconds to allow the moisture to escape). Prints properly dry-mounted will adhere to the mounts for many years.

Print Placement: When the print is the same size as the mount so that there are no borders, the print is "bleed-mounted." In most cases, however, the print is smaller than the mount, and there are borders.

Most workers mount vertical prints on a vertical mounting board and horizontal prints on a horizontal board. The borders on the two sides are nearly always made equal in size, except for some special effect. The bottom border is always made larger than the top border, generally by about 25 percent. Whether the top border is narrower or wider than the side borders depends on the relative aspect ratios of the print and the mounting board.

Mount Color: Mounts are intended to enhance prints, so they should not be too obvious. Hence, they are mostly light-colored, and fairly neutral. White and gray mounts are suitable for neutral- and blue-image-tone prints, while cream-colored

Using a straightedge as a guide, a small mat cutter is used to cut on the back of the board.

The window mat is hinged to a mount board. The print is inserted and taped or mounted to the mount board.

The finished mat makes a neat appearance for the photograph. The mat also serves as a separator when the photograph is to be framed in glass. The airspace keeps the print from ferrotyping on the surface of the glass.

mounts are more suitable for warm- and brown-image-tone prints.

Overlays: Additional protection can be given the print if a cutout overlay is mounted over the print. The print is dry-mounted to a board which serves as a backboard. The print need not be trimmed. A cutout overlay is purchased or made from another mount. The spacing of the opening that determines the border widths follows the same principles discussed above. This overlay is sometimes called a mat—and special mat cutters are available for production work. However, a metal straightedge and a sturdy, very sharp knife (mat knife) can be used to hand cut the overlay opening. The overlay can then be cemented to the backboard along the top edges, or it can be dry-mounted to the backboard along all four edges.

Underlays: The appearance of some prints is improved if an underlay is used. An underlay is a piece of paper, somewhat larger than the print and smaller than the mount, that is mounted under the print so that the outer edges of the underlay extend out on the mount beyond the edges of the print. It provides a secondary border.

The tone and color of the underlay and the width of the secondary borders are a matter of taste, but generally it is intended to enhance the print, not to compete with it. Hence, its color should be muted and its width relatively narrow.

A high-key print can be made to stand out from the mount if a very narrow (perhaps 1/16 inch/ 1.5 mm) black underlay border is provided. On the other hand, a low-key print can be mounted on a black mount with a very narrow white underlay border to mark the edges of the print on the mount.

Medium-gray underlays work well with normal full-scale prints. The width of medium-toned underlays can be somewhat wider—perhaps 1/4 to 1/2 inch (6 mm to 12 mm) in width, depending on the print size. With wider underlays, the bottom secondary border can be made wider than the sides and top secondary borders.

The underlay material is cut to size and dry-mounted to the mount. The print is then dry-mounted to the underlay.

A photo corner for an archival mat can be made from a small piece of acid-free paper folded as shown above. The photo corner slips over the corner of the print with the seam down.

The photo corners are taped to 100-percent rag acid-free mounting board with acid-free linen tape. The tape should not contact any portion of the print.

Archival Mat Preparation: Some workers prefer to use archival mats to store and display their photographs. An archival mat is similar to a mat prepared as described above, except that all archival materials are used and the print is mounted so that it is removable. This method is preferred by some who are concerned with long-term stability of photographs. By using all materials that are proven to be safe for long-term keeping of photographs, the deleterious effect of materials that are harmful or untested for their long-term effect on photographs is avoided. By having removable prints, the prints can be stored unmounted. The capability to store prints unmounted is a space-saving advantage and provides the flexibility to change mounts when the mount of a print becomes soiled or damaged or if it is desirable to use the mount for a different print.

To make an archival overlay mat, archival-quality mount board should be used, such as 100 percent rag acid-free mounting board. This type of board is available at art supply stores or from dealers specializing in archival supplies (such as Light Impressions, Rochester, New York, and Talas Division of the Technical Library Service, New York, New York). Other materials that are needed are acid-free linen tape and photo corners (which can be made from acid-free paper). Museum board available at many art supply dealers is often acid-free.

Instead of dry-mounting the photograph as de-scribed above, the print is attached to the backboard with photo corners and acid-free linen tape. Photo corners can be made by cutting some acid-free paper into a small strip (about ¾ x 1½ inches) and folding it in a triangular shape so that it wraps around the corner of the print. Acid-free linen tape is used over the photo corners to attach the corners of the print to the mount board, without using an adhesive directly on the print. The print can easily be removed at will. The overlay mat is hinged at the top using the acid-free linen tape, providing easy access to the print inside.

A protective overlay of thin acid-free paper can be attached to the backboard with linen tape to shield the print from abrasions when not being displayed. For more information on preservation of photographs see KODAK Publication No. F-30, *Preservation of Photographs.*

Framing Photographs: Putting photographs in frames is similar to framing any other type of picture, but there are two conditions that should be observed.

1. Keep the print surface away from the glass. If a photo surface is in contact with the glass, it may ferrotype against the glass and stick. If the print is dry-mounted so that it will not bulge with humidity, and if it is spaced away from the glass, this will not happen.

The window mat is hinged to the top of the mount board with linen tape. The print must be carefully measured before the mat is cut so that only the desired image area is visible in the opening. Extra-wide print borders are helpful with this type of mounting.

2. Small air vents should be arranged so that there will be an airflow between the print and the glass. If fumes from a varnished frame are trapped against a print surface, especially an untoned print, some dark areas may develop a red color as black metallic silver grains change to colloidal silver. This is especially likely to happen to prints made on resin-coated papers.

 If a print is made on fiber-base paper, is toned, and is framed with ventilation, this red spot problem does not occur.

Wet-Mounting: Some prints, such as photomurals, are too large to be dry-mounted and are consequently mounted wet, using a paste or glue. Such prints can be mounted directly on a wall, as wallpaper, or mounted on large cardboard, hardboard (such as floor underlayment), or foam-cored mounting stock, which consists of a plastic foam core with cardboard on both sides.

Bradley Svatek photos shown

A window mat enhances the appearance of a print to be hung in a gallery or exhibition. When the mat is made of archival materials the value of the print is thought to increase for the buyer.

Various adhesives can be used: wallpaper paste, wallpaper paste for vinyl wallpapers (for resin-coated papers), white glue, or padding compound. Padding compound is a gelatinous-rubbery compound used by printers to pad stacks of paper into tablet form. The pastes are mixed according to directions; the glue and padding compound are diluted with water for use in mounting prints.

The mounting surface should be sealed or sized. Bare plaster should be sealed with a commercial sealing material available at paint stores. Hardboard, cardboard and foam-core board should be sized with a diluted form of the adhesive being used.

The print should be soaked before mounting. The adhesive is applied to the back of the print with a brush or roller. The print is placed on the mount and flattened with a wallpaper smoothing brush or with a roller to work all the air bubbles out.

An old print or fixed and washed print should be adhered to the back of the mount board in just the same way. Otherwise, as the print dries and shrinks, it will put a curl in the board. With paper shrinking evenly on both sides, the mount board stays quite flat. Of course, this is unnecessary if the print is being mounted on the wall.

More details about mounting large prints can be found in KODAK Publication No. G-12, *Making and Mounting Big Black-and-White Enlargements and Photomurals.*

High technical quality in a print usually means delicate gradation in the highlights, good detail contrast in the middletones, and adequate tonal separation in the shadows. It often means that there is at least a small area of pure, paper-base white and at least a small area of black that approaches the D-max of the paper.

PRINT QUALITY

Technical Quality

The quality of a photograph is the result of four main factors.

The first has to do with the subject—its interest, viewpoint, composition, lighting, and treatment.

The second has to do with the camera—its format size, the lens (its focal length and quality) and lens aperture chosen, the focus and depth of field, the shutter speed, and any special devices such as filters.

The third has to do with the negative—the choice of film and developer, the amount of exposure and of development, and the care with which it has been processed.

The last has to do with making the print—the particular *enlarger*, the *choice of paper*, the *exposure* and any *special printing techniques*, the *processing chemicals and their use*, any *special after-treatments*, and, of course, *spotting and mounting*.

While all four contribute to the quality of the final print, those aspects of special interest in this publication relate to the last factor, and the characteristics of this factor are all technical. How can good technical quality be described?

Technical quality means, above all, excellent tone reproduction: delicate gradation in the highlights, with diffuse highlights separated tonally from specular highlights, which are reproduced as white paper; good separation throughout the middletones; and a range of shadow tones that provides enough detail but still has some areas of deepest black to provide a tonal foundation. The contrast and overall image tone must be appropriate to the subject, as must the sharpness and degree of graininess.

Quality in a print becomes obvious when it is poor and when it is excellent. When quality is poor, the photograph does not do justice to the subject. When quality is high, the subject is enhanced, and with most photographs viewers should become so aware of the subject that they are unaware of the print. The photograph then serves its purpose well as a medium of visual communication.

How Good Should the Quality Be? There is a practical consideration to print quality. A straight print from a negative, on a contrast grade of paper that matches the negative, properly exposed and processed, is quick to make and is suitable for most purposes.

There are two purposes, however, for which such prints almost always do not have high enough quality. If the print is to be displayed or if it is to be reproduced by a fine-screen halftone in a magazine or book, special treatments can be given to achieve the best quality possible.

Display Prints

Photographic prints are used for viewing directly under display conditions in a number of ways. Photomurals are used for decorating. Fine-arts prints are used for display in salons, exhibitions, and museums, and for decorations. Portraits are put on display in homes and in offices. Large prints are often used to show products in merchandising displays.

Display Light Level: The quality of prints made for display must be adjusted for the illumination level under which they will be displayed. The eye has a variable response to tones that depends on the level of ambient illumination.

If a gray scale that has even density steps is viewed under a normal interior light level of 50 to 100 foot-candles, the eye sees the steps between the light tones as larger than the steps between dark tones. As the light level is reduced, the steps between the darkest steps disappear, while the tone separation between the light steps seems to grow larger. Under very low light levels, such as the light given by a full moon, only the light steps will be visible, all the medium-gray and dark-gray steps will look black.

On the other hand, if the gray scale is taken out into the full sun, the separation between two dark steps appears greater, while the tonal separation between the light steps appears to lessen.

This means that prints made for display under high levels of illuminance should have slightly greater densities overall, while prints made for display under relatively low levels of illuminance should be somewhat lighter, overall, than normal.

Good highlight rendition is important in all prints, and especially in prints for high illuminance display. The diffuse highlights should have enough tone so that they will not "wash out" when displayed.

One method that helps achieve this is to make the print overall slightly dark and then give it a short treatment in dilute KODAK Farmer's Reducer. Just enough reducing is given to bring the specular highlights back to paper white, while leaving tone in the diffuse highlights. This procedure gives improved separation in the highlight tones, while leaving enough density so that the tones are visible when brightly illuminated.

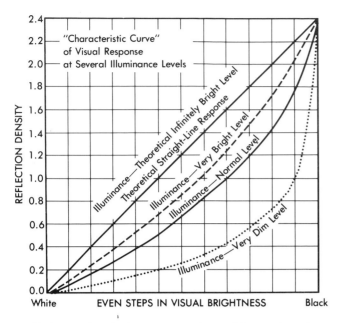

One good technique to use in making prints for low-light-level display is to make the prints on a selective-contrast paper. Use a relatively low-numbered PC filter to make the overall exposure so that all the tones will reproduce in the print when it is printed lightly. If developed at this point, the blacks would be gray. However, without moving anything, a second exposure is given through a PC4 filter. If this exposure is just the right length, only the black tones will expose on the paper. Such a procedure achieves lighter middletones but still produces some blacks—making the print suitable for viewing under low-illuminance display conditions.

Two Types of Display Prints: There are two treatment approaches used in the making of prints for display.

1. The print is intended to portray the subject as clearly as possible, and is made so that the viewer is primarily aware of the subject, and only secondarily of the print.

2. The printing technique is made to be an object of the viewer's attention, along with the subject as in other two-dimensional art forms. The *technique* becomes an equal partner with the subject in transmitting a visual message. Nearly always a large part of the purpose of this treatment is to give aesthetic pleasure.

For the first approach, smooth paper surfaces are chosen, with fairly neutral image tones. The subject is reproduced as clearly and as close to a visual approximation of the subject tones as the process permits. The print becomes a "window" through which the viewer sees the subject.

In the second approach, there can be a wide vari-

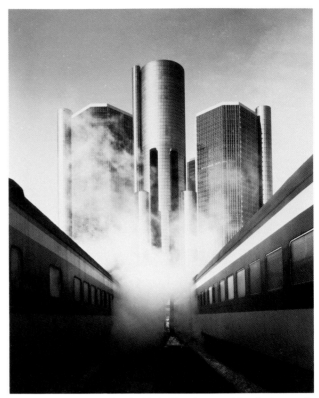

Display prints can be printed with the illuminance of the display area in mind. This print was made for display in a dimly lit (low illuminance) display situation.

ation in the type of photographic quality. Grain, or a pattern provided by the paper surface or by a texture screen, can be evident. The tonal range of the print can be altered to create any of a number of tonal effects. The print image may have been softened by use of a diffuser during enlarging. The final negative(s) from which the print is made may have been "derived" from the original negative(s) by one of many negative derivation processes (bas-relief, tone-line, posterization, Sabattier effect, etc). In some of these processes, the gradation of tone that is an intrinsic part of the normal process is purposely altered. Even when these processes are used, however, the clear whites and deep blacks mentioned above are usually desirable as part of the photographic quality.

Prints for Halftone Reproduction

Photographs are reproduced on the printed page by a halftone process. Printing presses can print black and white (ink or no ink) but cannot print any intermediate tones. The halftone process breaks up the image into dots. Light tones are small black dots with lots of white paper area between them. Middletones are a checkerboard effect of black and white squares. Dark tones are "white dots" on a black ink base.

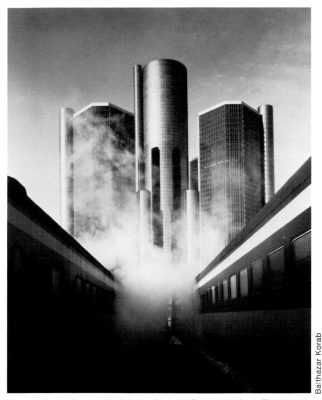

Balthazar Korab

A normal density print is the requirement for most prints. This is suitable for display where the illuminance matches that of a well-lit room.

For display outdoors, or in situations where the illuminance is very high, as when a spotlight is used for illumination, the print densities, especially those in the highlights, should be greater than in a normal print.

With most photographs, the intent is to portray the subject. The print surface becomes a "window" through which the subject is seen.

Angela Mrvica-Benson

In some cases, the print itself, and often the technique used to make the print, become as important as the subject. The tone-line technique was used to make this illustration.

John Zaiger

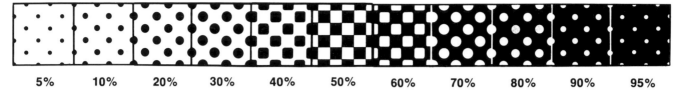

5% 10% 20% 30% 40% 50% 60% 70% 80% 90% 95%

There are three printing quality levels that need to be considered when making prints that are to be reproduced by a halftone process. The newspaper level gives the lowest quality level of reproduction. The dot size is fairly coarse, and the newsprint paper is not truly white, while the fast printing process limits the density of the black print. As a result, both light tones and dark tones are compressed badly, and most of the tone separation in the reproduction occurs in the middletones.

This affects both the way news pictures should be taken and the way the prints should be made for newspaper-type reproduction. As far as possible, important subject detail should be recorded in the middletones, and the printing of the negatives should emphasize these middletones. The usual efforts to separate the diffuse highlights is virtually useless because they will not reproduce on the newsprint. Dark-toned areas should usually be kept small in the pictures, unless, of course, it is intended that they print black. The paper should have a glossy surface.

The second and third quality levels of reproduction both require the same type of photographic print. The second level involves fine halftone screens and white, coated papers such as are used in "slick" magazines, so called because of the coated paper on which they are printed. As with newspapers, a simple printing impression is made. However, because of the type of presses used, a greater density of printing ink is laid down. Hence, because of the whiter paper and denser ink, the reproduction tonal scale is increased.

From the tone reproduction standpoint, the same type of print is required as an original for reproduction as for display prints—good tone separation in the highlights and shadows, with clean white specular highlights and good blacks. Good midtone tonal separation is also desirable.

When photographs are to be reproduced in newspapers, coarser halftone screens are used. It is important that the local contrast be relatively high, and that the subject be well separated from the background.

When a fine-screen halftone is made to print on a high-quality paper stock, more of the subtle tonal differences in the original photograph will be reproduced. This illustration was reproduced with a single halftone, and is not a duotone reproduction.

Bob Clemens

124

A high-quality halftone reproduction can reproduce subtle tonal gradations in both the light and dark tonal regions if they are well reproduced in the photographic print.

Bob Clemens

125

While normal procedure is to print for detail in the shadows, the photographer may choose to use deep black shadows as part of his composition.

Steve Kelly

In combination printing, the quality depends on careful workmanship in combining the images.

Jerry Uelsmann

There are two reasons for this type of high-quality print for fine halftone reproduction. The first is that, properly made, the halftone will show every tone separation in the original print, but the separation will be somewhat reduced. The second reason is that every print for reproduction, whether for advertising or for editorial use, has to be approved by a picture editor, art director, or client (or all of these). If the print has this type of high quality, such viewers will not reject the print for quality reasons. To get the longest scale of tone, a glossy paper surface is usually used, either an F-surface resin-coated paper, or a ferrotyped F-surface fiber-base paper.

There are two methods of printing that produce the highest possible quality black-and-white halftone reproduction. The first is called duotone, in which two halftones are made and printed. The first is a normal, full-scale halftone, while the second reproduces just the lower half of the tonal scale. The dark tones and blacks are given greater density by this double printing. Duotones are normally printed with offset lithographic presses. That is the way that this KODAK Data Book has been printed.

The second method that gives the highest level of reproduction is called gravure printing. Because of the way the printing plates are made and the type of presses used, a greater ink depth can be achieved, resulting in blacker blacks—hence an increased reproduction tonal scale.

Other Quality Factors

Whether prints are made for display or for reproduction, there are several quality factors in addition to those of tonal quality to be considered:

Appropriate size, tone, texture, and sheen

Freedom from defects

Image stability

Appropriate mounting

Size: Size usually depends on the end usage of a print. While the photographer normally has some freedom, there are often constrictions on print size imposed by conditions. Prints for most photographic exhibitions (salons) have a maximum size of 16 x 20 inches (40 x 50 cm). Prints for reproduction are normally made 8 x 10 inches (20.3 x 25.4 cm). There is an advantage, however, to having a reduction in size from the print to the reproduction, so that if the halftone reproduction is to be larger than 8 x 10 inches, the print should be correspondingly larger.

Some negatives do not stand enlarging many diameters for sharpness and grain reasons. A smaller print for such negatives appears to have better quality than larger prints. When there is a choice with such negatives, the smaller print is therefore recommended.

As a result of high atmospheric dust levels, the negative of this picture was low in contrast. Choice of paper and enlarging controls made possible this successful tone reproduction.

Freedom from Defects: Finished prints should look "perfect." This primarily means that they should be retouched carefully so that no spots show and that there are no other types of defects visible. In print handling, physical defects sometimes occur. Corners get bent, surfaces get scratched or stained, and prints are sometimes torn.

Prints that are to be viewed or reproduced should have a defect-free appearance, and this is achieved by careful work and handling throughout the entire printmaking process.

Image Stability: The various aspects of this subject are covered in the earlier sections "Processing for Image Stability" and "Handling and Storage of Photographic Paper." A photograph should be as permanent as the need for it. However, prints have a way of being useful long after the original need has been satisfied.

In most work it is wise to make each print as stable as possible, and to mount and store the prints with materials that are not harmful to long print life.

One particular precaution is to never store stabilized prints in the same file with other photographs. The stabilizer contains hypo, and any contact with a conventional print contaminates it with the hypo, thus shortening its life.

Appropriate Mounting: Prints for display are mounted both for appearance and protection. The heavy cardboard from which most mounts are made helps prevent damage to the print, and thus helps provide good print quality.

Since appearance of the mount is relatively unimportant for reproduction purposes, the prints are often dry-mounted on a plain card somewhat larger than a print. Tracing paper or matte acetate is often taped to the mount to provide additional protection and to provide a surface over the print on which cropping marks and other information can be placed.

Index

The quality of this illustration depends on the careful reproduction of tones in relatively small areas in the picture.

KODAK POLYFIBER Paper

Applications ■ For high-quality, general purpose enlarging

Characteristics ■ Variable contrast control by filters
■ Fiber base
■ Neutral tone
■ Brightener in base for clean whites
■ Wide development latitude
■ Surface and contrast characteristics are as follows:

Symbol	Brilliance	Texture	Tint	Weight	Grades
F	Glossy	Smooth	White	Single	1-4*
				Double	1-4*
G†	Lustre	Fine-Grained	Cream-White	Double	1-4*
A‡	Lustre	Smooth	White	Light	1-4*
N	Semi-Matt	Smooth	White	Single	1-4*
				Double	

*With KODAK POLYCONTRAST Filters.
†Not available in single weight.
‡Available in lightweight paper only.

Safelight ■ KODAK OC Safelight Filter (light amber); keep safelight exposure to a minimum.

Paper Speed

POLYCONTRAST Filter	No Filter (white light)	PC 1	PC 1½	PC 2	PC 2½	PC 3	PC 3½	PC 4
ANSI Paper Speed	250	200	200	200	160	125	100	50

Development The table below is for tray processing at 68°F (20°C).

KODAK Developer	Dilution	Development Time in Minutes		Capacity—8 x 10-in. (20.3 x 25.4 cm) prints	
		Recommended	Useful Range	Per U.S. Gal	Per L
DEKTOL (powder)	1:2	1½	1 to 3	120	32
EKTAFLO Type 1	1:9	1½	1 to 3	100	26
HOBBY-PAC™	See pkg	1½	1 to 3		15

Toning The table below gives the image-tone change to be expected in KODAK Toners. Treatment in KODAK Rapid Selenium Toner at a dilution of 1:20 for 3 minutes at 70°F (21°C) protects the print from oxidizing gases and increases the D-max (deeper blacks) without giving a tonal change.

KODAK Toner	Tone Change
Brown	Full
Sepia	Full
POLY-TONER 1:24	Moderate
POLY-TONER 1:50	Moderate
POLY-TONER 1:4	Slight
Rapid Selenium 1:3	Moderate
Rapid Selenium 1:9*	Moderate
Rapid Selenium 1:20*	None

*The 1:9 and 1:20 selenium toning baths can be mixed with the hypo clearing agent bath. To dilute the toner, use the hypo clearing agent bath instead of water. To avoid stains, don't rinse the prints after fixing; go directly into this combination bath and then into the water bath for washing.

Characteristic Curves

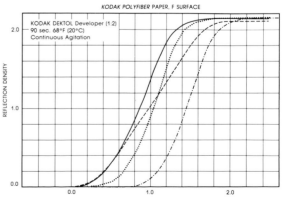

KEY

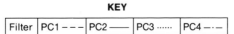

| Filter | PC1 – – – | PC2 —— | PC3 | PC4 —·— |

KODAK POLYPRINT RC Paper

Applications
- For press, commercial, school, and hobbyist uses
- Especially useful for tray processing requiring wide development latitude
- Cannot be processed in KODAK ROYALPRINT Processor

Characteristics
- Variable-contrast with filters
- Resin-coated paper base for rapid processing and fast drying
- Brightener for brilliant whites
- No incorporated developer agent—allows wide development latitude from 45 seconds to 3 minutes.
- Medium-weight paper with cool, neutral tone
- Back of paper specially coated for ease of writing
- Surface and contrast characteristics are as follows:

Symbol	Brilliance	Texture	Tint	Weight	Grades
F	Glossy	Smooth	White	Medium	1-4*
N	Semi-Matt	Smooth	White	Medium	1-4*
E†	LUSTRE-LUXE®	Fine-Grained	White	Medium	1-4*

*With KODAK POLYCONTRAST Filters.

†E surface not available in all countries.

Safelight
- KODAK OC Safelight Filter (light amber); keep safelight exposure to a minimum.

Paper Speed
- F Surface Developed in KODAK DEKTOL Developer at 68°F (20°C) for 90 seconds

POLYCONTRAST Filter	No Filter (white light)	PC 1	PC 1½	PC 2	PC 2½	PC 3	PC 3½	PC 4
ANSI Paper Speed	250	200	200	200	160	125	100	50

Development Can be machine processed in KODAK DEKTOMATIC Chemicals. The table below is for tray processing at 68°F (20°C).

KODAK Developer	Dilution	Development Time in Minutes		Capacity—8 x 10-in. (20.3 x 25.4 cm) prints	
		Recommended	Useful Range	Per U.S. Gal	Per L
DEKTOL (powder)	1:2	1½	¾ to 3	120	32
EKTAFLO Type 1	1:9	1½	¾ to 3	100	26
HOBBY-PAC™	See pkg	1½	¾ to 3		15

Toning The table below gives the image-tone change to be expected in KODAK Toners. Treatment in KODAK Rapid Selenium Toner at a dilution of 1:9 or 1:20 for 3 minutes at 70°F (21°C) protects the print from oxidizing gases and increases the D-max (deeper blacks) without giving a tonal change.

KODAK Toner	Tone Change
Brown	Full
Sepia	Full
POLY-TONER 1:24	Moderate
POLY-TONER 1:50	Moderate
POLY-TONER 1:4	Slight
Rapid Selenium 1:3	Slight
Rapid Selenium 1:9*	None
Rapid Selenium 1:20*	None

*The 1:9 and 1:20 selenium toning baths can be mixed with the hypo clearing agent bath. To dilute the toner, use the hypo clearing agent bath instead of water. To avoid stains, don't rinse the prints after fixing; go directly into this combination bath and then into the water bath for washing.

Characteristic Curves

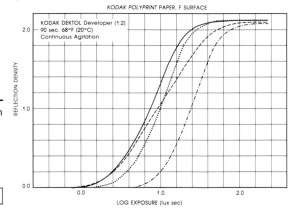

KEY

Filter	PC1 – – –	PC2 ———	PC3 ·······	PC4 – · —

KODAK PANALURE II Repro RC Paper

Applications
- Making black-and-white enlargements from color negatives
- For commercial, portrait, and school usage, especially when used for halftone reproduction
- For hobbyist usage when a lower contrast paper is needed

Characteristics
- Panchromatic emulsion sensitivity for proper tonal rendition from color negatives
- Resin-coated paper base for rapid processing and fast drying
- Brightener for brilliant whites
- Warm-black image tone
- Surface and weight characteristics are as follows:

Symbol	Brilliance	Texture	Tint	Weight	Grades
F	Glossy	Smooth	White	Medium	*

*Contrast of this paper is approximately one grade lower than that of KODAK PANALURE II RC Paper, whose contrast is matched to typical color negatives.

Safelight
- KODAK Safelight Filter No. 13

ANSI Paper Speed

	KODAK ROYALPRINT Processor Model 417	KODAK DEKTOL Developer
Color Negatives	320	320
Black-and-White Negatives	500	800

Development Tray-processing recommendations are as follows:

KODAK Developer	Dilution	Development Time in Minutes		Capacity—8 x 10-in. (20.3 x 25.4 cm) prints	
		Recommended	Useful Range	Per U.S. Gal	Per L
DEKTOL (powder)	1:2	1	¾ to 2	120	32
EKTAFLO Type 1	1:9	1	¾ to 2	120	32
EKTONOL	1:1	1½	¾ to 3	120	32

NOTE: Do not ferrotype. This paper dries to a natural surface gloss without ferrotyping. Drying with warm air may enhance the gloss.

Characteristic Curve

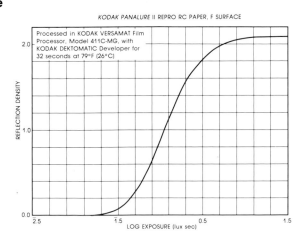

KODAK PANALURE II REPRO RC PAPER, F SURFACE

Processed in KODAK VERSAMAT Film Processor, Model 411C-MG, with KODAK DEKTOMATIC Developer for 32 seconds at 79°F (26°C)

KODAK ELITE Fine-Art Paper

Applications
- Fine-art, commercial, and industrial photography
- Any use where superb quality is needed

Characteristics
- Moderate-speed paper with same speed for each grade
- Fiber base
- Neutral tone
- Brightener in base for brilliant whites
- Silver-rich emulsion for deep blacks
- Thick gel overcoat for high-lustre surface with air drying
- Surface and contrast characteristics are as follows:

Symbol	Brilliance	Texture	Tint	Weight	Grades
S	High-Lustre	Ultra-Smooth	White	Premium	1, 2, 3

Safelight
- KODAK OC Safelight Filter (light amber); keep safelight exposure to a minimum.

Paper Speed

Contrast Number	1	2	3
ANSI Paper Speed	320	320	320

Development
The table below is for tray development at the normal grades of 1, 2, or 3 at 68°F (20°C). By using split development, each paper grade can be lowered by approximately half a grade. For split development, develop first in KODAK SELECTOL-SOFT Developer (diluted 1:1) for half the time in the table below, then in KODAK DEKTOL Developer for the other half of the time. By developing solely in SELECTOL-SOFT Developer, you can lower contrast nearly a full grade.

KODAK Developer	Dilution	Development Time in Minutes		Capacity—8 x 10-in. (20.3 x 25.4 cm) prints	
		Recommended	Useful Range	Per U.S. Gal	Per L
DEKTOL (powder)	1:2	2	1 to 4	120	32
EKTAFLO Type 1	1:9	2	1 to 4	100	26
HOBBY-PAC™	See pkg	2	1 to 4		15

Toning
The table below gives the image-tone change to be expected in KODAK Toners. Treatment in KODAK Rapid Selenium Toner at dilutions of 1:20 and 1:40 for 3 minutes at 70°F (21°C) protects the print from oxidizing gases, increases the D-max (deeper blacks), and gives only a very slight tonal change.

KODAK Toner	Tone Change
Brown	Full
Sepia	Full
POLY-TONER 1:24	Moderate
Rapid Selenium 1:3	Slight
Rapid Selenium 1:9	Slight
Rapid Selenium 1:20*	Very slight
Rapid Selenium 1:40*	Very slight

*The 1:9 and 1:20 selenium toning baths can be mixed with the hypo clearing agent bath. To dilute the toner, use the hypo clearing agent bath instead of water. To avoid stains, don't rinse the prints after fixing; go directly into this combination bath and then into the water bath for washing.

KEY

Contrast	No. 1 – – –	No. 2 ———	No. 3

Characteristic Curves

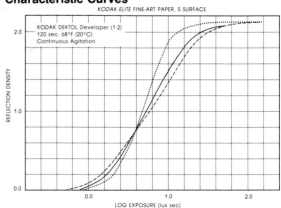

KODAK ELITE FINE-ART PAPER, S SURFACE

KODAK DEKTOL Developer (1:2)
120 sec. 68°F (20°C)
Continuous Agitation

REFLECTION DENSITY

LOG EXPOSURE (lux sec)